D1319745

History Becomes Form

History Becomes Form

Moscow Conceptualism

Boris Groys

The MIT Press
Cambridge, Massachusetts
London, England

MIT Press books may be purchased at special quantity discounts for business or sales promotional use. For information, please email special_sales@mitpress.mit.edu or write to Special Sales Department, The MIT Press, 55 Hayward Street, Cambridge, MA 02142.

This book was set in Stone Sans and Stone Serif by Graphic Composition, Inc., Bogart, GA. Printed and bound in the United States of America.

Library of Congress Cataloging-in-Publication Data

Groĭs, Boris.
History becomes form : Moscow conceptualism / Boris Groys.
 p. cm.
Includes bibliographical references and index.
ISBN 978-0-262-01423-6 (hardcover : alk. paper) 1. Conceptual art—Russia (Federation)—Moscow. I. Title. II. Title: Moscow conceptualism.
N6988.5.C62G76 2010
709.04'0750947—dc22
 2009045668

10 9 8 7 6 5 4 3 2 1

Contents

Introduction

Moscow conceptualism was, like many other art movements of the 1960s and 1970s, de facto a return to realism. After many decades of modernist attempts to produce non-mimetic, autonomous artworks artists began again to be interested in the depiction of the outside world. But this return to realism as an artistic attitude could not mean, of course, a return to realism as an artistic style, because the world had changed since the time of nineteenth-century realism. It had changed—and it continues to change. The central drama of the nineteenth century was a conflict between forces of progress and forces of the status quo. Even today there is a widespread belief that to be critical of the world as it is is to be against the status quo and for change, for progress, for the different and the new. But, in fact, our world is always already on the move, already permanently changing, already directed toward the future that is generally expected to be different from the past. Our status quo is change—permanent change, in an attempt to make the world a better place or at least to avoid an impending catastrophe. From all sides we hear that something old has just been abolished and that something new has just emerged—so that things will never be the way they were before. The contemporary human being lives in an ongoing project—he has a vision of the future and learns its lessons from the past. But he tends to overlook the present because he experiences the present as merely temporary, transitional, and, therefore, unimportant. In other words: He overlooks the status quo, he lacks an image of the status quo as something stable—as a definite form that is visible and can be contemplated. That is why the status quo—or, let's say, "contemporaneity"—has today become the primary concern of contemporary art.

Today's visionary is a stock broker, an upstart entrepreneur or a progressive politician; maybe also a creative designer. Today's artists are mostly not visionaries. Rather, they watch the world that follows a vision—or numerous visions—and make visible how this world looks, here and now. In his *Being and Nothingness* Sartre describes a scene in which a spectator absorbed in contemplation of his vision is viewed by another person—seen from the outside and turned into an object by this outsider's look that cannot and does not want to share any inner vision of the spectator, but, instead, is able

to see his "objectified," external image that is presented to the world.[1] One can argue that here a new possibility of a critique emerges. It is not a critique of the status quo in the name of any messianic hope, be it strong or weak, but a critique of the contemporary world as being completely absorbed by a messianic hope—and being, therefore, completely incapable to reflect on itself, to see itself as it truly is. Sartre says that when a person who is immersed in his inner vision and lives in his inner project is caught by an outsider's look, this person feels himself deeply ashamed—by the mere fact that through this look he ceases to be a subject of a project and becomes an object, a presence in the world. The typical reaction of such a person is a flight into "bad faith": One says to oneself and to the others that he is not this object that they see, that he is somewhere else, in the future, that he is in the process of changing, that he should be judged on his inner vision and not on the image that he offers here and now to a possible spectator.

Our contemporary world can be seen in its totality as a world of "bad faith" because it is a world of projects and visions. But the Soviet Union was arguably the embodiment of bad faith par excellence. The Soviet Union was a society completely oriented toward the future, completely immersed in the vision of the future—a society living in a unifying Communist project. Everything "present" was automatically experienced as being only transitional, as being something to be used and then eliminated on the way to the radiant Communist future. The true Soviet citizen was somebody living in total oblivion of the present. This lack of contemporaneity also produced a certain feeling of shame that the Soviet State and its citizens always experienced under the gaze of the outside world—like somebody who is looked on by a stranger while getting dressed. However, the outside world also tended to see the Soviet Union as a place of a still unfinished Communist experiment—disregarding its culture as it had already formed itself here and now. During the cold war everyone was either for or against the Communist project. People shared the Communist vision, or they were in opposition to this vision. Nevertheless, the artists of Moscow conceptualism tried to avoid the "vision thing" and to see not change and ongoing projects but the culturally repressed repetition of sameness.

Thus, the goal of Moscow conceptualism was to change the direction of one's own gaze from future to present, from inner vision to external image. Or: to become external spectator in a world of shared visions. After Guy Debord our present society is often described as a society of the spectacle. But a society can become a society of the spectacle only for somebody who has already become a spectator. And in a contemporary society that is totally immersed in activity, creativity, and change, to become a spectator is anything but an easy task. It was not easy for Debord. It was also not easy for the members of the Moscow conceptualist circle. That is why the themes of void, emptiness, and marginality play such a prominent role in the discourse and art of this circle. One looked for empty spaces in the dense Soviet reality to become able to occupy these

spaces and to create a possibility of spectatorship, a possibility of looking on the Soviet life as a spectacle—a possibility that otherwise only the secret service, the KGB, enjoyed because it operated in an empty space protected by the state. The artificially created empty space of contemplation was often symbolized in the works of Moscow conceptualists by the color white—referring to the white background of Malevich's suprematist paintings or to the Russian fields covered with snow. But the visual and linguistic gaps, paradoxes and poetic nonsense played the same role of creating the ruptures and empty spaces in the fabric of the Soviet life. At the time in which Moscow conceptualists made a spectacle out of Soviet life this gesture was experienced by Soviet culture itself as shaming and shameful. And it was experienced in this way by both the Soviet official and unofficial cultural milieus—though for different reasons. However, today the spectator's gaze that was previously perceived as critical, cruel, and even cynical seems in retrospect to be sentimental and nostalgic. Moscow conceptualism not only made a spectacle of Soviet life but also saved its memory for a future that became different from that of the Communist vision. It is a memory of shabbiness and austerity of the Soviet everyday life but also of the utopian energy of the Soviet culture. Through the art of Moscow conceptualism a certain period of modern history—namely, the history of realization of the Communist project—finally becomes form.

Now, though I'm not an artist I was still a member of this circle—and this book documents thirty years of my involvement with Moscow conceptualism. The essays collected here were not rewritten or modified for this book—only lightly edited. Thus, these essays do not necessarily reflect my attitudes or interests today. Rather, they show how these attitudes were changing throughout the time. These changes also reflect, of course, the evolution of the Moscow conceptualist movement itself. However, precisely because these essays are authentic documents of the recent past, they are far from being able to give the reader a comprehensive view of Moscow conceptualism. All of them were written in response to certain requests with the goal to be published in different journals, catalogs, and collections of essays dedicated to individual Russian artists or to Russian art in general. These practical goals influenced, of course, their topics, approaches, and scope. Again, this can be seen as both a weakness and a strength at the same time. Namely, these essays witness not only the intentions of their author but also the requirements and expectations to which the author was reacting. This introduction attempts to historically situate them partly by describing the historical and biographical contexts of their emergence, and partly by trying to compensate for omissions and gaps that result form their fragmentary character.

1 Historical and Autobiographical Remarks

My own involvement with the artists that are associated with the Moscow conceptualist circle started after I moved from Leningrad (now St. Petersburg) to Moscow in the

year 1976. Already during my stay in Leningrad I had become acquainted with the milieu of unofficial Russian culture, namely, with the milieu of artists, poets, writers, and intellectuals who were not strictly speaking dissident and politically involved but who practiced art and theoretical discourses that could not find a place within the official Soviet culture of that time. The limits of this official culture were actually very narrow: They excluded everything that looked religious, modernist, decadent, existentialist, sexually explicit, or politically implicit. Accordingly, there were thousands of reasons for intellectuals and artists to drift into the unofficial cultural milieus—it was enough for them to be interested in Mallarmé or in Russian icons, in Heidegger or in Nabokov, in Magritte or in Tibetan Buddhism to find themselves outside of the official Soviet cultural framework. These unofficial cultural milieus were more or less tolerated by the authorities but completely cut off from the state-controlled media and wider audiences. Among my acquaintances from Leningrad and Moscow there were also many unofficial artists—and I knew their work. But these artists worked mostly in the tradition of surrealism, cubism, or expressionism. Their art was not contemporary in a sense in which Western art was—contemporary art that I knew from reading Western art magazines and books that described the art practices of minimalists, conceptual artists, performance artists, and so on. Thus, I didn't think that it made any sense for me to write about Russian unofficial art at that time.

My attitude changed after I became acquainted with Ilya Kabakov, Erik Bulatov, Dmitri Prigov, Lev Rubinstein, Ivan Chuikov, and some other Moscow artists. When I saw their works, I had for the first time a feeling that I was being confronted with art I would be interested to write about. But there was no possibility that I would be able to publish anything I wrote on their art—and so I just spent a lot of time speaking with these artists in their studios and homes without pursuing any specific writing projects. The situation changed when Ivan Chuikov told me that his friend, artist Igor Chelkovsky who had recently emigrated to Paris, was going to start a magazine there under the title *A-Ya* (a transliteration of the first and last letters of the Russian alphabet). This magazine was to be published in both Russian and English and was destined for both the Western and the Russian public—the editors planned to smuggle a certain number of issues of the magazine into the Soviet Union and distribute them there. Ivan asked me if I would be ready to write an introductory text for the first issue. I said: Yes. This was in 1978—and the first issue that opened with my text appeared in 1979 (figs. 0.1– 0.2). This first issue also contained a conversation between me and Erik Bulatov. The second issue of *A-Ya* included a text by me on Ilya Kabakov. The next issues appeared more or less annually. A total of seven issues were published before Igor Chelkovsky decided to discontinue the magazine in 1986.

I mention these details because my introductory text had the title "Moscow Romantic Conceptualism." Later the word "Romantic" disappeared from the Russian collective memory, and the term "Moscow conceptualism" began to function as the name for

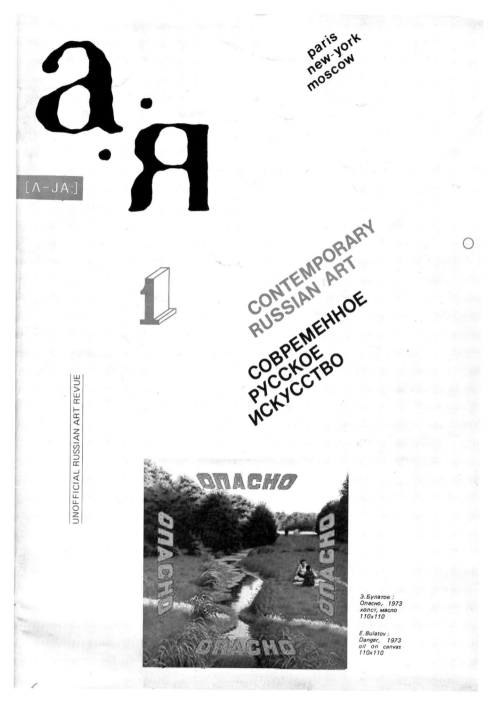

Figure 0.1
Cover of the art magazine *A-Ya*, no. 1, Elancourt, France, 1979.

МОСКОВСКИЙ РОМАНТИЧЕСКИЙ КОНЦЕПТУАЛИЗМ

MOSCOW ROMANTIC CONCEPTUALISM

B.Groys
Б.Гройс

Борис ГРОЙС - родился в 1947 г. в Берлине.
В 1970 г. окончил Ленинградский Университет по специальности математическая логика.
В настоящее время живет в Москве.
Занимается проблемами философии языка, философии искусства и литературно-художественной критикой.

Boris GROYS - was born in 1947 in Berlin.
In 1970 he gratuated from the University of Leningrad where he studied mathematical logic.
Residing now in Moscow, he works in the field of philosophy of art and language. He is also active as an art and literary critic.

Сочетание слов "романтический концептуализм" звучит, разумеется, чудовищно. И все же я не знаю лучшего способа обозначить то, что происходит сейчас в Москве, и выглядит достаточно модно и оригинально.

Слово "концептуализм" можно понимать и достаточно узко как название определенного художественного направления, ограниченного местом и временем появления и числом участников, и можно понимать его более широко. При широком понимании "концептуализм" будет означать любую попытку отойти от делания предметов искусства как материальных объектов, предназначенных для созерцания и эстетической оценки и перейти к выявлению и формированию тех условий, которые диктуют восприятие произведений искусства зрителем, процедуру их порождения художником, их соотношение с элементами окружающей среды, их временной статус и т.д. Возникновение "модернизма", или искусства "авангарда" разрушило непосредственную узнаваемость произведений искусства как некоторых вещей или текстов среди других вещей или текстов. И художник, и зритель в конце X1X века ощутили недоверие к тому природному дарованию, которое побуждало художника творить и давало ему возможность делать вещи, похожие на другие вещи, в чем ранее полагали его задачу. Сам принцип сходства оказался под сомнением. Выяснилось, что сходство объектов есть манифестация судеб художника и зрителя и функция общей дорефлективной основы суждения, которой художник и зритель обладают как члены одной и той же человеческой общности. Но лишь только это было осознано - общность распалась. И художники стали аналитиками : их анализ был направлен теперь на то,чтобы найти не сходство между произведением искусства как "представляющим" и объектом как "представленным", а различие между произведениями искусства как присутствующим в мире объектом и другими объектами, присутствующими в мире на равных правах с ним. Сходство было осознано как "условность", и выход за условность сходства воспринимался каждый раз как эксперимент, показывающий, как далеко можно отойти от сходства, но все еще остаться в пределах искусства. Каждый удачный эксперимент раздвигал пределы искусства и, как казалось, уточнял границу между искусством и неискусством. Негодование публики стало столь же убедительным доказательством правильности пути, как ранее им было восторженное приятие.

Кризис стал явным, когда негодование публики исчезло и обнаружилось, что условность никуда не делась. Условность сходства стала условностью различия. Т.е. условность сходства произведения изобразительного искусства (а изобразительны все искусства) с изображенным объектом, базировавшаяся на "природном" тождестве художника и зрителя, превратилась в условность различения между художником и нехудожником, т.е. условность признания имярек художником. Дело в том, что раз такое признание совершилось — все остальное в порядке : художник все, т.е. в точности все объекты, способен сделать произведениями искусства.

Казалось бы, все хорошо. Каждый художник делает, что хочет, выражает этим свою индивидуальность — и прекрасно. Но этому выводу противоречили два соображения : во-первых, если раньше истина изображения состояла в сходстве, то куда она делась теперь? Если она вместе с условностью перешла в существование художника, то возникает вопрос, какое существование есть истинное существование, а этот вопрос ставит индивидуальность художника под сомнение. И второе : хотя, казалось бы, должна господствовать индивидуальность, и она действительно господствует в работах, рассмотренных синхронно, в смене направлений явно видна логика.

Для разрешения этого противоречия естественно было обратиться к вопросу о функционировании произведения искусства в отличии от функционирования предметов иного рода. Понятно, что если искусство обладает какой-то истиной, то она должна выявиться именно здесь. Но это и значит, как сказал бы Гегель, что Искусство приходит здесь к своему понятию, т.е. становится "концептуальным."

However odd the juxtaposition of these two words may sound, I know of no better term than romantic conceptualism to describe the present development in the moscow art field.

The word «conceptualism» may be understood in the narrower sense as designating a specific artistic movement clearly limited to place, time and origin. Or, it may be interpreted more broadly, by referring to any attempt to withdraw from considering art works as material objects intended for contemplation and aesthetic evaluation. Instead, it should encourage solicitation and formation of the conditions that determine the viewer's perception of the work of art, the process of its inception by the artist, its relation to factors in the environment, and its temporal status. The rise of modernism or avant-garde art did away with direct cognitive reception of works of art as objects. At the end of the nineteenth century, artists and spectators alike began to doubt whether there was such a faculty as an inborn gift. The artist was creating things resembling other things. The very principle of resemblance was challenged. As it turned out, resemblance between objects mirrored analogous aspects in the lives of artists and their audiences. And it was a function of a general pre-reflective ground for judgement, shared by the artist and the viewer as members of one and the same community. But as soon as this was recognized, the unity fell apart. Artists became analysts : their analytic efforts were now aimed not at finding a similarity between the art work as representation and the subject represented, but rather the distinction between art works as extant objects and other objects existing in the world on an equal footing. The resemblance was perceived as a «contingency», and when the resemblance exceeded the realm of contingency it was always regarded as an experiment showing how far one might depart from similarity while yet remaining within the confines of art. Each successful experiment extended the boundaries of art and, or so it seemed, sharpened the demarcation between art and non-art. Previously, if the audience was enthusiastic, that meant the artists were on the right track ; now, public disapproval was seen as a proof that the approach was valid !

The crisis came to the fore when public indignation waned, and it was discovered that contingency didn't reach far. The contingency of resemblance became contingency of difference. That is to say, the contingency of resemblance between works of figurative art (and all arts are figurative) and the object depicted, based on a «natural» identity of artist and viewer, was transformed into a contingency of the distinction between artist and layman. The fact remains that, once this recognition has taken place everything else falls into line : the artiste is capable of turning any object into a work of art.

And so it would appear that all was going well. Each artist did what he wanted, thereby expressing his personality, and everything was fine. But there are two objections to this view : Firstly, if pictorial truth had previously resided in resemblance, where was it now to be found ? If it had passed over, along with contingency, into the artist's existence, then the question arises : what kind of existence is a true one ? This very question casts doubt upon the artist's individuality. Secondly, while individuality is supposed to predominate, and does indeed predominate in works viewed synchronically, there is a logic that can be seen plainly in a succession of trends.

It was natural, in seeking a solution to this contradiction, to look at the question of how art works function by comparison with other types of objects. Clearly, if art possesses some kind of truth, it is precisely at this point that it should be discovered. Here, however, as Hegel might say, Art comes into its concept ; that is, it becomes «conceptual». True, Hegel himself held that, with attainment of Absolute Spirit (or the sphere of ideas or concepts), art disappears, because of its very nature which is that of the actualization of the immediate. Yet if art subsists while having ceased to be direct, it is only for the reason that it has become a «concept». Again the question arises as to what happens to the immediate. Has it really been left behind once and for all ? I think this is hardly the case, but the scope of the present essay will not allow for a detailed examination of the problem.

From what has been said so far, it is evident that conceptual art by its very nature must be absolutely explicit. It should contain within itself the clear criteria of its existence as art. It must not imply any immediacy. The

Figure 0.2

First page of the art magazine *A-Ya*, no. 1, Elancourt, France, 1979.

the artistic movement that was presented in this text. During the following decades I was congratulated but also criticized for inventing this term. The critique was concentrated on my usage of the word "conceptualism." It was said time and again that I had not used this term in its precise sense because the term "conceptual art" designates primarily the practice of the group "Art & Language" and of Joseph Kosuth—and Moscow conceptualist art production does not look like that of Kosuth. However, I myself said precisely that at the beginning of "Moscow Romantic Conceptualism." And I used the word "Romantic" precisely to indicate the difference between Anglo-American conceptual art and Moscow art practices. But, on the other hand, who can tell what is the precise sense of a certain notion? At least Wittgenstein did not believe in our ability—or in the necessity—to define the precise sense of any notion at all. And Wittgenstein, as we know, is by no means a foreign figure to conceptual art. Beyond that, the term "conceptual art" was also applied to the art practices of Marcel Broodthaers and Robert Filiou, or Brazilian artists like Ligya Clarke and Julio Oticica, whose work—at least optically—has even less to do with Art & Language than the art of Moscow conceptualism.

But, of course, it is not this famous "precise sense" that interests the people who are unhappy with the name in the first place. The deeper source of a certain uneasiness that is felt by some Russian artists regarding the term "Moscow conceptualism" is a completely different one: The term seems to suggest that the Russian art movement was not an original phenomenon but was merely a variation of Western conceptual art—deeply dependent on its prototype. We have here a manifestation of the same offended nationalistic sentiment that motivated Russian futurists as they boycotted Filippo Tommaso Marinetti during his visit to Moscow and St. Petersburg before World War I: They did not want to accept him as a mentor, as the head of the international futurist movement to whom Russian futurism would be subordinated—because of a concern that their art would then be seen from the Western perspective as derivative. From a historical standpoint these worries seem to be completely unfounded. Today, nobody would see Russian futurism as derivative from Italian futurism. One would, rather, tend to overlook similarities more than differences. The term "Moscow" is heavy enough to outweigh any Western term like "futurism" or "conceptualism."

Having said that I would like to stress—as an explanation, not an excuse—that when I gave this title to my essay I did not intend to coin a name for any Russian art movement. I wanted simply to use terms that would make a certain kind of Russian art more understandable to a Western reader, as I imagined him or her at that time. But I also wanted to explain some aspects of Western art to potential Russian readers. The strategy of the essay is dictated by this twofold goal. Namely, the term "Romantic conceptualism" seemed to me a suitable name for a combination of dispassionate cultural analysis with a Romantic dream of the true culture that was characteristic for the artists whom I was interested in. But I was also interested in differentiating the conceptual practices in Moscow from those in the West. At the same time, all these differentiations had

to be expressed in a somewhat oblique, indirect way, because I did not want to mention all the names of the artists and authors I had in mind without their permission, and I also did not want to describe the situation of Russian art in direct, politically explicit terms. The whole project had to be realized in a more and less clandestine way; it was somewhat dangerous and in any case an adventure. This should be not overlooked when the texts and images that were published in the magazine are seen from today's perspective.

What's more, the term "Moscow conceptualism" acquired its current meaning in Russian culture after *A-Ya* was already shut down. After the perestroika that took place in the mid-1980s the media became interested in contemporary art and in the artistic discussions that previously had been limited to small unofficial art circles. The term Moscow conceptualism suited the media very well—and became known to a greater audience. But in the late 1980s and early '90s, this term was applied not so much to the first generation of the Moscow conceptualist artists as to their younger students and followers—the second generation of the Moscow conceptualism. This second generation included, among others, the group Medical Hermeneutics (Pavel Pepperstein, Sergei Anufriev, Yuri Leiderman), Vadim Zakharov, and Yuri Albert. These artists were influenced by Kabakov, Prigov, and Bulatov, but they mainly were involved in the activities of the Moscow conceptualist circle through their participation in the performances and discussions organized by Andrei Monastyrski and "Collective Actions," the group surrounding him. This genealogy greatly influenced their artistic practices. The first generation of Moscow conceptualism was primarily interested in the functioning of texts and images in the general framework of the Soviet culture, in its everyday life and its mass propaganda. But already Monastyrski and Collective Actions began to develop their own esoteric and hermetic artistic language suited to describe events and experiences known only to the initiated few. The second generation of the Moscow conceptualism was also interested, in the first place, in the activities of its own milieu—and less in the general Soviet or Russian culture of its time. Thus, Moscow conceptualism, which in the time of cultural isolation and unofficiality produced images and texts that were potentially accessible to everyone, reacted to the opening up of the public space by self-closure, by cultivating a sectarian and esoteric atmosphere, by making itself inscrutable to and impenetrable by uninitiated outsiders.

This attitude was, of course, a seductive and provocative one. And it confirmed the widespread notion that contemporary art was necessarily incomprehensible to a wider audience. That is why Moscow conceptualism—represented now by its second generation, because almost all first-generation Moscow conceptualists had left the country after the perestroika—quickly became controversial and widely known. As an allegedly esoteric artistic practice, Moscow conceptualism was opposed by the artists of Moscow actionism, like Oleg Kulik or Anatoly Osmolovsky, who programmatically addressed

their art to the greater audience. In the 1990s the controversy between Moscow conceptualism and Moscow actionism very much dominated the Russian art scene. But today these polemics seem to be completely obsolete. The overwhelming impact of the new Russian mass culture on the greater public and the influence of the art market marginalized all kinds of serious art to the same degree. So, in our day, almost anyone who is interested in serious art sees Moscow conceptualism and Sots-art of the 1970s as its precursor.

So it is important also to say some words here about Sots-art. Along with the group of Moscow conceptualists, *A-Ya* covered the activities of Russian émigré artists who lived at that time in New York and belonged to the group that became known as Sots-art and included such artists as Vitaly Komar and Alexander Melamid, Alexander Kosolapov, and Leonid Sokov. As in the case of Moscow conceptualism, the Sots-art group united for some time artists with fairly different but nevertheless compatible aesthetic programs. The Moscow conceptualists and the Sots-artists shared many concerns— and many artists of the later generation were influenced simultaneously by both these groups. Meanwhile, much discussion took place about the similarities and differences between Moscow conceptualism and Sots-art. These discussions seem to me to be rather sterile. Of course, many differences resulted from the mere fact that one group worked throughout the late 1970s and the first half of the '80s in Moscow—and the other one worked during the same time in New York. Of course, the artists living in New York were subjected to different influences, had different audiences, and were not subjected to the same kind of (self)-censorship as their colleagues living in Soviet Moscow. Beyond that there are also purely stylistic differences between the two groups. The Sots-artists, in particular Komar and Melamid or Kosolapov, were more interested in the tradition of academic painting and pop art than were the Moscow conceptualists, who were much more oriented toward the predominantly black-and-white aesthetics of Malevich's suprematism and Anglo-American minimalism and conceptual art. But all these characterizations are imprecise and allow many exceptions. Bulatov, for example, was interested from the beginning in the aesthetics of propaganda posters, whereas Komar and Melamid made some works that seemed unmistakably hard-core conceptualist. But much more important is the fact that both groups were interested in an artistic analysis of Soviet culture—even if they looked at it from different perspectives. That is why I have included the texts on Kosolapov and Grisha Bruskin in this collection of essays—even if they were not formally members of the Moscow conceptualist circle (and Bruskin was also not a member of the Sots-art group), they shared with this circle many of its artistic attitudes and concerns.

With the exception of the two texts that were written for *A-Ya*, all the essays published in this book were written in the West after my emigration in 1981. One might expect that I would have used my newly won freedom of speech to write more extensively on

the art of my conceptualist friends, but as a reader of this book can easily see, that was not the case. The art of Moscow conceptualism was a non-topic for the Western audience of that time. From the perspective of the Western Left, this art lacked the utopian, emancipatory, and constructivist impulse that was characteristic of the Russian avant-garde and was expected to manifest itself in a progressive Russian art. For the Western Right, this art was not dissident, anti-Communist, or accusatory enough—no mention of Gulag, no defense of human rights. For the art world per se, this art simply could not exist: The Soviet Union was seen as a totalitarian desert where the population was too unfree, too thoroughly cut off from the outside world, and simply too poor to be able to make art. Art making is often enough perceived in the West to be the privilege of affluent countries and the rich: A human being is supposed to care in the first place about the satisfaction of his immediate needs before he becomes able to be interested in art. The opposite seems completely unthinkable. But it is in this opposite way that the Russian artists practiced. And maybe most important of all: The Moscow conceptualists were not physically present in the West, but remained somewhere in Moscow hidden behind the Iron Curtain. To speak of them was like to speak of life on Mars—with the same degree of credibility.

The situation has changed after the perestroika, the dissolution of the Soviet Union, and the end of the cold war. Many Russian artists came to the West—for a visit or to stay. The Western art world became interested. A series of exhibitions of Russian art took place. But these group exhibitions tend to have titles like "Russian Art Now" or "Russian Art of the '90s," as if the participating Russian artists emerged at the same time as they were "discovered" by the Western curators. In fact, many of these Russian artists were already mature if not even old in the 1990s—and began their careers already in the 1950s, after the death of Stalin. The official Soviet art of socialist realism, to which many of these artists referred ironically, was almost unknown in the West. So the initial wave of interest receded soon enough. However, in this early time after the perestroika a certain curiosity related to Russian art was widespread. The reaction of Russian art institutions, galleries, and private collectors to the art of the 1970s and its influence on later Russian art was much slower but more systematic. In recent decades, Russian museums and galleries have organized exhibitions dedicated to all the major figures of Russian unofficial art, including the leading figures of Moscow conceptualism. A large volume on Moscow conceptualism has also been published in Moscow.[2] Recently I was given the opportunity to curate the first exhibition of Moscow conceptualism that was shown in Frankfurt and Madrid, and also used works from Russian private collections.[3] All these exhibitions and publications make it easier today to learn about the history of the movement. However, this movement itself has meanwhile become a thing of the past—even if most of the artists who were members of this movement are still alive and continue to work.

2 Who Is the Artist?

The historical closure of Moscow conceptualism raises the question of its specific place in the art historical perspective. Some answers to this question will be given in the essays that follow, as this question haunted the practice of Moscow conceptualism from its beginning and throughout its history—as is, of course, the case with many modern and contemporary art movements. Any genuinely modern or contemporary art practice is motivated by the question: What is art? But this question takes different forms at different times and for different art movements. The Western conceptual art of the 1960s and '70s understood this question as, roughly speaking, the question: What is an artwork? This issue was treated by the group Art & Language and by many other artists of this time. At the center of their concerns was the relationship between the artwork and commentary on this artwork, the possibility of including the commentary as part of the artwork, even to substitute for the artwork such a commentary, or, generally, to replace the image with text, the "material" artwork with artistic intention, and in this way to "dematerialize" and "decommodify" the artwork. This last concern has led to an interest in institutional critique, that is, a critique of the ways in which institutions identify, evaluate, and treat the work of art.

All these problems related to the status of the artwork were, of course, relevant also for the Moscow conceptualist artists, but in the center of their interests was not so much the question "What is the artwork?" as was the question "Who is the artist?" In the West the artist is understood as a professional. The artist is anyone who makes art professionally. And to make art professionally is first of all—and even essentially—to make one's living by selling one's art production. That is why in the context of Western art the status of the artist seems unproblematic. What seems problematic is, rather, everything that helps or hinders the artist in making his or her living, in being successful or, at least, in surviving—everything that affects the artist as a professional: the power relationships of the art world; the role of curators, museum directors, and collectors; the tastes of the rich; the tastes of the public; the coverage of art events and art stars in the media; the role of gender, ethnicity, and class in the artist's professional success; the laws of the art market; and so on. All these questions are, indeed, central to the functioning of the artist as an art professional. And they deserve a thorough investigation from the professional standpoint. But all these questions were completely irrelevant for the Russian unofficial artists of the Soviet era—and, especially, for the artists of the Moscow conceptualist circle—because these artists were not professional artists in the Western sense of the word: They did not make their living by making their art.

The Soviet unofficial artists had no access to any galleries, museums, art markets, or media. The art market and galleries did not exist in the Soviet Union, and museums and the media did not let them in. So these artists made their living in different

ways, practicing different professions. Some of these professions were connected in a certain way to art—like book design and illustration in the case of Ilya Kabakov, Erik Bulatov, Francisco Infante, and Vadim Zakharov. Or it could be any other profession only remotely or even not at all connected to art. In any case, no one in these unofficial circles could make a living from the artworks they produced—even if some artists did sell their work from time to time to a number of Russian or Western collectors. For these artists, art making was a leisure time activity. In this respect, the unofficial Soviet artists were nonprofessional hobbyists, like many people in the West making art for themselves or their family and friends, for the goal of self-therapy or just to relax after working hours or on a Sunday.

At the same time, however, Russian unofficial artists had ambitions and goals typical of the professional artist—they wanted their name inscribed in art history; they wanted to find a pictorial language that would be able to describe and represent their own, namely Soviet, culture in the global cultural context; and, in general, as Russian futurists put it earlier in one of their manifestos, they wanted to be "the face of their time." And in a certain way their high ambitions were confirmed by the Soviet authorities—in the form of severe censorship and surveillance by the KGB. To what extent this surveillance was real and to what extent imaginary is, of course, difficult to say. But in any case the unofficial artists were sure of at least one official audience: the KGB. This audience signaled to them that it took their art very seriously by forbidding and restricting it. The fact of being taken seriously by the most powerful institution in the Soviet Union proved to these artists that their art had relevance not only for their family and friends but also for the fate of the whole Soviet State—maybe even the fate of the whole world. That gave these artists a feeling of being part of a historical mission and at the same time the desire to hide themselves from the gaze of the invisible spectator—to escape its attention, to become invisible themselves. Now, one can ask why these artists did not practice something like an institutional critique directed against the power structures operating within these Soviet cultural institutions, why they were not politically engaged and did not try to reform these institutions. Of course, a certain unwillingness to confront the Soviet repressive apparatus played a role. But that is not the whole story. The answer to this question requires a brief analysis of the situation of the Soviet official art of that time.

The official artistic life of the Soviet Union was dominated by the Union of Soviet Artists: One was regarded as a professional artist if he or she was a member of this union. Membership offered many privileges to an artist. The Union had its own houses, artistic residences, even restaurants, supermarkets, and medical centers. Whatever a member of the Union wanted in life—an apartment, travel abroad, or medical treatment—he or she had to apply for it to the different levels of the Union's hierarchy. And that means that the life of an individual artist was completely dependent on the favors that he or she could get from the bureaucracy consisting of other artists—also members

of the Union, but with a higher position in its hierarchy. The Western institutional critique is directed mostly against curators, museum directors, and collectors. In this sense an artist practicing institutional critique can rely on the implicit support of his or her colleagues even if they don't practice such a critique themselves. The Western institutional critique represents ultimately the professional interests of the artists inside the art system—a kind of trade unionism without a trade union. In the Soviet Union the role of curators and museum directors was minimal—in fact, almost nonexistent—and the only collector was the state. The Union of Soviet Artists was a partner of the state and acted like a large corporation delivering its product to the state authorities. The Union elite operated on the highest level of political power, having direct access to the Communist Party's leadership, the Ministry of Culture, and so on. Now it is obvious that such a corporation had to produce, and de facto produced, not an individual but a collective, anonymous artistic product. All its members shared a certain aesthetics—the collective Soviet aesthetics. An influential, important artist was simply an artist who made it to a certain level inside the hierarchy of the Union of Soviet Artists and received privileged access to political power—not an artist who created his or her own aesthetics. All that means that the professional, official artists of the Soviet era also cannot be seen as artists in the modern sense of the word. The function of Soviet art is reminiscent more of the medieval artistic guilds than of the modern art system. To struggle against the Union of Soviet Artists would be simply to engage in the quarrels among artists. And to struggle against the aesthetics of the state also made no sense, because in these matters the state relied again on the leadership of the Union of Soviet Artists. Ultimately the Union of Soviet Artists was the embodied utopia, the artist's paradise: Artists exhibited and bought their own works. Thus, any struggle against the art system made no sense under Soviet conditions—one cannot struggle against paradise. The bureaucratically organized hierarchy of the Union of Soviet Artists reminds one of the celestial hierarchies described by Giorgio Agamben: totally defunctionalized, their remaining activity is reduced to singing *Gloria*.[4] Soviet Artists painted *Gloria* instead of singing it. But could we call a singing angel a singer? If one is living and painting in paradise, can he or she still be called an artist?

Thus, one can say that the place in which Russian unofficial artists situated themselves as artists was neither the Western art market (because they had no access to it) nor the Soviet official art system (which they despised). Rather, they situated themselves in universal art history—a space that included all past and present artistic practices but at the same time was transcendent in relationship to any past or present art institutions. This space of universal art history existed, of course, only in the imagination of the Russian unofficial artists—it was a purely utopian space. Real art history is always part of national history. There is a global art market, but there are no international art institutions. At the same time a utopian vision of such a universal art history undoubtedly liberates the artist from any psychological dependence on existing art

institutions, be they local or foreign. Art has to do with fiction: The general context of art is ultimately also a fictional one. And it is only because this context is fictional or, rather, utopian, that it liberates art and artist from any servitude to reality—which is ultimately always a servitude to existing power structures. But it is also obvious that such a utopian vision of the international art context was—directly or indirectly—generated by the utopian universalism of the Communist ideology. The Western professional artist is thought of as more practically minded.

Thus, the difference between Soviet art (official and unofficial alike) and Western art during the time of the cold war could be diagnosed not so much on the level of art production, which uses more or less the same vocabulary, be it academic tradition, mimetic realism, or modern art, but on the level of the professional and social status of the artist. It is precisely this uncertainty of the (self-) definition of the artist that was investigated and thematicized by Moscow conceptualism. And this uncertainty is of course by no means relevant only for the Soviet cultural situation at that time. The standard analysis of the artistic situation uses mainly the notions of art, non-art, and kitsch. But in the West one is also confronted with a huge mass of hobbyist art, with the artistic activities of millions and millions of people. Today, almost everybody takes photos and videos, arranges one's apartment as a kind of artistic installation, creates Web sites on MySpace, or tries to create a public image of him- or herself as being cool, up-to-date, aware of fashion and artistic trends. These activities obviously can be described neither as contemporary art, nor as non-art, nor as kitsch. But in fact, they are not so different from what professional artists are doing. Joseph Beuys was completely right when he claimed that everybody should be an artist—or, rather, that everybody must be understood as being an artist. This requirement is not part of a utopian vision, as was often assumed. Rather, it is a correct description of the facts as they already are. The status of the artist as a result becomes unclear and uncertain everywhere—even if this situation is not analyzed to the extent to which it should be.

3 Examples of Moscow Conceptual Artistic Practices

Komar and Melamid

In 1973, Vitaly Komar and Alexander Melamid created a story about a fictional artist, Apelles Ziablov (figs. 0.3–0.4). The hero of the story, which was written in standard art historical style with references to documents, eyewitness accounts, correspondence, and so on—all fictitious, of course—was an eighteenth-century artist and serf who began painting abstract art in this early period. Samples are given of his painting in the massive frames typical of that time. Rejected by the uncomprehending Academy and forced to copy antique pictures, Ziablov finally hangs himself in despair. The authors seem at first to identify with the hero. After all, they were also once rejected as "formalists" by the dominant academicism, and like Ziablov they were subjected to police coercion

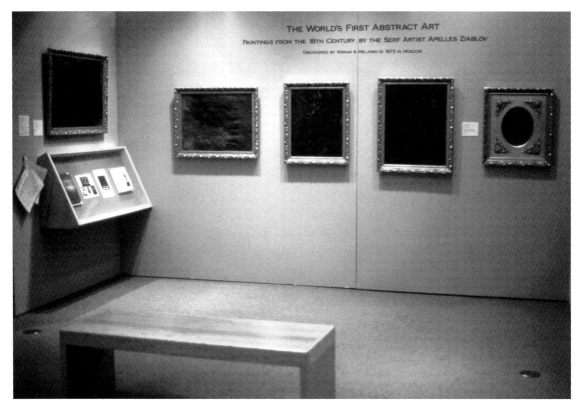

Figure 0.3
Vitali Komar and Alexander Melamid, *Apelles Ziablov, Seven Paintings and One Book,* 1973. General view of installation. The Norton and Nancy Dodge Collection of Non-Conformist Art from the Soviet Union at the Jane Voorhees Zimmerli Art Museum, Rutgers, The State University of New Jersey.

intended to suppress in art anything "not encountered in Nature, or which, if encountered, does not correspond thereto and which without particular necessity is by certain persons employed solely to demonstrate disregard of the rules," as one could read in the (fictional) official evaluation of Ziablov's work.

But an abstract painter does not have, in the eyes of Komar and Melamid, the exclusive privilege of being ignored or persecuted by power. In another story, they tell the fate of—again fictional—artist Nikolai Buchumov, who being a student of Malevich tries to practice realist art. Because of this he is severely beaten by another of Malevich's students and as a result loses one of his eyes (fig. 0.5). After this dramatic event he lives the life of a lonely hobby artist, forever depicting the same landscape that he sees with his

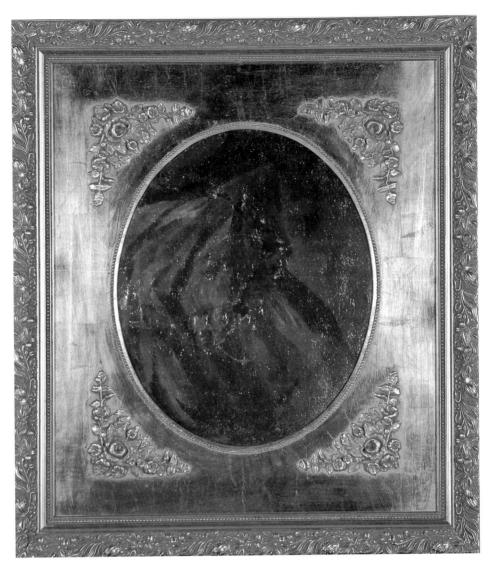

Figure 0.4
Vitali Komar and Alexaner Melamid, *Apelles Ziablov—"His Majesty 'Nothingness,' 1783,"* 1973. Oil on canvas, 76.5 × 69 cm. The Norton and Nancy Dodge Collection of Non-Conformist Art from the Soviet Union at the Jane Voorhees Zimmerli Art Museum, Rutgers, The State University of New Jersey.

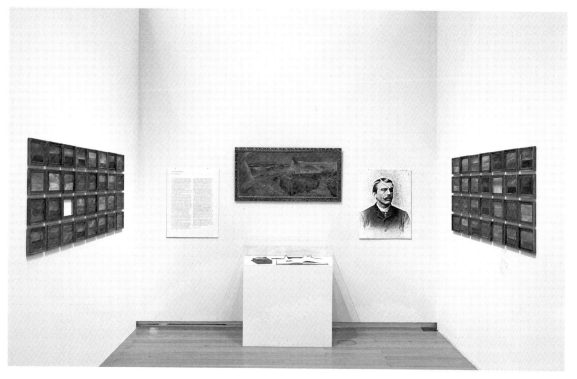

Figure 0.5
Vitali Komar and Alexander Melamid, *Nikolai Buchumov*, 1973. Installation: Oil on posterboard, 59 panels, 12.7 × 17.8 cm each. In addition, seven Buchumov objects (1. eye patch; 2. his autobiography, his notebook; 4. his palette; 5. coat hanger; 6. one oil painting, *Seascape with Girl*; 7. a small photograph of Buchumov). General view of installation, at the exhibition Total Enlightenment: Conceptual Art in Moscow 1960–1990, Schirn Kunsthalle, Frankfurt am Main, 2008.

remaining eye—a landscape partially covered by the image of his own nose, which grows steadily as he ages. Both Ziablov and Buchumov are—like Komar and Melamid themselves—lonely figures and hobby artists living at the margin of society. But, as Dostoyevsky already taught us, the distance between such a humbling and humiliating situation and the ecstasy of extreme self-empowerment is much shorter than we might think. In some of their other works Komar and Melamid present themselves as the greatest and most famous artists of the world and explicitly compare themselves to Lenin–Stalin (or, more ironically, Stalin–Trotzky) (fig. 0.6), who embodied for them the figure of artist as demiurge—creator of the state as an artwork. Their artistic strategy reflects a twofold repression that took place in the post-Stalin period in the Soviet Union: the repression of the anti-Stalinist opposition and, simultaneously, the repression of the image,

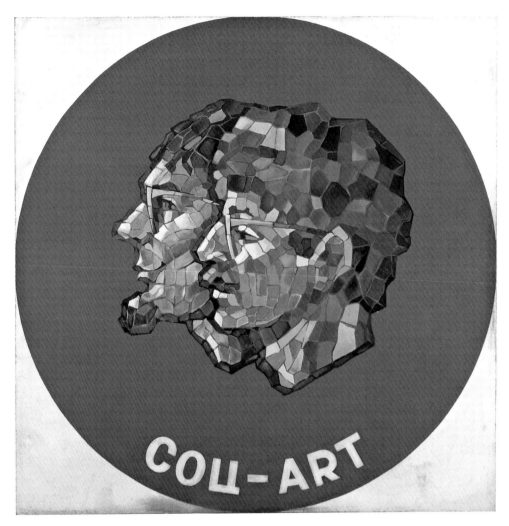

Figure 0.6
Vitali Komar and Alexander Melamid, *Double Self-Portrait*, 1984. Tempera on cardboard, 150 ×
150 cm. Antonio Piccoli Collection.

of the memory of Stalin himself. While in the post-Stalinist period the average Soviet citizens wanted to live out their life peacefully "as if it all had never happened," Komar and Melamid evoke the image of the repressed Stalinism, foregrounding its dangerous and seductive potential.

Ilya Kabakov

The figure of the lonely artist who oscillates between misery of his everyday life and the grandiosity of his visions is also central to the art of Ilya Kabakov. In one of the following essays ("Ilya Kabakov: The Theater of Authorship"), I speak more specifically about this aspect of Kabakov's work. Here I would like only to indicate that Kabakov's investigation of the figure of the artist starts with the image of a black square, the initial image of his first album that tells the life story of a fictitious artist, Primakov (figs. 0.7–0.9). This artist is presented as a boy sitting in a drawer—and his field of vision is presented by Kabakov through a quotation from Kazimir Malevich, namely as a black square. Only slowly the boy begins to open the drawer and see the fragments of the "real" world—but very soon the images of everyday objects come to be substituted by their written names. And then these names also begin slowly to disappear—leaving finally a blank, white space. One can say that on the purely pictorial level this album describes the journey of the artist's imagination from Malevich's black square to its white frame—via realism and conceptual art. Malevich showed his *Black Square* in the context of the exhibition "0.10" in 1915. The title of the exhibition referred to its ten participants who were supposed to have gone through "point zero"—and found themselves on the other side of zero, in the universe of negative numbers. Ten heroes of the first series of Kabakov's *Ten Characters* albums, from 1972 to 1976, are also "0.10"—they also went through point zero, that is, they moved from the sphere of positive reality into the sphere of nonreality, negativity, virtuality, pure imagination. Later Kabakov presented the installation *Ten Characters* at his first major New York exhibition at the Ronald Feldman gallery in 1988. The installation consisted of ten rooms (plus a corridor and kitchen) in a fictional communal apartment—referring to the Soviet habit of housing different families in the same apartment. This metaphor of a communal apartment became popular in Russian writing after perestroika. One began to speak about communal bodies, communal modes of existence, and much later even of communal conceptualism. Indeed, the Soviet Union was a rather poor country. And in poor countries the members of the poorer classes live in close proximity to each other. Of course, the housing situation in Soviet Russia was not so dire as, for example, that in India or Brazil, where this kind of communality is much more extreme; but still the proximity of human bodies was greater in the Soviet Union than in the northern countries of the West.

But whatever one can say about the sociological side of Soviet life, Kabakov's communal apartments have nothing to do with their real Soviet counterparts, because

Отец пришел с работы.

Открытый шкаф.

Figures 0.7–0.9
Ilya Kabakov, three sheets from the album *Sitting-in-the-Closet-Primakov*, 1972. Ink, colored pencil, 24 × 32 cm. Courtesy of Ilya and Emilia Kabakov.

Kabakov's apartments are populated not by "real" bodies but by their absences, by negative bodies—by bodies that have already gone through point zero. The rooms of Kabakov's apartments are empty, their inhabitants disappeared mysteriously—without ever being seen leaving these rooms. Kabakov's communal apartments are spaces haunted by negative bodies—spirits, ghosts, specters. One sees the shadows, one hears the voices, but one is never confronted with any living presence. The world of Kabakov's art is an abandoned world. It is a world in which everything that could happen has already happened. But it is not a world without hope, for in this world everybody can become an artist—and then also abandon it. Especially characteristic in this respect is Kabakov's installation *NOMA* (Kunsthalle Hamburg, 1993) (fig. 0.10). This installation, built as a communal space for the members of the Moscow conceptualist group, consisted of rooms arranged in a circle. Every room was dedicated to a member of the group. It was furnished with a table, a bed, two chairs, and a lamp, and contained a small archive of its member's activities: images and texts. Moscow conceptualism itself

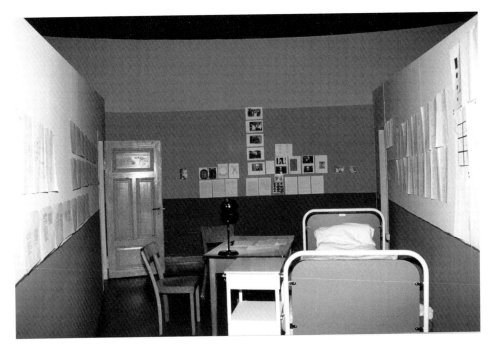

Figure 0.10
Boris Groys's room from the installation *NOMA* of Ilya Kabakov, Kunsthalle, Hamburg, 1993. Photograph by Natalia Nikitin/Natalia Nikitin Archive.

was represented thus as a communal apartment—but again as an abandoned one in which everyone was replaced by his archive. For Kabakov, the ultimate grace is identical with the possibility of emigration—from a positive body of reality into a purely negative, absent body of imagination.

Erik Bulatov

Malevich's suprematism was also crucially important for Erik Bulatov, whose series of paintings that were made in the 1970s had a great impact on the Moscow conceptualist and Sots-art movements. The first painting in this series is *The Horizon* (1972) (fig. 0.11). Based on an early photograph, it shows a group of people in typical Soviet dress walking along a beach toward the sea and the horizon. The line of the horizon, however, cannot be seen, because it is covered by a flat quasi-suprematist form that seems to be superimposed on this conventional picture, cutting horizontally across its entire breadth. On closer examination this form turns out to be the ribbon of the Order of Lenin. The movement toward the sea and the sun is an allusion to the optimism of the socialist realist art of the Stalin years. But the ribbon of the medal that covers the

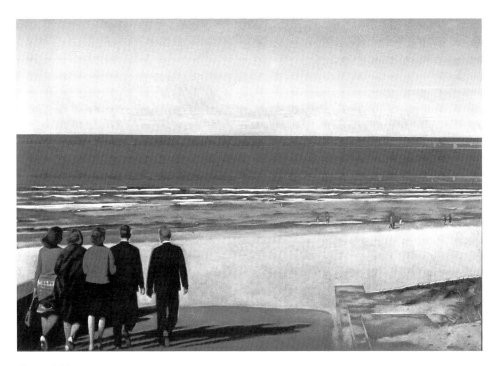

Figure 0.11
Erik Bulatov, *Horizon*, 1971–1972. Oil on canvas, 150 × 180 cm. Ludwig Forum Aachen.

horizon seems to obstruct the movement of the group and bring it to a halt. This ribbon is simply superimposed on the painting and is a signal to the viewer of the flatness of the painting, destroying the spatial illusion created by the movement of the group.

Bulatov writes: "Malevich simply forbids space. He abolishes it by outright revolutionary decree." Hence, he continues, the constructivists' "replacement of the space of art by the space of society. For the first time, art set society as its final goal, and society killed it."[5] Malevich's "suprematist form" is not simply quoted but is decoded ideologically when it is made to coincide with the highest honor of the Stalin era. By symbolizing the victory of social space, the Order of Lenin, so to speak, concretizes Malevich's "abstract" geometric forms.

In other works, Bulatov further develops this same device of combining an illusionary three-dimensional realistic picture with suprematist flatness. Like Kabakov, Bulatov is as interested in the Russian revolutionary avant-garde as in socialist realism because he believes that all Soviet art is art after the *Black Square*—after the point zero of art that can be also understood as the point zero of life. In this sense all postrevolutionary

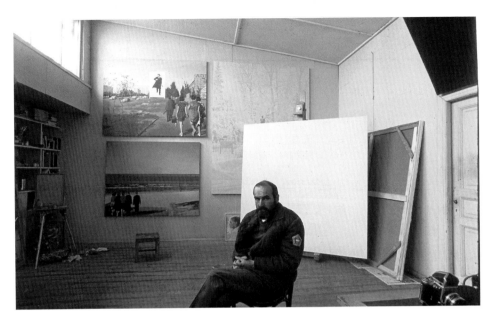

Figure 0.12
Erik Bulatov in his studio. Moscow, 1979. Photo by Igor Makarevich.

Soviet life manifests itself as life after death, as the postmortal mode of existence, because it was totally transposed from life into art. And all Soviet citizens had negative bodies, moving not in space but only on the surface—like specters, ghosts, spirits populating the margins of the Soviet ideological space, the center of which was occupied by Soviet ideological symbols.

Dmitri Prigov

The art of Dmitri Prigov can be seen as the most interesting attempt to move—at least symbolically—from this marginal, peripheral position to the cultural center. In the Soviet era Prigov worked officially as a sculptor. Unofficially, he started to write poetry, and in the 1970s he became well known as a poet in Russian literary and artistic circles. From the beginning of his artistic carrier Prigov concentrated less on the poetic text itself—though he wrote wonderful poetry—than on the figure of the poet. In the European cultural tradition after Romanticism, the main subject of poetry is supposed to be the subjectivity of the poet. Even if this Romantic attitude was criticized time and again, it remained deeply ingrained in the public imagination. The poet has not only a right but also a duty to be purely subjective—to live exclusively in his or her own

imagination. In this sense the public figure of the poet as an embodiment of subjectivity—as a virtual body of imagination—is more important than his actual poetry. This is especially true for Russian culture in which the poet was for a long time perceived as a doppelgänger of the czar. The nation's poets, like Pushkin, Blok, Mayakovsky, or Pasternak, were central to Russian cultural self-identification. The historical succession of great poets had almost the same importance for national historical narrative as did the succession of political leaders—and both symbolized the personalized character of Russian concept of power, be it political or poetic. In his well-known cycle of poems on the militiaman (the Soviet version of the policeman), Prigov appropriates in an ironical way this figure of political-poetic authority. The militiaman is portrayed as a Christ-like figure that unites heaven and earth, law and society, divine and human wills, reality and imagination:

When the Militiaman stands here at his post
He can see all the way to Vnukovo
The Militiaman looks to the West, to the East—
And the empty space beyond lies open
And the center where stands the Militiaman—
He can be seen from every side
Look from anywhere, and there is the Militiaman
Look from the East and there is the Militiaman
And from the South, there is the Militiaman
And from the sea, there is the Militiaman
And from the heavens, there is the Militiaman
And from the bowels of the earth . . .
But then, he's not hiding

However, Prigov downplays the traditional ambitions of the poets here by indirectly comparing the poet not to the czar but to a policeman. He often himself wore a militiaman's cap when he gave readings of his poetry. But the ironic undertone of this poem should not mislead the reader into believing that Prigov is somehow critical of the attitudes and ambitions of his predecessors. Rather, he deplores the fact that he is no longer capable of believing in the absolute power of the poetic word and in the figure of a poet as leader and savior—like a corrupt policeman who no longer believes in the universal validity of law and order. In all of his poems written in the 1970s Prigov oscillates between presenting himself in two ways: as ordinary Soviet citizen and as almost sacred bearer of the magical, prophetic word. These two claims seem to be contradictory, but in fact they have something in common: Neither fits into the "normal" liberal Moscow cultural milieu of that time, which despised the Soviet masses for being loyal to the Soviet system and at the same time was deeply suspicious of any alternative claim to power—be it even a poetical one. It is this Moscow cultural *juste milieu*

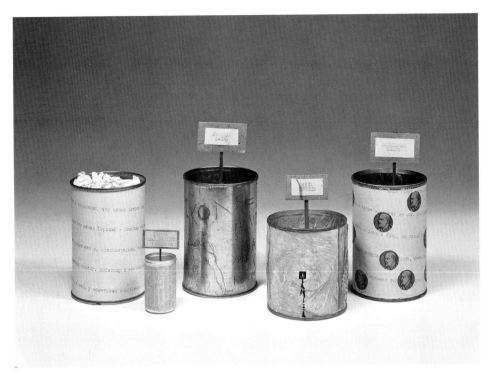

Figure 0.13
Dmitri Prigov, *Untitled (5 Cans)*, ca. 1975. Collage on food cans. Dimensions variable. From left to right: 1. Unlabeled can. 2. Small person's can. 3. Trinity can. 4. Russian can. 5. Soviet can. Ludwig Forum Aachen.

that Prigov liked to provoke because of its duplicity and hypocrisy: Its members had a fairly comfortable life in the Soviet capital but believed themselves to be better, morally superior human beings because they told each other anti-Soviet jokes while drinking vodka in their kitchens.

In the late 1980s and '90s this provocative gesturing by Prigov became more and more desperate. The post-perestroika opening of the Russian public space led to the inundation of this space by commercialized mass culture. Thus, the futility of the Romantic attempt to manifest the poetic truth in the middle of the public space became even more obvious: The Soviet public space was occupied by an ideological text that was at least formulated in the same media as a poetic text—and so could create an illusion that both texts were able to compete with each other. But as a commodity a poetic text has, of course, no chance on the contemporary media market. In the 1980s and '90s Prigov began to stress and further develop the performative side of his poetic practice that was already present in his early poetic readings during the '70s. His poetic

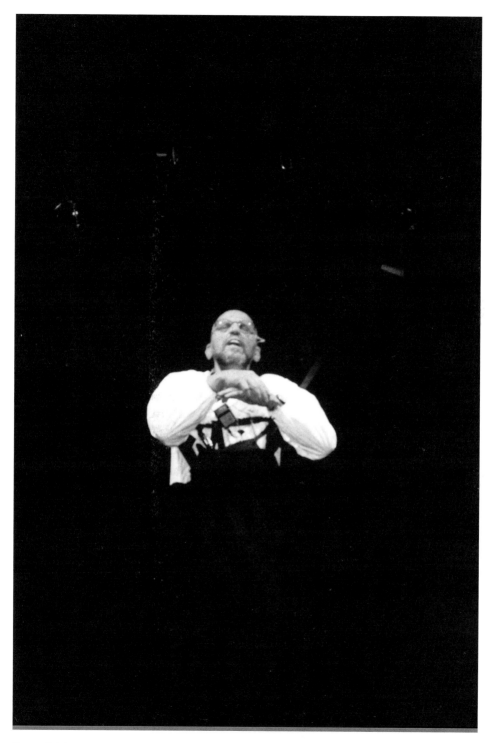

Figure 0.14
Dmitri Prigov, performance, Vienna, Tanzquartier, 2002. Photo by Natalia Nikitin.

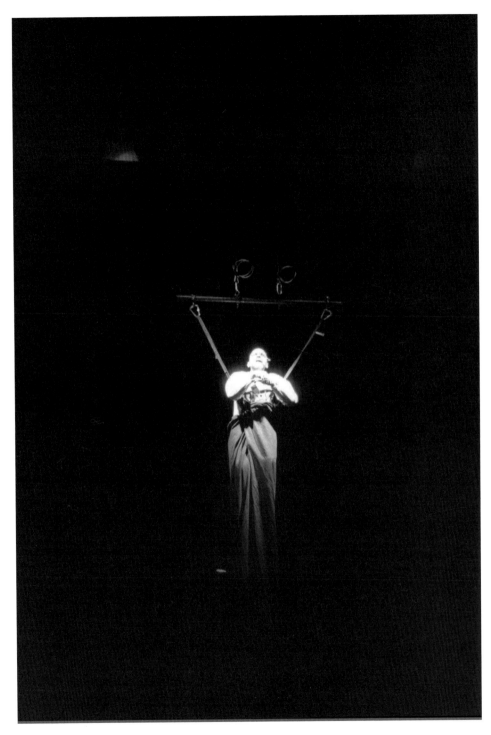

Figure 0.15
Dmitri Prigov, performance, Vienna, Tanzquartier, 2002. Photo by Natalia Nikitin.

performances were reminiscent of religious incantations, early Dadaistic events, and almost animalistic howl. During his readings Prigov time and again began to shout his verses, forcing his voice to the extreme (figs. 0.14–0.15). Obviously, that was more a metaphor of the desire to be heard than a real attempt to catch the attention of the listener. The topics of the Prigov's poetry also changed at this time: from a complicity between political power and poetic mission to loneliness and death.

During this same time Prigov started to be more and more involved in the visual arts. He produced a great number of drawings and installations that combined drawings with readymade objects (figs. 0.16–0.17). For his paper works Prigov mostly used newspapers. He painted isolated words in bold black or red letters over the newspaper's text—and in this way symbolically affirmed the primacy of the individual poetic word over the anonymous mass of informative and/or ideological texts. But this poetic word invariably looked like a promise of coming catastrophe painted on the wall—evoking biblical prophecies. Also, in his installations (some of which used newspapers, others not), Prigov painted words or signs on the walls in black and red colors, suggesting death and mourning. In our contemporary mass society the individual voice can only function

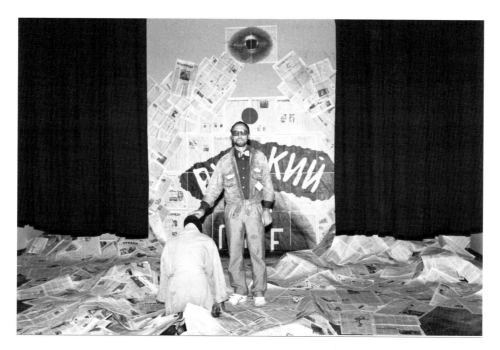

Figure 0.16
Dmitri Prigov in his installation *Russian Snow*. Stedelijk Museum, 1990. Photo by Natalia Nikitin.

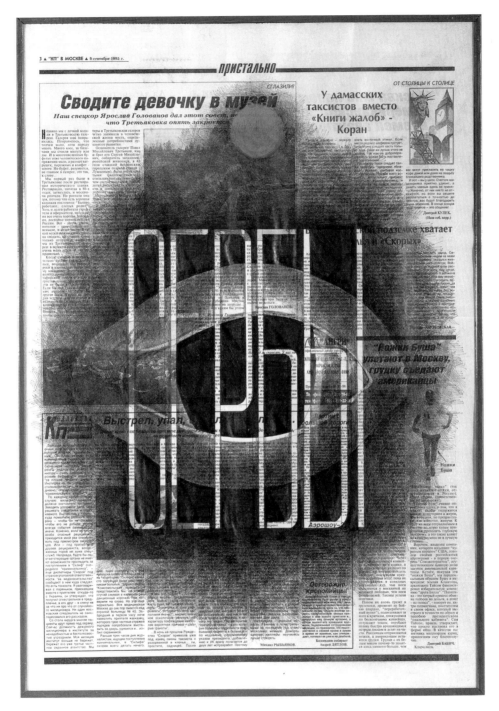

Figure 0.17
Dmitri Prigov, *Serbs*, 1995. Ink on newspaper, 59 × 41 cm. Antonio Piccoli Collection.

as a medium of dark prophecies that promise the total apocalyptic destruction of the human masses. But even such a voice is almost never truly heard. Prigov's art became more and more dark and desperate before he died in 2007. But at the same time his public persona remained amiable and communicative. It is this contrast between his public image as a polite and reasonable communicator (often invited to public discussions and radio and TV talk shows) and extreme inner tension that becomes revealed only through his art that makes his figure so unique—and uniquely attractive.

Indeed, Prigov's attempt to embody in his own public figure and artistic practice the tension between individual voice and contemporary mass media remained fairly isolated in the Moscow cultural milieus at that time. As I said earlier, the protagonists of Moscow conceptualism reacted to the post-Communist ascent of commercialized mass culture with a gesture of self-closure. They created their own micro-communities like Andrei Monastyrski, imagined such micro-communities like Vadim Zakharov, or ironized this strategy like Yuri Albert in his series *Elite-Democratic Art* in which contemporary art practices that programmatically affirm their hermetic character are compared to the languages of the blind or deaf (fig. 0.19). These artists also, of course, started to

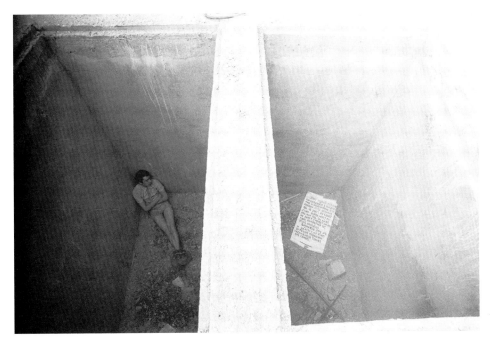

Figure 0.18
Vadim Zakharov, *Well*, 1983. Black-and-white photograph, 60 × 80 cm. Courtesy of Vadim Zakharov.

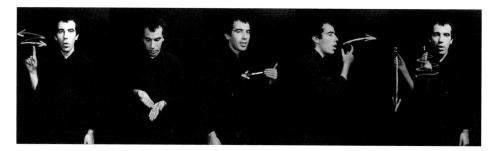

Figure 0.19
Yuri Albert, *For Deaf-Mutes (What Did the Artist Want to Say with It?)*, 1987. From the series *Elitist-Democratic Art*. Acrylic on photo mounted on Masonite, 100 × 350 cm (five parts, 100 × 70 cm each). Studio of the Artist.

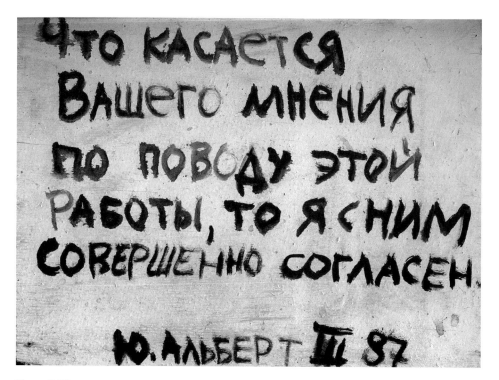

Figure 0.20
Yuri Albert, *As Far as Your Opinion of This Work Is Concerned, I'm in Complete Agreement with It*, 1987. Acrylic on plywood, 24 × 30 cm. Collection Dmitry Machabely.

participate in the art market that was developing in Russia in recent decades—along with other phenomena of the emerging capitalism. However, it is fair to say that the end of Soviet Communism was also the end of Moscow conceptualism as an artistic movement. Now this movement belongs to the historical past. Nevertheless, contemporary Russian art perceives itself as remaining in the tradition of Moscow conceptualism and still relates to this tradition—be it in a positive or polemical way.

1 Moscow Romantic Conceptualism

However odd the juxtaposition of these two words "Romantic conceptualism" may sound, I know of no better term to describe a present trend in the Moscow art milieu that looks sufficiently up to date and at the same time original.

The word "conceptualism" may be understood in the narrower sense as designating a specific artistic movement clearly limited to the place and time of its origin and a restricted number of participants. Or, it may be interpreted more broadly to refer to any attempt to withdraw from the production of artworks as material objects intended for contemplation and aesthetic evaluation and, instead, to thematicize and shape the conditions that determine the viewer's perception of the work of art, the process of its production by the artist, its positioning in a certain context, and its historical status. The rise of modernism did away with the possibility of identifying artworks as mimetic objects or texts among other objects and texts. At the end of the nineteenth century, artists and spectators alike began to doubt whether there was such a faculty as an inborn gift that stimulated the creativity of the artist and his ability to produce things resembling other things. The very principle of mimesis, of resemblance, was challenged. As it turned out, resemblance between objects merely manifested a common prereflective ground for judgment, shared by the artist and the viewer as members of one and the same community. But as soon as this was recognized, the common ground fell apart. Artists became analysts: Their analytic efforts were now aimed at finding not a similarity between the artwork as representation and the subject represented, but rather the distinction between artworks understood as mere objects and other objects existing in the world on an equal footing with them. The resemblance was perceived as a "convention," and every attempt to overcome this convention was regarded as an experiment showing how far one might depart from mimesis while yet remaining within the confines of art. Each successful experiment extended the boundaries of art, or so it seemed, and defined in a more precise way the demarcation between art and non-art. Previously, if the audience was enthusiastic, that meant the artists were on the right track; now, public disapproval was seen as a proof that the artist was heading in the right direction.

The crisis came to the fore when public indignation waned, and it was discovered that the conventions had not disappeared. The convention of mimesis had simply been transformed into the convention of difference. That is to say, the convention of resemblance between works of visual art (and all arts are ultimately visual) and the object depicted, based on the "cultural" identity of artist and viewer, had been transformed into a convention of the cultural difference between artist and spectator, a convention that allows the recognition of somebody as being an artist. Once this recognition has taken place everything else falls into line: The artist is capable of turning any object into a work of art.

And so it would appear that all was going well. Each artist did what he wanted, thereby expressing his personality, and everything was fine. But there are two objections to this view: First, if the truth of art had previously resided in resemblance, where was it now to be found? If it had passed over, along with convention, into the artist's mode of being, then the question arises: What mode of being is a true one? This very question casts doubt on the artist's individuality. Second, while individuality is supposed to predominate, and does indeed look as if it predominates if different artworks are viewed synchronically, there is a logic that can be seen plainly in a historical succession of trends.

It was natural, in seeking a solution to this contradiction, to look at the question of how artworks function by comparison with other types of objects. Clearly, if art possesses some kind of truth, it is precisely at this point that it should be discovered. Here, however, as Hegel might say, art comes into its concept; that is, it becomes "conceptual." True, Hegel himself held that, with the attainment of Absolute Spirit (or the sphere of ideas or concepts), art disappears, because of its very nature, which is that of the demonstration of the immediate. Yet if art subsists while having ceased to be immediate, it is only because it has become a "concept." Again the question arises as to what happens to the immediate. Has it really been left behind once and for all? I think this is hardly the case, but the scope of the present essay will not allow for a detailed examination of the problem.

From what has been said so far, it is evident that conceptual art by its very nature must be absolutely explicit, transparent. It should contain within itself the clear criteria of its functioning as art. It should not refer to any immediacy. The artistic project must be presented to the viewer in a way that he could repeat it, as if it were a scientific experiment. Though the knowledge and equipment may be lacking, it should always be possible to do this in principle. A work of conceptual art should contain in itself the explicit preconditions and principles of its production and reception—and it should be able to convey these to the audience.

An artwork possesses that capability as far as it integrates in itself the critical position. For a fairly long time, it was recognized that contemporary works of art were "incomprehensible" without the assistance of the critical language. That means that criticism

had lost its original role as a metalanguage and had taken over some of the linguistic functions that are proper to art. Conceptual art is now reclaiming these functions.

There are different forms of transparency. In England and the United States, where conceptual art originated, transparency meant the explicitness of a scientific experiment, clearly exposing the limits and possibilities of our cognitive faculties. In Russia, however, it is impossible to produce a decent abstract painting without reference to the holy light of Mount Tabor. The unity of collective spirit is still so very much alive in our country that mystical experience here appears quite as comprehensible and lucid as does scientific experience. And even more so. Unless it culminates in a mystical experience, creative activity seems to be of inferior worth. And this is essentially true to the extent that, where a certain level of understanding has been attained, it must be traversed. Along with religious mysticism, and related to it, we also find a definite sort of "lyrical" and "human" quality in Russian art—an element reclaimed even by those artists who de facto have happily left such things far behind.

The general tenor of emotional life in Moscow, thus forming a lyrical and Romantic blend, stands opposed to the dryness of officialdom. And this climate is propitious to the phenomenon of romantic and lyrical conceptualism—a phenomenon rather clearly discernible in the emotional atmosphere of the capital. I do not hesitate to call it conceptualism, notwithstanding the lyrical aspect, bearing in mind its basics and remembering that the term has been also applied to Yves Klein, a French artist who distinguished in a very French manner between a world of pure dream and a world governed by earthly laws.

There are even more important reasons for using this term. During the 1970s, Western artists drew a line between conceptualism and the "analytical approach," on the one hand, and the rebellious mood of the 1960s on the other. In those days, art was regarded as the last forward-defense position held by the individual human being in his battle against a depersonalizing existence within the society. Belief in the unique status of the artist as a privileged person, and in his ability to rebuild life in keeping with the dictates of creative freedom, proved illusory. In the 1970s the collapse of this belief prompted conceptualists to cling to a notion of artistic creativity as belonging to a specific profession, possessing its own techniques, purposes, and confines, alongside other professions. Art acquired an operational definition: What art is will be evident when you can see what the artist does, how he does it, and how the results of his work interrelate with other objects in the world.

Nonetheless, this kind of positive-transparency approach to art presupposes a new form of academicism. For it confronts the artist in his creative work with a certain extrahistorical norm that is identified with the clearly demarcated boundaries of the profession or, as they say, of the media within which the artiste operates. Romantic, "metaphysical," and other trends in art likewise have their ways of doing things. Furthermore, to each school belong its particular practices in the field of perception, or

interpretation. That is, the "Romantic" view of art has its own facticity: Reducing it to illusion amounts, above all, to closing one's eyes to the facts. Even if art of this type loses its immediate appeal, it still preserves its significance, which is to say, its relationships with the realms of action and cognition. It is important to clarify these relationships, without stressing, as before, the totality and immediacy of perception, and to free ourselves from the evocation inherent in attempts to present a work of art as a revelation that speaks for itself.

The positivist view of art as an autonomous sphere of activity determined solely by an available historical tradition has always been alien to the Russian mind. We can hardly reconcile ourselves with the idea that art should be regarded as being simply the total sum of its techniques, which have lost their purpose. Therefore, Romantic conceptualism in Moscow not only testifies to the continued unity of the "Russian soul"; it also tries to bring to light the conditions under which art can extend beyond its own borders. It makes a conscious effort to recover and to preserve all that constitutes art as an event in the History of Spirit and which renders its own history incomplete.

I shall now examine the work of several artists and poets who may be numbered—somewhat arbitrarily, to be sure—among the Romantic conceptualists.

1 Lev Rubinstein

At first encounter, what strikes us about the texts of Lev Rubinstein is their resemblance to machine algorithms. And this is not only because they are written on library cards (figs. 1.1–1.2). The texts themselves are performatory. They shower the reader with imperative instructions and they register irreversible events. But they also contain descriptions. As in the case of real working algorithms, the texts are structured into descriptions and instructions. Generally speaking, descriptions in algorithms have no autonomous significance. No one expects them to do anything more than to provide information for continuing action. And they contain nothing more than that. Actions predominate over description, and the structure of the actions is determined by their sequence. This is how the algorithm-like texts of Lev Rubinstein look at first glance. The unity of the text is ascertained not by the unity of description or of the object being described, but rather by the unity of action—unverbalized and confined to pauses between individual texts. We get the impression that, from card to card, something is going on: Something is blinking, unfolding, making a dull grinding noise and altering the world around us.

As we go on reading, however, it dawns on us that something is not quite right with those imperative instructions. And in the attempt to find out what exactly is wrong with them, we also slow down our reading somewhat and turn our attention to the description of those situations that the instructions are designed to act on.

And then it becomes clear that they are not precise enough to serve as a basis for machine activity and, at the same time, they are too precise to serve as a basis for

Figure 1.1
Lev Rubinstein, Three ring binders with sheet protectors, 1976–1985. Author's manuscript, A5. Book 1, *From Thursday to Friday: If It's Not One Thing, It's Another*, 43 pages, 1985. Courtesy of Lev Rubinstein.

human action. They are not so much precise as they are subtle, refined, and just plain Romantic. Yes, Romantic.

For example, in the *Catalogue of Innovations in Comedy* (September 1976) we read: "It is possible to discern the causes of various phenomena and not share this knowledge with anyone."

"It is possible to look at one another with such keen watchfulness that this can become a rather exciting kind of game."

Yes, that is possible. That is indeed the way Romantic heroes behave. They conceal their knowledge and they play exalted games with each other. Yet we know very well the price of that "possible." It exudes the horror of the impossible. If this Romantic "possibility of being impossible" is broken up into isolated instructions, it becomes impossible to use the halo of the Romantic hero's personality to inspire direct confidence in the Romantic type of behavior as a desirable though indeterminate model for

Figure 1.2
Lev Rubinstein, *All That—*, 1979. Fragment of a ring binder. Courtesy of Lev Rubinstein.

emulation. The anonymous "it is possible," replacing the description of the "hero who can" and with whom the reader can identify himself—even if he does so in a somewhat unconscious and illusory manner—leads the reader to an insight into his own possibilities. Here we see a revelation of the inner mechanical nature of Romantic discourse as well as a challenge addressed at the reader: to take cognizance of the true character of his participation in the Romantic dream. The distance between "able to do it" and "able to read it" becomes evident.

In the text "That Is All," the subjectivity that constitutes the world discovers its own romantic origins. This text is a sort of "anti-Husserl." The description is given inside that space of language which is formed, as it were, by the language's own possibilities and to which no experience corresponds.

"That is All—an avalanche of forebodings, crashing down for no reason at all

—the voice of longed-for repose, drowned out by other voices" and so on.

When we read the definitions of this type, the ease with which we can understand what is being said is in proportion to our utter bewilderment when we try to relate it to our own extraliterary experience. These descriptions are possible only in a world where literature exists as an autonomous sphere of linguistic expansion and functioning. Whereas Husserl sought to provide a foundation for the word through purely subjective experience, here the subject faces a task that is transparent on the literary plane but cannot be carried out empirically.

We may say that here Lev Rubinstein, in the way he builds his definitions, is coming close to René Char. But René Char believed it possible to live in the world as defined by him. Rubinstein, on the other hand, leaves the question open: whether it is possible to live in that world or merely to read about it. Surely we cannot seriously suppose that we are capable of participating in "All of That," which

gets built
gets bound
analyzes
signifies
gets explained
originates
relates
gets more involved et cetera

Here, for all to see, there is an infinitude of descriptions, flagrantly contrasted with the finitude of our existence and yet open to being read and understood. An infinitude of descriptions is Romantic to begin with. And the infinitude of descriptive literary stereotypes grasped at a glance by the reader is likewise Romantic, because the analysis cannot break it down into elementary components.

So what about those imperative instructions? They have turned out to have no basis. They have not gained so much as a square inch of ground for justifiable action from the conquest of literary language-space. The only action forming an exception to this is that of reading. All of the instructions boil down to an order to read.

Thus, we find the following text ("New Entracte," 1975):

—Read, beginning with the words

"At certain moments many resort to silence," etc.

up to the words

"The author excels in silence."

So the reader reads and the author is silent. And further on in the same text we read:

—"Turn the page"

or

"See below,"

written at the end of the page. Or

—read the following:

"Things which have invaded the sphere of poetical perception become signs in a poetic sequence."

We now know the kind of algorithms we are dealing with. They are algorithms of reading. The only activity in which we are given "all that" and in which the that-is-all becomes "it is possible" is reading: Life as reading, life as existence in the impossible space of literary language. The pages are turned one after another with effort, amid loud interjections by the author. "Read, turn the pages, read, turn the pages. . ." and the things become signs in a poetic sequence.

Performatory verbal acts reveal their illusory character and return us to the text as pure literature, making nothing evident but the despair and the torment of reading. The literary text itself is impenetrable and transparent: It requires no interpretation. Hermeneutics has been replaced by an algorithm of reading. Understanding is attained by means of the effort it takes to turn the page. What is reading? It is turning the pages. The rest is obvious on its own terms. In the writing of Lev Rubinstein, the reading process uncovers its own active substratum, its nature as vital effort. The effort of reading is disclosed to be a principle of textual production. The text is that which is performed in the reading of it: You turn the pages, you move your eyes, and you "imagine." Although the Romantic imagination occupies its rightful place at this point, in the pose of the person reading, it then begins once again to beckon in the endless distance of the reading effort that produces the text.

As the reading is, so is the writing. In the "Program of Works" (1975), no descriptions are offered, yet at the same time no instructions are issued on what to do. The "Program" sketches out the emptiness occupied by pure spontaneity, that is, by Romantic subjectivity as such. And in this text we read:

In the event that the realization of this or that point in the Program should be factually impossible, the verbal expression of these points is to be regarded as a special case of realization or as a fact of literary creation.

Actually, two imperatives are being equated here: to read and to write. Literature is endowed with being, with its own reality and with "realization" when another form of realization is "factually impossible"—in other words, always.

A text by Lev Rubinstein is both the syntax and the practice of the Romantic, given in unity. The effort of reading and the effort of writing here appear as autonomous work

engendering and organizing an independent reality. As cognizance of the practice of the Romantic, these texts likewise lead beyond the boundaries of Romantic conscience. And they return this Romantic consciousness to the finitude of its existence, to the state of being doomed to labor and to die, while at the same time they soberly set up the landmarks of those possibilities for its existence that are attainable through the poetic language and are not attainable by any other road.

2 Ivan Chuikov

Ivan Chuikov is an artist who centers his attention on the problem of the correlation between illusion and reality. A picture, in the traditional sense of the term, is a thing that is not self-identical. It presents us with the spectacle of something different from itself, and so distinct is that presentation that the picture erases its own material being, as it were, in the object represented. This, precisely, is the illusory nature of the picture as a work of mimetic art. The attempt to perceive things in their external aspect has always been tied to the attempt to know them by discovering their identities and differences. Modern science, however, has cut the ground out from under such attempts.

Behind the apparent external aspect of things, science has uncovered something else—atoms, vacuum, energy, and, last but not least, the mathematical formula. The traditional contemplative perception of things has itself become an illusion, an illusion moreover that leads one astray. The identical and the nonidentical have lost their old connection to the similar and the dissimilar. The world of appearances has become the deceptive shroud of Maya, cast across the void or over matter as the case may be.

Under these circumstances, art has veered away from illusion, which it regards as a lie. Art has become analytical. The work of art has disclosed its own structure and its material presence in the world. Attention is now focused on what distinguishes the artwork from other things, rather than the resemblance to other things that it acquires by means of illusion—which is to say, attention has been directed to the constructive basis of the image as an object that is simply there. This process gave rise to what we call avant-garde art.

Nonetheless, representations are still there, and this means that art did not lose its links with illusion. Discovering the laws of an empirical world, science destroyed the visible world and accomplished its disintegration only to assert thereafter the identity of its findings with the hidden laws of nature. Scientific experimentation, trying to find the laws of the visible, moves ever farther away into the invisible. But art does not extend beyond the sphere of representation. A painting, containing the depiction of the structure of some other earlier paintings, hangs alongside them on the wall of a gallery. Its privileged status can be proven only historically. It passes judgment by itself on the art before, just as it is judged by that art. A stone smashed into bits and reduced to atoms is still the same stone; but a picture torn to shreds is either annihilated as a work of art or is transformed into a different picture. Experimentation in art does not

penetrate the sphere behind the representation or destroy illusion—it merely engenders a new representation and reestablishes the illusion. As long as society protects art from outright destruction, art retains the fundamental character of an insurmountable illusion that no experience is able to transgress.

Ivan Chuikov's work is a thematic treatment of this aspect of art as a protective force. He stretches a film of landscape over parallelepipeds and airtight windows. This way of handling the landscape is in keeping with its function as a membranous encasement that conceals the thing-in-itself from the solitary Romantic rapt in contemplation. To a classical landscape-painter, the landscape was a view to be understood as a stage in the cognitive process. The next stage in that process is the next view—the one opening up to the wanderer who travels to the interior of nature and gains knowledge through observation. The contemporary human finds landscape overcome at the very first step on the cognitive road. Landscape is an illusion that makes up the world of Romantic subjectivity, or else it is a collective illusion shared by those who dwell within it: the illusion of art.

The insurmountability of art is the same thing as the insurmountability of landscape. Chuikov exposes the material substratum of Romantic subjectivity. A thin layer of paint is applied to the surface of a anonymous object without a distinct form of its own. The social definition of art, by its very essence, renders that object both unattainable and invisible. The parallelepiped wrapped in a landscape emerges in all its coarse materiality to the viewer's gaze. It is "right at hand," as Heidegger might put it. The void behind the film of a "real" landscape, surrounding the observer on all sides, has taken on the vulgar form of a box which now passes into the ownership of the viewer. However, as the material carrier of the film of "art" this box is no more accessible than is the thing-in-itself—the Kantian *Ding an sich*. The box is under guard, and in its banal materiality it remains an eternal secret. Its discovery would be equivalent to the demise of art; this would be sacrilege, not experimentation (fig. 1.3).

Here we see the role played by illusion, institutionalized in art as defense and protection. In this context, the anonymity of style in which the illusion is reproduced ensures collective recognition of its protective character.

The works mentioned above retain a certain degree of ambiguity. The question arises as to whether the artist is trying to make a gesture of protection and defense, as being the purpose of art. Or is he demonstrating the conditions for the display of a Romantic painting? One may suspect that Chuikov's demonstration of a box-landscape was inspired less by a desire to conceptualize the Romantic experience than by an aspiration toward a nostalgic and ironically secured elaboration of the Romantic image itself. The transcendental conditions for that gesture would thereby be shown.

All reasonable considerations lead us to favor the second of these alternatives. Indeed: In itself, the parallelepiped and the completely anonymous window are such negligible objects that the artist can hardly be seriously interested in their preservation. Hence

Figure 1.3
Ivan Chuikov, *Panorama II*, 1976. Enamel on fiberboard, 29 × 65.8 × 65.4 cm. Peter and Irena Ludwig Stiftung, Aachen, on long-term loan at Ludwig Museum-Museum of Contemporary Art, Budapest.

the parallelepiped is taken here to serve, rather, as a tangible example. And it could be replaced by any other object. So what we see is the sheer possibility of protection, rather than the actuality, insofar as it leaves the viewer emotionally indifferent. The pathos of involvement as authentic interestedness is not aroused in his soul. On the other hand, the landscape depicted on the box is itself so trivial and easy to grasp that its reproduction by the artist would perhaps appear to have been occasioned solely by the problem of conceptualizing the representation as such.

Of course, an interpretation based on this kind of reasoning is still nothing more than an interpretation. It stands in contrast to the artist's work by presupposing an external vantage point. Conceptualization is not carried out in the work itself. The individual work is not placed within any kind of series, nor is it supplied with any attributes which might unequivocally impose a reading. An artwork as such must possess an expository force and a compulsive quality directed at the viewer. That is what distinguishes it from natural objects revealing themselves passively to humankind. If a concept takes form only in the mind of the observer, that means that in the artwork it exists only as a potentiality, without having acquired genuine actuality. Thus it is only natural to suspect that, in the case at hand, the box-landscape is not so much an attempt to conceptualize the Romantic experience, but rather is still another nostalgic elaboration of the Romantic image itself.

Ivan Chuikov proposes to define art as illusion—a definition that unquestionably narrows the field of art, reducing it to an art that is already there. In essence, art is always a project to reach the things themselves. Not of course in the sense that the art becomes a thing in itself, but that it affords us an insight into the true nature of things. By presenting us with an image of art as illusion, and that in all seriousness, Ivan Chuikov is saying something true to us. Further, by creating a work of art in which art displays its illusory nature, he raises the claim that his own art is a true one.

At this point we must inquire whether that work still belongs to the realm of art, or whether it goes beyond it. One way or the other, we arrive at a paradox. Maybe this very paradox gave the artist pause, preventing him from using the resources of art to complete his exposition of the artistic truth revealed to him. One gets the impression that Chuikov assumes the existential status of art to be revealed not in itself but in the discourse of which it is the object. However, it is contemplation and not illusion that is insurmountable in art. To suppose that contemplation is always illusion, or that genuine contemplation is impossible and that all contemplation must be founded on the unseen (in other words, on reasoning), is to remain within the Romantic framework and to deprive oneself of the right to truth. Yet in practice a perceptive grasp of existing art, that is, of art as illusion, has always been for the artist a motivating occasion to overcome illusion and to go out toward the things in themselves in true contemplation. Artistic truth is historical, and like history itself it is irremovable.

Ivan Chuikov does accomplish the journey beyond the confines of the conditional, not by way of conceptualizing the Romantic (as earlier suspected) but rather via its further expansion. In the works entitled *Corners and Zones* he opts conclusively for the direct gesture, eschewing self-analytical reflection (fig. 1.4). In these works he restores to an enclosed space—the room—its ritual and mystical significance. (Let us recall: the Red Corner, Happy and Unhappy Walls, the Place for Household Gods, etc.) *Corners and Zones* organizes space in such a manner that it acquires a half-profane, half-sacred character and loses the impersonality of mere living space. At the same time there is a risk of nonrecognition of this art intervention as art, which signifies a genuine departure beyond the confines of reflection on art as such.

Unlike the box, the room calls for protection, and this appeal arouses an immediate reaction in the viewer. The authenticity of the interest thus stimulated guarantees an involvement in the happening, which transforms one or two lines on the ceiling and in the corners of the room into a work of art. A few elegant and reliable tracings confer on the room the status of an indestructible object of contemplation, unrelated to any stereotype; its illusory character is thereby transcended, and it becomes rooted in authentic emotional experience. The specific characteristics of these tracings (the permanent change of their configuration from different viewpoints as the viewer moves about, for instance) are not very important, and in fact are superfluous. What is important is that Ivan Chuikov, in denying art the right of true contemplation, is directly continuing the tradition of incantatory gesture and chivalrous defense which he singled out and

Figure 1.4
Ivan Chuikov, *Corners*, 1977. Drawings, ink on paper. Courtesy of Ivan Chuikov.

perceived as one possibility for intelligent artistic activity in our time—for art understood as insurmountable yet genuinely experienced illusion.

3 Francisco Infante

At the beginning of our century, art became aware of its autonomy with respect to "life," or the depiction of life, and at the same time it grew inflated with an attitude of arrogant superiority toward it. If art has its laws, then life, too, can be understood as art; and life perceived in this way may be quickly recognized as ugly art. An artist familiar with the law of creative freedom has a duty to transform life in accordance with that law—to make life beautiful. Futurism and Bauhaus are well-known examples of artistic projectionism. In the 1950s and '60s a desire to subordinate life to art found expression in the happening and in utopian visions of the future. But from the very outset the aggressivity of art was met with resistance. Indeed, can an artist really lay claim to a position above the society in which he lives? In his activity the artist is defined by the limits of his vision and by the way he relates what he sees to reality.

But the limits of his vision are narrow ones, owing to the finitude of his existence. And the investigation of the mechanism by which the visible and the knowledgeable are interrelated becomes an adventure without end. This mechanism is above all anonymous and historical. It holds the artist prisoner. To discover and to grasp it he has to overstep the bounds of art and rely on other practices that have little or nothing to do with art. Thus he falls into renewed dependence on "life" as it is practiced here and now. The extension of art into the social domain, or the attempt to force a particular aesthetic ideal onto society, is always an anachronistic undertaking, for that ideal is itself nothing more than the same society, albeit in its historically earlier form.

Art in our day is more than ever disinclined to put its faith in the clichés of the beautiful and to apply them to the common life. The old arrogance toward the banality of life is gone forever. And yet the dream and the ritual have not died, not by any means, as the work of Francisco Infante so eloquently testifies.

Stylistically, his art lies within that tradition of the European and Russian avant-garde that took upon itself the mission of remaking the world. Infante's images are also projects for another kind of life in another, better reality. Of late he has begun photographing the modifications introduced into the natural environment by superimposition of artifacts, as well as organizing actions in natural settings that take on a ritual character (figs. 1.5–1.6). But the actions organized by Infante are performances rather than happenings. They are not aimed at inciting the audience to direct participation or to at bringing about changes to our customary ways of life: the artist wants a pure visual show. It is not the action itself that is so important as the photographs taken with the artist's camera.

For a long time, painting was looked on as the antithesis of photography. Painting was assumed to disclose a world of the artist's imagination, whereas photography presented "things as they are." The myth of the dispassionate photographer, however,

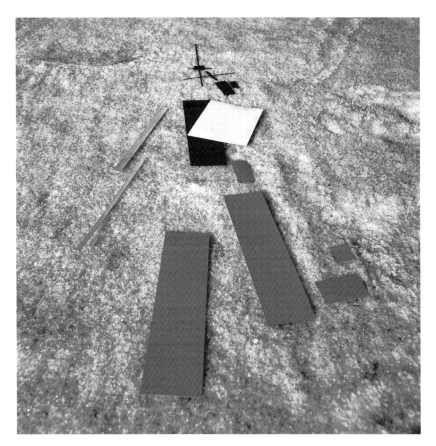

Figure 1.5
Francisco Infante, *Dedicated to Malevich*, 1969. Snow, capboard, paint. Photo by and courtesy of Francisco Infante.

vanished quite a while ago, and the artist's imagination seems no longer so very individual; but in performance photography, both of these illusions spring to life anew. The artist operates here on the level of the signified and not of the signifier: The photograph is presented to us as a document testifying the authenticity of what has happened. Instead of aggression, what predominates here is the nostalgic dream.

The performance art in Infante's version looks quite different from the Western one. In the West, attention is centered on individual, social, and biological definitions of the human body and on the limits of human existential possibility; Infante gives us a world of technological reverie reminiscent of the dreams of early childhood. By their grace and elegance, their clarity and wit, his photographs stand distinctly apart from the science-fiction design that became so boring for everyone. Infante's world is a world

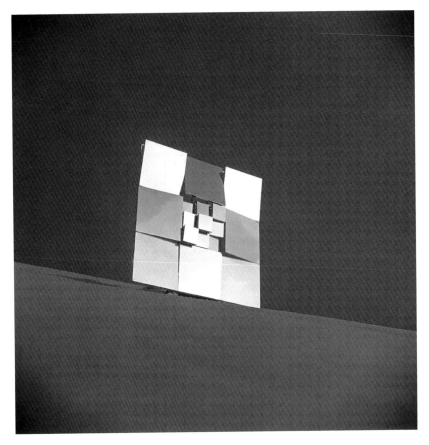

Figure 1.6
Francisco Infante, from the series *Artefact*, 1977. Photo by and courtesy of Francisco Infante.

of trust, whereas the real technological world is a world of distrust; for technology is control, and you cannot exercise control without suspicion. What makes the reality presented by Infante's photographs attractive is its character of being a pure form. This reality is free from suspicion inasmuch as it does not provoke the spectator to look, to penetrate behind the form. Consequently, only the photographs themselves are real. The subject photographed is merely art, being real only to the degree to which art is real at all. Infante modifies the concept of an image in such a way as to preserve that concept: Deception lies at its basis, but it is precisely that deception that constitutes art. Infante reveals a certain conservatism of the avant-garde—and by doing so he moves the avant-garde from life back to art where it has de facto always resided.

4 The Collective Actions Group: Nikita Alekseev, Andrei Monastyrski, and Others

Performance art is represented in Moscow by the group known as "Collective Actions." The artists in the group have assigned themselves serious tasks, in an attempt to decompose the visual effect produced by events into its primordial elements—such as space, time, sound, or a number of figures. A characteristic common to all these works is their pure "lyricism," or their dependence on the viewer's emotional predisposition.

Their performances are all somewhat ephemeral. They set up no law as to how they should be approached and judged; they give themselves over to the observer's perceptive whims. The viewer's encounter with these works is often intentionally left to chance. The artist, for example, may leave a ringing bell under the snow, or a painted tent in the woods. This kind of accidental encounter with the art objects opens up a world of unexpected premonitions and amazing discoveries—the sort of world in which humankind was actually living not so very long ago (figs. 1.7–1.9). There was a time when people believed to come time and again across inexplicable traces of some indefinite presence, signaling the existence of active and purposive forces that acted beyond the limits of commonsense explanations. These indications pointing to the presence of magic forces can be regarded as facts of art, as opposed to facts of reality—facts that cannot be explained but only interpreted. The artists of Collective Actions endeavor to involve the contemporary observer into such accidental encounters or discoveries, discoveries that will compel him to engage in the process of interpretation.

In the foregoing we have undertaken to analyze the artistic practices of several contemporary Moscow artists. This naturally leads us to a further inquiry into the typical characteristics of contemporary Russian art as a whole. What is it that makes this art unique, if indeed it is unique? Can we oppose Russian art to Western art even if their similarity is obvious?

It is certain that such an opposition does in fact exist. Perhaps the differences are not so plainly evident in the works of Moscow artists, but the contrast is clear, beyond all doubt, in the way the public and the artists themselves understand their work. Consequently these works bear the stamp of distinguishable difference, though unfortunately to an only half-recognized extent, so that an additional interpretation is required in order to see this difference in a proper light.

In one way or another, Western art says something about the world. Even when concerned with faith it speaks of faith as incarnate in the world. It may turn its attention inward onto itself, but what it says has to do with its own process of realization in the world. Russian art, from the age of icons to our time, seeks to speak of another world. Russians today like to point out that the term "culture" is derived from "cult," where culture is understood as the totality of the arts. Culture comes out as the guardian of original revelation and also as the mediator for new revelations. The language of art differs from everyday language not because it speaks of the world in a more elegant and

Figure 1.7
Collective Actions, *The Pictures*, 1979. Photograph by Andrei Monastyrski/Andrei Monastyrski Archive.

Figure 1.8
Collective Actions, *The Pictures*, 1979. Photograph by Andrei Monastyrski/Andrei Monastyrski
Archive.

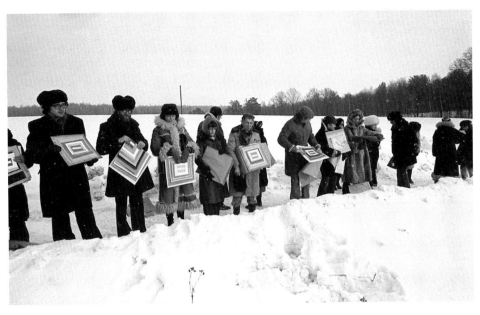

Figure 1.9
Collective Actions, *The Pictures*, 1979. Photograph by Andrei Monastyrski/Andrei Monastyrski Archive.

beautiful way or discloses the "internal world of the artist." What makes it different is the message it has to convey about the other world—something that only art can say. The inner structure of artistic language empowers it to convey the image of that other world, just as the inner structure of our everyday language discloses the world of here and now. Each discovery of the power of artistic language to communicate something new is accordingly a discovery of something new, something never known before, about the structure of the other world. We may love the artist for showing us a place we long for; we may hate and fear him for revealing a world we do not want. In Russia, art is still magic.

What is the other world? It is the world opened up to us by religion. It is the world that opens itself to us only through the medium of art. It is also the world that is situated at the point where those two worlds intersect. This is why there is so much tension in the relationship between art and faith in Russia. At all events, the other world is neither the past nor the future. It is rather the "other" presence in the present into which we may withdraw without reserve. No waiting around, no wheeling and dealing is needed in order to live in the church or in art. All you need to do is to take one sideward step, and you find yourself in another place. This is quite as simple as dying;

and, essentially, it is the same thing as dying. You are dead in the world and you are resurrected alongside the world.

Magic subsists in space but not in time. The cosmos is constituted in such way that it contains enough space for different worlds.

The artists whose works have been discussed here are not religious persons; yet they tend to comprehend art in terms of belief. Whether as merely potential existence, or as straightforward portrayal (revelation, de-concealment), or as a sign from above that calls for interpretation, art—as artists see it—involves the invasion of that other world into our own. We must make an effort to understand what this invasion signifies. The invasion has occurred with the artists' complicity, and we cannot be ungrateful to them on that account. By invading our history, the other world gives us the power to make statements about our world that the world as it is could not make about itself. And what may we finally conclude? Precisely this: That other world is not another world at all, but our own historicity, revealed to us here and now.

2 Privatizations/Psychologizations

The long-anticipated but nonetheless sudden abdication of the Soviet State in the year 1991 transformed the vast territory of the Soviet Union into a completely ownerless, neutral space. As a result, a situation emerged that is without precedent in the historical past. None of the wars, revolutions, or coups d'état that we know from history has ever led to such a radical confiscation of private property as was effectuated by the October Revolution of 1917. Only the so-called personal ownership has been allowed that consisted of the few items that the Soviet State put at the disposal of its citizens for their personal use. The standard of living was thus linked directly to one's position in the State hierarchy: If one's position was lost, one's standard of living, that is, personal ownership, went with it.

The October Revolution intended to put an end to private property and create a free society of unpropertied citizens. In reality, however, all the rights of private ownership were transferred to the state so that the plurality of small property owners was replaced by one big owner—the Soviet State. The second original goal of Communist ideology, namely the elimination of the state, was thus postponed until further notice. According to the dialectical teachings of "historical materialism," the state would "die off" of its own accord after "socialist construction" had been completed. As we all know, the perfect and final victory of socialism was solemnly proclaimed in the Brezhnev era. The future had arrived and could no longer be postponed. And indeed, as soon as the victory of socialism was announced, the Soviet State did disappear.

The old Leninist–Stalinist "dialectic" canon about the disappearance of the state as a consequence of the unlimited growth of its power—for years the target of commentators' irony—turned out to be true after all. The Soviet State's unchecked domestic and international rise to power actually led to its own historical sublation. In a sense this was the ultimate fulfillment of the October Revolution, because the death of the last and only owner left behind a society of unpropertied people. No wonder Gorbachev considered himself a loyal Leninist, at least when he did away with the Soviet State.

The disappearance of the Soviet State was therefore not merely a political event. We know from history that governments, political systems, and the balance of power often

change without a substantial effect on private ownership. The structures of social and economic life persist even when political life is undergoing radical change. But not a single social contract survived the abdication of the Soviet Union. The country became a legal desert that had to be completely restructured—like the American Wild West.

This is the background against which the process of *privatization* is currently taking place in the territory of the former Soviet Union. Certain administrative departments of the old Soviet bureaucracy privatized areas that had previously been under the jurisdiction of the Soviet State. This brought about post-Soviet republics like Russia or the Ukraine. And some of these administrative departments privatized branches of the economy. And single citizens have been privatizing anything they can get their hands on. This does not happen without a struggle; in fact, a direct violent fight is inevitable in such a lawless situation.

But this fight is not to be understood simply as the conversion of an unpropertied country (back) into a country of private ownership. Privatization is not a transition but a permanent state, namely, the state of uncertainty about what belongs to us and what doesn't: In other words, where does private ownership begin and where does it end? Under Soviet rule, the legal specifications that once distinguished between private and public property were nullified. It is impossible to restore them in their entirety because privatization itself is now a state program in Russia. Private ownership is discovering here its fatal dependence on public space: Private spaces necessarily rise out of the rubble of the monster that was the state. We are dealing here with the violent dissection and private appropriation of the corpse of the Soviet State, as in the sacred celebrations of yore at which a tribe consumed the dead totemic animal. On one hand, such a feast signifies a privatization of the animal because everyone receives a piece of it; on the other, the feast itself establishes a supraindividual community that transcends private demarcation.

The process of privatization which currently dictates economic and social life in Russia in all its ambivalence has not left Russian art unscathed. There it takes the form of *psychologization*. Psychology is religion and the chief occupation of societies, such as those in the West, in which individual private souls are strictly separated from each other through an external legal and economic system of relations. In contrast, the Soviet State intervened directly in the souls of its subjects and manipulated their impressions, feelings, and experiences. The soul of every Soviet citizen thus remained incomplete, nonautonomous. Traumatic experiences, incessantly inflicted upon the Soviet citizens by the state, were immeasurably stronger than all the traumas described by traditional psychoanalysis. The purely external, manipulative power of the Communist state was far more effective than all the forces of the unconscious. This gave rise to a huge reservoir of experience that was not attributable to any particular soul in the sense of traditional psychology, its only legitimate subject being the state. It was a kind of territory of the psyche that was congruent with the territory of the state. In the

Soviet era, private psychology was subordinated to official ideology and therefore was also nationalized.

Just as the Soviet State left a vast territory for private appropriation upon its demise, the simultaneous death of Soviet ideology also left a vast empire of feelings, a huge estate released for psychological appropriation. Soviet Marxist–Leninist ideology was based on a specific desire: a desire for Communism, which signified the coming of cosmic salvation and ineffable joy. This desire might be called a state desire. And this state desire suffered a number of frustrations in the course of its historical career, but also produced many moments of consummate happiness and generated many fantasies, whose subject was always the state itself—but they were also imparted to the open, incomplete souls of all Soviet citizens, to the same extent, though not necessarily with the same meaning.

Marxism and Leninism of the Soviet kind, though primarily a kind of philosophy of history, was clearly more than a specific interpretation of familiar world history. This world history itself looked different in Soviet territory from its counterpart in the West: different names, dates, events, and patterns of storytelling. And it was not simply a national or regional history of Soviet Russia. Had Soviet history been a mere national or regional history, it could easily have been integrated—apart from a few minor adjustments—into the common universal history. But Soviet history was *a different universal history,* which could not be included into the supposedly neutral and scholarly Western historiography precisely because it had its own claim to universality. It was the history that articulated the state desire for Communism. Even after the demise of Soviet ideology, this other history that prevailed during the Soviet era still remained as the dead unresolved body of this ideology. And it is this other universal Soviet history that forms the territory occupied by the empire of state feelings, or the nationalized psyche of the Soviet citizen.

With the death of the Soviet State, the rightful subject of state desire fell apart as well. The empire of state feelings lost its sovereign administrator. The empire lost both its rulers and its subjects. To put it differently: The former state territory of feelings and experience was transformed into a subjectless, nameless unconscious, a psychological desert that anyone can appropriate as his or her own individual unconscious. This private appropriation of the former state desire as one's own unconscious is the salient feature of current Russian art. What was once felt as external coercion on the part of an alien state-owned subject is now reinterpreted as the inner coercion of the collective, that is, subjectless, unconscious, and thus psychologically internalized. To a certain extent, the original objective of the October Revolution to provide for collective experience with no institutional interference has been fulfilled.

This psychologizing of Communism has incidentally enjoyed a rhetorical boost during the past few decades from philosophical discourse on the impersonal desire—the discourse practiced in the West, more specifically, in France, and exemplified by

such authors as Foucault, Lacan, Deleuze and Guattari, and Derrida. Their discourse fed on the failure of the May '68 revolution in Paris and had already undertaken to psychologize Marx: Productive forces and the conditions of production gave way to desire. The Marxist history of emancipation was thus absolved of the need for empirical evidence without sacrificing its validity, because desire has a reality of its own. This discourse has now acquired currency in recent philosophical debate in Russia, which makes use of such terms as "collective body" or "collective unconscious" or "collective desire," thereby translating into a modern-day idiom what was once the main principle of Soviet Marxism, namely that "(collective) being determines (individual) consciousness."

But instead of being emancipatory, this language of desire has become appropriative. In his recent book *Spectres de Marx*, Derrida still interprets the Marxist vision of history as apocalyptic promise, the "ghost of Communism" that keeps haunting us with the promise of a shared "other" event that will deconstruct our private individual existence. However, by clearly setting itself apart from the West and proclaiming its radical difference from Western culture, Russian art exploits the difference and singularity of Soviet history as an opportunity for radical privatization. Russian art believes that it has not only a different conscious but also a different unconscious. The concepts of a collective unconscious or a collective body deployed in the West to critique the isolation and self-identity of the individual conscious are used affirmatively by some Russian artists and intellectuals as a means of preserving and stabilizing their own cultural identity. But as in the case of privatization of former state-owned property, the psychologization of former state-owned desire does not lead to the emergence of an individual psychology. Paradoxically, complete psychologization has led to a standardization of the Russian psyche: It is not impersonal, unconscious desire but rather clearly defined and calculated subjectivity that is perceived to be a threat to the stability of Russian cultural identity. Precisely because Russian art wants to acquire a solid cultural identity that would guarantee its special place in the international context, it clings to the collective unconscious that it inherited from the Soviet State. The paradox of an identity based on the unconscious can only be called into question by analyzing the strategies with which art operates when it appropriates or privatizes the collective unconscious.

By means of these strategies, the unreal, phantasmal, ideologically generated history of Communist desire is reinterpreted as the artist's own personal mythology. In fact, artists all over the world are pursuing comparable strategies. They exploit their ethnic background or their gender, external features of identity, as readymades in their work instead of removing these traits in an effort to find their "genuine, hidden identities," as was once the case in early modernist art. There is also a certain tradition to thematize a Communist, fascist, Nazi, or, generally speaking, totalitarian other. But it is a tradition that also illustrates the difficulties in dealing with this kind of otherness.

Since the identities that are generally on the agenda of dominating postcolonial discussions are all premodern, the problem is how to represent or transform them within the framework of liberal, democratic modernity. We ask ourselves how the traditional feminine role should be redefined, how premodern ethnic identities should be reassessed and represented, and so on. But the so-called totalitarian forms of culture are just as modern as liberal, democratic modernity. We are faced here with a different modernity and not with the survival of premodern identities. And the radicalism of this totalitarian modernity makes it even more modern in many ways than liberal, democratic modernity. The result is a rivalry that does not allow a sentimental treatment of the other, which is the main technique currently involved in dealing with local cultural identity.

Totalitarian Soviet ideology characteristically ascribed a decisive role in the struggle for or against Communism to whatever seemingly insignificant and trivial objects or events happened to be at hand. Thus "our" socialist cows grazing on meadows signified the victory of socialist agriculture while "their" capitalist cows grazing on meadows signified the abuse of an idyllic image as a cover-up for the horrors of capitalist exploitation. This same technique—a one-time Soviet favorite—has now been adopted as an artistic device by new Russian art in order to privatize and psychologize this ideology. A simple, banal, insignificant object is given weight by means of an interpretation that lends it the status of art. This is not simply the readymade technique of turning an object into a work of art by sheer artistic will, because the work of art in this case is not the object but rather the interpretation itself.

Interpretations are, however, no longer universally binding in new Russian art. The installations and writings of Medical Hermeneutics (Sergei Anufriev, Pavel Pepperstein, Yuri Leiderman), for example, demonstrate the collapse of all explanation, all interpretation, all justification—while any randomly chosen item serves as the locus of this collapse. The choice of object is apparently dictated by an obsession that unites orphaned state desire with the artists' private obsessions: The line between purely personal and ideological fetishes is blurred in the work of this group (fig. 2.1). In the final analysis, however, the result is a kind of empty desire, divested of any specific references and exhausting itself in mere words, empty talk. Medical Hermeneutics proceeds by systematically talking content to death. The group's discourse is always witty and entertaining and always leads to a great gaping void that takes the place, if you will, of Communism, of universal wish fulfillment.

In Vladimir Sorokin's novels and stories, the everyday glides noiselessly, almost imperceptibly and perfectly naturally, it would seem, into extreme violence that is also identified with the ultimate fulfillment of sexual desire. The wish fulfillment of Communism has not vanished but instead takes the shape of total, ecstatic destruction reminiscent of Bataille. But the radicalism and specific discursiveness of this work is virtually unparalleled in literature after de Sade, although it is still literary through and

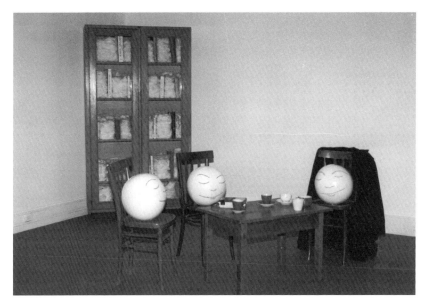

Figure 2.1
Medical Hermeneutics, view of the installation *Landing Sites for Warming Up*, featured in an exhibition held at the Museo d'Arte Contemporanea Luigi Pecci, Prato, Italy, 1990. Photograph by Natalia Nikitin/Natalia Nikitin Archive.

through. The objects Sorokin shows as an artist are of a packaged and portable uncanniness—like the magician's suitcase or Duchamp's boxes.

Both the artists in the Medical Hermeneutics group and Sorokin were influenced by Andrei Monastyrski (fig. 2.2), who belongs to the older generation of new Russian artists and made a name for himself largely through performances staged in the 1970s and '80s with Collective Actions. These enigmatic actions that were meant to generate a kind of "zero event" were the subject of lengthy comment by Monastyrski himself and provoked intense debate among his friends as well. Monastyrski used a code in his interpretation of these actions that did not correspond to conventional cultural tradition in Russia, namely, the philosophy, literature, and mysticism of ancient China. He thus broke up the monopoly enjoyed by a typical brand of Russian–Soviet political and literary discourse based on the literary classics of nineteenth-century Russia or Communist/anti-Communist sociological terminology. The terminology of ancient Chinese wisdom, applied to the interpretation of these performances that generally took place in the rural outskirts of Moscow, must surely have had a special appeal: It led in the succeeding generation to a discursive mannerism that strove to dissolve Soviet ideology and language along with other more fashionable discourses in endless ideological wordplays on zero-sums.

Figure 2.2
Andrei Monastyrski, *Cannon*, 1975. Wood, cardboard, bell, text sheet, 54 × 54 × 74 cm.
Courtesy Charim Galerie, Vienna.

These esoteric games played with interpretations, readings, and ideologies are certainly hard to document; all that has survived is a vast bewildering jumble of texts and documents that makes little sense to the uninitiated reader. In consequence, a twilight zone has emerged in which it is difficult to distinguish the rigorously kept records of history from fantasy. Vadim Zakharov works in this zone chronicling new Russian art like a member of a secret lodge, using magic rituals incomprehensible to the layperson. The resulting historical record is indistinguishable from artistic invention and thereby undermines the conventional domain of history (fig. 2.3).

Yuri Albert's works often take an ironic approach to the rituals on the discursive void practiced by his friends. He confronts their mannered, esoteric, ideological idiom with the language of, for example, the deaf, the blind, or professional jargon such as the language of sailors (figs. 2.4–2.5). The arcane and mannered obtuseness of artistic discourse in new Russian art eliminates meaning rather than engaging its traditional practice of illuminating a deeper meaning. But it still separates the initiated from the uninitiated, although the latter are the ones who are waiting for the deeper meaning. In contrast, Albert shows us how the simplest statement that makes no claim to profound insight can still be a mystery accessible only to an elect, for instance, when a blind person suddenly sees a picture that van Gogh never painted because he has read a description of it in Braille: He enjoys the privilege of envisioning paintings by van Gogh that are withheld from those of us who can see.

Olga Chernysheva's works remain faithful to the black-and-white aesthetics of "lettering." But in contrast to the work of most of her colleagues, she makes sparing reference to ideology. In the midst of rampant Russian–Soviet ideology, Chernysheva devotes herself to everyday rituals of neutral ideological import: baking a cake, being a mother, being a child. But she lends these ordinary occupations a certain indefinable wit: There is indeed something funny about residing in Russia and trying to live an everyday life.

And last but not least: Vitaly Komar and Alexander Melamid present a work in progress: *People's Choice* (figs. 2.6–2.7). The artists conduct inquiries in which they ask the public at large from a number of countries what content, figures, colors, shapes they would or would not like to see rendered in a picture. Then they paint pictures of the values that received the best and the worst ratings respectively. The artists thereby bow to democratic choice and to the power of statistics, which is a time-honored policy in politics, business, and commercialized mass art. The pictures that people "want" are obviously classicist, nostalgic, symbolic—just what, in fact, artists themselves love. And the pictures people "do not want" are abstract—just what artists themselves hate. The art created by Komar and Melamid involves playing with statistics the way other artists play with language.

But even so, having said everything that supposedly ought to be said about contemporary art, the question remains: Why does an artist do what he does, and not

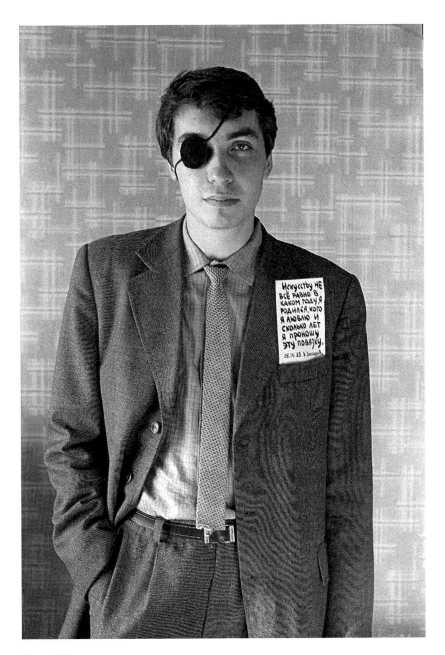

Figure 2.3
Vadim Zakharov, "Eye Patch," 1983. Black-and-white photograph, 70 × 50 cm. Courtesy of the artist.

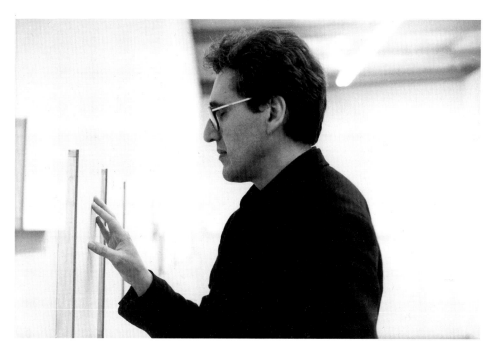

Figure 2.4
Boris Groys in Yuri Albert's installation *Pictures for the Blind*, 1995. Photo by and courtesy of Yuri Albert.

Figure 2.5
Dmitri Prigov in Yuri Albert's installation *Pictures for the Blind*, 1995. Photo by and courtesy of Yuri Albert.

Figure 2.6
Vitaly Komar and Alexander Melamid, *Amerika's Most Wanted*, 1994. Acrylic and oil on canvas, 24 × 32 inches (dishwasher size). Courtesy Ronald Feldman gallery, New York (private collection, Russia).

something else? Since—obviously—there is no limit to the kinds of things that can be used in art today, the reason for their use can lie only in ironic treatment, in interpretive discourse, in analysis of the social code. That is certainly true. And it is a point I have already made. But it is also true that irony, discourse, and analysis are often used today as a means of publicly justifying a private wish to occupy oneself with certain things simply because one likes them, while at the same time sensing that they would not be unconditionally acceptable to the public. This is a common practice everywhere. Russian artists do it, too, because apparently the globalized public will not simply appreciate Soviet reality, aesthetics, rituals. So, permission to deal with the Soviet reality is conditioned by practicing its ironic analysis.

Figure 2.7
Vitaly Komar and Alexander Melamid, *Amerika's Most Unwanted*, 1994. Tempera and oil on canvas, 8.5 × 5.5 inches (book size). Courtesy Ronald Feldman gallery, New York (private collection, Russia).

3 Sots-Art: Eastern Prophecies

To anticipate the future was a declared goal of many modern art movements. Very few of them were endowed by a sufficient divinatory power to achieve this goal. Russian "Sots-art" of the 1970s and '80s never wanted to be futuristic. But contemporary Russia looks like a Sots-art installation: Orthodox priests consecrate the updated Soviet intercontinental rockets decorated with a red star; Lenin's mummy can be seen not very far from Armani and Gucci boutiques. The visual world of the Soviet past is amalgamated with Western consumer brands. This post-Soviet development was prefigured already by the name of the movement: Sots-art. It was coined as a combination between socialist realism, or Sots-realism (the English transliteration "sots" reflects the Russian pronunciation of "soc"), and pop art. This name suggests that Communist propaganda art of the Soviet era was not only compared with but also equated with the branding of the consumer goods circulating on the Western markets. But this equation was of course more deliberately ironic than sociologically correct. The pop art of the 1960s emerged inside the market economy and operated within a gap between the markets for the cheap goods destined for mass consumption and a more restricted, elitist art market. The pop artists have found a way to elevate the cheap commodity to the status of an expensive artwork. Of course, this could be also seen as a critique of the capitalist economy and/or of the traditional notion of high art. But in any case it was a clever market strategy. Sots-artists could not develop such a strategy because under the Soviet system there was no market—no market for consumer goods and no art market. The consumer goods were produced and distributed according to a centralized plan; the value of ideological signs, including art, was defined according to their positioning in the symbolic economy operating by social recognition and political acceptance.

The main goal of Sots-art was to reveal the mechanisms of this symbolic economy. And these mechanisms were ambiguous enough. On the one hand, the private, Sots-artistic, officially nonrecognized use of the portraits of Lenin, Stalin, and Brezhnev, or of a red banner stating: "Our goal is Communism!" as mere readymades, was a profanation of these ideological signs. Originally, they were supposed to be used exclusively by the official art of socialist realism; their use was inscribed in Soviet ideological

rituals designed to educate the masses, to prepare them for the coming Communism. Removed from their educational function, these iconic images of the Soviet ideology looked strange, surreal, even embarrassing. Imagine an ancient Egyptian artist who would make an exhibition of Egyptian mummies in his or her private studio, instead of concealing them inside the pyramids. Or imagine a Byzantine artist making a private exhibition of the self-produced Christian icons, instead of keeping them in a church. That would provoke quite a shock in the audience—even if the mummies and the icons would be correctly and carefully executed. Sots-art was a comparable provocation for the Russian authorities—a parody, a blasphemy. But, on the other hand, this kind of blasphemous use of the official ideological signs constituted the true popular culture of the late Soviet civilization in the 1970s and '80s. It was primarily a culture of more-or-less dirty jokes, making fun of Soviet rituals, leaders, and slogans. And, of course, the official Soviet elite was also a part of this culture. In Brezhnev's time the official party carrier was more and more regarded as merely a way to get permission to travel abroad and to buy Western consumer goods, including anti-Soviet literature. And, actually, the difference of between Soviet and anti-Soviet was more than problematic from the beginning: To be truly Soviet was to know what it means to be anti-Soviet—at least with the goal of avoiding it. It is precisely this ambivalence of the Soviet ideological universe that is thematized by Sots-art. The ideological signs circulated in the Soviet culture according to the rules of symbolic economy were not easily recognizable by an external spectator—and at the same time, the ability to describe them required the artists to distance themselves from Soviet culture, to look at it from the outside.

This made Sots-art irritating for many spectators—in the East and, especially, in the West. During the cold war the central question was: Are you for or against Communism (or capitalism, for that matter)? Are you critical (of this or that) or supportive? Especially in the Protestant parts of the West, religion is discussed mainly in terms of faith—and politics in terms of personal commitment. But already Mikhail Bakhtin has shown that blasphemy should be seen as a kind of religious practice—without ceasing to be blasphemous, even without loosing its critical edge. Everybody who participates in the symbolic economy that is regulating the circulation of texts and images of a certain religion or ideology enters a religious or ideological universe. To be critical of a certain ideology is also to be a part of it. The subjective (positive or critical) attitude toward an ideology is here of less importance than the "objective" participation in the circulation of its signs. This approach to ideology is rooted in the Marxist tradition because ideology is perceived here more as an "objective" social practice than as a matter of personal conviction. But even more, it reflects a new ambiguity between critique and advertisement that is characteristic of our time. In our media-driven culture, the fact that a certain political attitude or religious belief is publicly mentioned is of greater relevance than the way in which it is mentioned—be it positive or negative, affirmative or critical.

Figure 3.1
Vitaly Komar and Alexander Melamid, *Quotation*, 1972. Oil on canvas, 118 × 79 cm.
Courtesy Ronald Feldman gallery, New York (private collection, United States).

Figure 3.2
Vitaly Komar and Alexander Melamid, *Laika Cigarette Box*, 1972. From the Sots-art series. Oil on canvas, 77 × 58 cm. Courtesy Ronald Feldman gallery, New York (private collection).

That is why Sots-art was a provocation for both sides of the Soviet political spectrum. The official negative reaction was quite predictable. The artists who participated in the Sots-art movement positioned themselves from the beginning in the context of the unofficial art scene that developed in the Soviet Union after the death of Stalin. This art scene—it was concentrated mainly in Moscow and Leningrad—was tolerated by the authorities but, of course, regarded by them from the beginning as suspicious and potentially anti-Soviet. But Sots-art was also a provocation for the unofficial art milieu, because Sots-artists began to invade the supposedly pure space of the independent, unofficial culture by the vulgar signs of Sovietness. The majority of unofficial artists, writers, poets, and intellectuals believed that the true protest against the oppressive power of the Soviet system consisted not in criticizing it but in ignoring it. Of course, they told each other the same (anti-) Soviet jokes as everybody else in the country, but they preferred to forget this at the moment as they started their serious artistic work. And, thus, they saw in the Sots-artistic use of Soviet symbols more an advertisement for the Soviet ideological regime, more its expansion on the territory of the unofficial culture, than a critique of this regime. In this sense their critique of Sots-art was not unlike the well-known critique of pop art in the name of high art. And, of course, this critique was, in its turn, criticized as elitist and as disdainfully disregarding the real culture of the majority of the Soviet population.

But also, in the West, the Sots-art strategy was barely understood—even if Sots-art is better known internationally than any other Russian artistic movement from the historical period after the World War II. First of all, political convictions are regarded in the West mainly as a private affair—even if an external spectator may have a different opinion about it. At least in the time of cold war Western cultural production, including art, was regarded in the Soviet Union both by the authorities and by the opposition as a promotion for Western political-ideological values: individualism, freedom of expression, entrepreneurial freedom. But in the West itself, popular culture is understood primarily in terms of consumption and entertainment. That diminishes the interest of a Western spectator in understanding the impersonal, collective dimension of religious and ideological practices. And one should not forget: under the conditions of the cold war, Soviet culture remained for an absolute majority of the Western public an unknown and ultimately uninteresting phenomenon. Paradoxically enough, the reason for that lies in the fact that the Communism was regarded in the West as something already very well known. The 1970s and '80s were a time of the intense interest in the other, in theoretical discourse on the other. Every kind of cultural identity was investigated and the signs of its "difference" extensively discussed. The only exception was—and still is—Soviet culture, because it was seen not as a culture but simply as a misunderstood and badly applied Western Marxism. Looking at the Soviet Union, Western intellectuals became convinced that they interpreted Marxism better than the Russians did—and this insight was enough for them to see all of Soviet culture

Figure 3.3
Leonid Sokov, *Project to Construct Glasses for Every Soviet Citizen*, 1976. Painted wood, 11.3 × 33.3
× 31 cm. The Norton and Nancy Dodge Collection of Non-Conformist Art from the Soviet Union.
Jane Voorhees Zimmerli Art Museum, Rutgers, The State University of New Jersey.

as simply a historical mistake. Any further investigation into Soviet culture made no
sense for them, because it was clear from the beginning that this culture was based on
an interpretation of Marxism that was simply wrong (dogmatic, primitive, etc.). One
could perhaps be interested in Russian culture (Dostoyevsky, Tolstoy, and so on), but
not in Soviet culture—and if so, then only to clarify why the Russians were so terribly
wrong in their reading of Marx. On the Right of the Western political spectrum one saw
the Communist regime only as a machine of repression and was interested only in the
cultural activities that were censored by the Soviet power—and almost never in the cul-
ture that was generated by Russian Communism. On the Left one was interested only
in one question: How to keep the promise of the better life, of the utopia, and of the
transformation of society alive after this promise was so cruelly parodied and so deeply

compromised by the Soviet reality. And that means: Almost nobody in the West was interested in the culture of Soviet Communism itself—everybody was interested only in one's own relationship to and interpretation of Communist ideology.

But whatever one can say about the Soviet system, many generations of Russians and non-Russians spent their whole lives—or the greater part of their lives—within this system. Beyond being an embodiment for a certain reading of Marxism, Soviet culture was an everyday experience for millions of people throughout almost the entire twentieth century. Soviet citizens participated in the festivities on May 1 or on October Revolution Day in the same way as citizens of Western countries continue to participate in the celebration of Christmas or Easter—that is, without necessarily being Communist or Christian believers. To erase the Soviet dimension of the Russian identity would be a reactionary and futile attempt to demodernize Russia. And beyond that it is simply an impossible task. The naive anti-Communist iconoclasm of the 1990s failed, after all. The contemporary post-Soviet culture is an effect of the profanation and secularization of the Communist past—not of its disappearance. And it is precisely this secularization that was already anticipated and effectuated by Sots-art long before it became the political reality of contemporary Russia. Therefore, it is quite understandable that after the end of the Soviet system, the present generations of the Russians who spent their childhood or their younger years during the Soviet period, and who still have some fresh memories of everyday Soviet culture, are glad to discover Sots-art and to identify themselves with its attitudes and sensibilities. Thus, the Sots-art that seemed to be critical in the Soviet era became the only form in which Soviet culture was able to survive the end of the Soviet ideology. Today, many new Russian art collectors are eager to buy it, and many younger artists work in its tradition. At the same time, the history of Sots-art remains hardly known. In the most narrow and at the same time most historically precise sense the term, Sots-art should be taken to apply mainly to a small group of Russian artists who emigrated from Moscow to New York in the 1970s: Vitaly Komar and Alexander Melamid, Alexander Kosolapov, Leonid Sokov (their works were included in the first exhibition of Sots-art [1986] shown at the New Museum of Contemporary Art, New York, and curated by Margarita Tupitsyn), but also to some artists who remained in Moscow, such as Boris Orlov or Rostislav Lebedev. To a certain extent this term can be applied to Grisha Bruskin who later also emigrated from Moscow to New York. This group of artists widely used the easily recognizable Soviet ideological icons in their artistic practice: red banners, Communist slogans, and portraits of the Soviet leaders like Lenin or Stalin.

Meanwhile, the aestheticized, ideologically and politically neutralized images of the Soviet past become a part of a new national folklore. In this form they function as the easily sellable commodities on the quickly expanding contemporary Russian art market. Here the aestheticization of the Soviet ideology leads to its commercialization, to its adaptation to the extremely consumerist attitudes dominating contemporary

Figure 3.4
Alexander Kosolapov, *Sashok! Would You Like Some Tea?* 1975. Painted wood, tape, burlap, nails on panel, 50 × 107 × 4 cm. The Norton and Nancy Dodge Collection of Nonconformist Art from the Soviet Union. Jane Voorhees Zimmerli Art Museum, Rutgers, The State University of New Jersey.

Figure 3.5
Alexander Kosolapov, *This Is My Body*, 2001. Digital print. Dimensions variable.

Russian society. But, on the other hand, the Sots-art legacy also shows itself today to be fairly effective as a reaction to the current attempts by the Russian leadership to replace the Communist ideology with a more spiritual guidance through the Russian Orthodox Church. The highly irreverent, carnivalistic use of Christian images is especially characteristic of the contemporary work of one of the veterans of the Sots-art movement—Alexander Kosolapov (fig. 3.5). Here Sots-art still remains virulent—now as Orth(odox) art.

4 Communist Conceptual Art

The goal of the present exhibition (Total Enlightenment: Conceptual Art in Moscow 1960–1990) is to introduce to the Western public an art movement that is known in Russia as Moscow conceptualism and that today's art world in Russia rightly considers the most important Russian art movement of the second half of the twentieth century. Admittedly, many of the artists whose work is being presented in the exhibition—such as Ilya Kabakov, Erik Bulatov, Vitaly Komar, and Alexander Melamid—are already relatively well known in the West. Recently, moreover, works by Andrei Monastyrski, Vadim Zakharov, Pavel Pepperstein, and Yuri Albert have also been frequently shown. However, these have all been either solo exhibitions or contributions to group shows that offer an overview of current Russian art or to international art exhibitions such as documenta in Kassel or the Venice Biennale. Although the contributions of the individual artists are by all means interesting, something important is missing: namely, an opportunity to categorize these contributions historically, to understand their cultural and social context, and to define their relationship to one another and to other kinds of Russian art of recent decades. Moscow conceptualism is a coherent, relatively clearly defined art movement that has consciously set itself apart from other Russian art; it has its own aesthetic, which is readily identifiable to Russian viewers, and even its own quasi-institutional internal organization. This group solidarity of the Moscow conceptualists—even if it may have faded with time—has both fascinated and irritated many in the Russian art world. In any case, Moscow conceptualism is a well-defined concept for Russian culture and is very familiar to everyone who deals with art inside Russia itself. In the West, however, the situation looks rather different.

The reason for that lies above all in the way information about developments in Russian art since World War II has reached the West. Moscow conceptualism is an art movement that evolved within the independent, unofficial art scene in Moscow in the 1960s, 1970s, and 1980s. This scene emerged in the larger cities of the Soviet Union almost immediately after Stalin's death in 1953. Although it was tolerated by the relevant authorities, it was almost entirely cut off from both official exhibition activity and the state-controlled mass media. For that reason, information about this scene was not

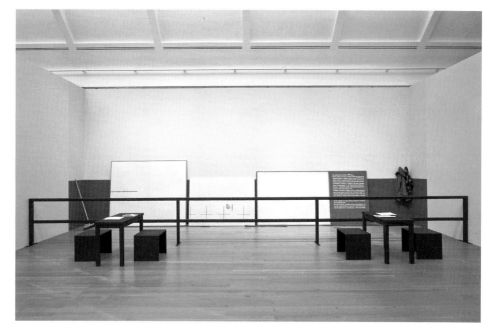

Figure 4.1

Ilya Kabakov, *The Metaphysical Man*, 1998. Installation. Three paintings, one balustrade, three wall fragments, two tables, and four benches. Kunstverein Bremen. A view from the exhibition Total Enlightenment: Conceptual Art in Moscow, 1960–1990. Schirn Kunsthalle, Frankfurt am Main, 2008. Paintings: *Berdyanskaya Spit*, 1970. Enamel on Masonite, 185 × 216 cm. *Man and the House*, 1969. Enamel on Masonite, 135 × 160 cm. *At the Great Artistic Counsel*, 1983. Enamel on Masonite, 135 × 160 cm.

available to broader audiences either in the Soviet Union or the West. The few Western collectors who were already interested in unofficial Russian art back then could not get an overview of the totality of the scene. The selection of works was usually random and determined primarily by the personal acquaintances and individual preferences of the collector in question. Moreover, the conditions for acquiring and exporting unofficial works of art often entailed quite a bit of risk. Nor did the situation improve much with the end of the Soviet Union. The Western curators and collectors who traveled to Russia in the 1990s were confronted with a large number of unfamiliar artworks signed with names that were just as unfamiliar. Once again, it was largely a matter of following chance and personal intuition. Numerous exhibitions resulted that attempted to offer a survey of Russian art current at the time. From an art historical perspective, however, they mixed up very different, often incompatible artistic positions.

Thus, in contrast to, say, surrealism, *arte povera*, or pop art, Moscow conceptualism was not initially presented to a wider audience as a specific art movement defined by

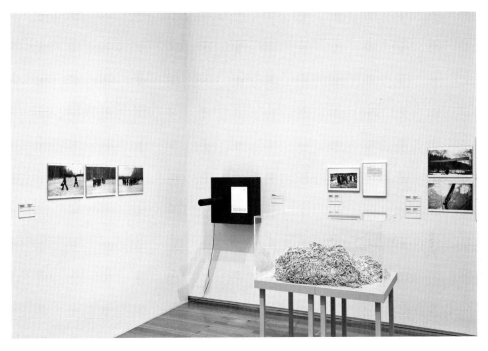

Figure 4.2
A view of the space dedicated to Collective Actions from the exhibition Total Enlightenment: Conceptual Art in Moscow, 1960–1990. Schirn Kunsthalle, Frankfurt am Main, 2008.

a shared aesthetic and a binding group ideology that later broke down into individual artistic positions. The West became acquainted with the art of Moscow conceptualism in the opposite way. Its introduction to it started in the 1990s, at a time when the original group dynamic was beginning to wane and the shared ideology was crumbling. Hence works by individual artists were absorbed without the historical context in which they had been produced being clearly addressed. It was not just in the East that the cold war necessitated a later period of catching up. In the West too, many cultural events that had taken place behind the Iron Curtain had been overlooked. We have set ourselves the task in our exhibition to remedy this deficit and to document both the history and ideology of Moscow conceptualism as completely as possible. Even the group's name deserves particular analysis. The attribute "Moscow" may seem unproblematic at first, as it was indeed a group of artists in Moscow. The term "conceptualism" poses greater problems, however. It obviously refers to the Western—more precisely, Anglo-American—conceptual art of the 1960s, which can give the impression that it was merely an attempt to relocate Western conceptual art to Moscow. The artistic praxis of the group Art & Language and that of Joseph Kosuth were indeed well known to the

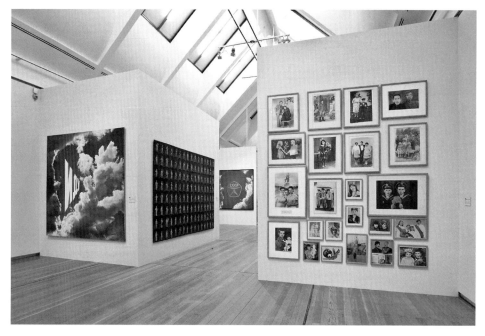

Figure 4.3
View of the main gallery of the exhibition Total Enlightenment: Conceptual Art in Moscow, 1960–
1990. Schirn Kunsthalle, Frankfurt am Main, 2008.

Moscow conceptualists, thanks to Western journals and catalogs that managed to reach
Moscow at the time. Yet this praxis underwent a fundamental transformation in Mos-
cow. The attribute "Moscow" is thus more a program than a mere place-name.

The nature of the transformation that conceptual art underwent in Russia resulted
from the specific circumstances under which art as a whole functioned in the Soviet
Union. Conceptual art can be characterized briefly as the result of putting image and
text on the same level. The image is replaced by a written commentary, by a descrip-
tion of a certain art project, by a critical statement. This use of language can be seen as
a dematerialization and hence decommercialization of art. In the capitalist West, the
artwork is above all a commodity. Art is primarily defined by the art market. Every com-
modity, however, is first and foremost a material object. Hence it was very tempting at
first to see the substitution of the artwork by the word as a path from the "material-
ist" art market to the freedom of the immaterial and hence the unsalable, the "unex-
changeable." Meanwhile, of course, it has become clear that text is also a kind of image,
because language has its own materiality, and that conceptual art cannot therefore lead
the artwork to immateriality or liberate it from commerce. In retrospect, conceptual

Figure 4.4
General view of the "Documentary Labyrinth" in the exhibition Total Enlightenment: Conceptual Art in Moscow, 1960–1990. Schirn Kunsthalle, Frankfurt am Main, 2008.

art can rather be seen as a crucial step toward objectifying and hence commercializing language. In any case, the relationship of art to the art market—and to the market in general—was and is a central theme for Western conceptualist theory and praxis.

In the Soviet Union, by contrast, there was no market and hence no art market. The value of a work of art was determined not by the rules of the market economy but by the rules of the symbolic economy that governed life in the Soviet Union in general. They were rules of social recognition and political relevance as laid down in certain texts—whether official statements or unofficial pamphlets—that determined the value of every single work of art. Thus the theoretical, philosophical, ideological, or art historical commentary on an artwork—and not its price—ultimately decided its fate. Or rather, the ideological texts circulated in the Soviet symbolic economy just as money circulated in the Western market economy. It could be said that Soviet culture had always been conceptual, and indeed in its entirety. When looking at a painting normal Soviet viewers quite automatically, without ever having heard of Art & Language, saw this painting inherently replaced by its possible ideological-political-philosophical commentary, and they took only this commentary into account when assessing the

painting in question—as Soviet, half-Soviet, non-Soviet, anti-Soviet, and so on. From this it followed that the explicit use of texts of art commentary, philosophy, ideology, science, or literature in the artwork as practiced by the Moscow conceptualists functioned primarily to reveal the procedure that defined all of Soviet culture—and not as an alterative to a Western-style market economy.

In a certain sense, however, Moscow conceptual art was quite closely related to Western conceptual art. Anglo-American conceptual art of the 1960s and 1970s was primarily concerned with the question "What is art?" For that reason, it is often seen as a point of departure for institutional critique. And in fact the market did not require discursively formulated definitions of art; the bureaucracy that governs the museums, exhibition halls, and other institutions of art needs them to justify and legitimize its decisions. It could thus be said that by moving away from the market and asking the question "What is art?" conceptual art ventured forward into the discursive realm that had previously be reserved for bureaucratically run institutions. This is particularly true of continental European conceptual art such as that of Marcel Broodthaers or Hans Haacke.[1] The institutional critique that had its origins in conceptual art was relatively uninterested in mass culture, and left it to pop art and the artists in that tradition to descend into the dregs of mass culture. In that sense, one could say that Western pop art and conceptual art divided up the realms into which Western culture is split. Pop art was concerned with commercial, "low" mass culture, which was considered low precisely because it is disseminated outside of the discursive, institutional legitimization of art—that is to say, outside the question "What is art?" Conceptual art, by contrast, was concerned with institutional, "high" art and made institutional criteria of assessment and recognition, of inclusion and exclusion, its themes.

It is well known, of course, that the Soviet Union was one great bureaucratically administered institution. There was no distinction between commercialized mass culture and institutionalized high culture. Soviet culture was uniform—and it was exclusively institutional in character. The administration of everyday mass culture was just as centralized, bureaucratic, and institutional as that of high culture—and was assessed, recognized, and disseminated by essentially the same ideologically correct criteria. For that reason, the official discourse on what art is had an all-determining role in all areas of Soviet culture. The main modus operandi of Moscow conceptualism was to exploit, vary, and analyze this official discourse privately, ironically, and profanely. In that sense, the Moscow conceptualists were practicing a kind of enlightenment—specifically, total enlightenment. As Hegel rightly noted in his *Phenomenology of Spirit*, enlightenment—that is to say, the free use of one's own reason—can only succeed in a society that has already acknowledged reason as its basis; divine reason, for example, as was the case in France before the rise of the Enlightenment.[2] The Catholic church had already acknowledged reason—understood to mean God's reason—to be omnipotent. And so it was an easy game for the Enlightenment to practice a kind of privatization of

reason and ironically comment on the church's monopoly as a consequence of a lack of reason, of prejudice. The Soviet system was also based on reason—namely, Marxism as the embodiment of historical reason—and specifically as a direct successor of the classical Enlightenment. It was thus an easy game for the opposition to try to depict the party's monopoly as the result of ideological blindness. Moreover, the Soviet state had always been a kind of artwork designed according to the taste of the party leadership and as the result of centralized planning of all aspects of Soviet life. In that sense, it was art that was best suited as a means of enlightenment. Hence the Moscow conceptualists could extend their analytical and critical method to the entire Soviet system; they could claim to reflect all of Soviet culture. The Moscow conceptualists understood their praxis to be enlightening Soviet culture about its own ideological mechanisms.

In the process the artists of the first generation of Moscow conceptualism of the 1960s and 1970s, such as Ilya Kabakov, Vitaly Komar and Alexander Melamid, Dmitri Prigov, and Lev Rubinstein, employed above all the language of the "simple Soviet citizen." The carefully chosen and repeatedly censored formulations of official Soviet ideology were inevitably damaged and misplaced in their daily, "uncultivated" use and in the process mixed with every conceivable purely private and half-baked opinion. Ilya Kabakov and Dmitri Prigov in particular drew frequently on this storehouse of everyday, uncultivated theorizing for their commentaries on their own art and that of others. Thus these commentaries became a place where the most diverse theoretical discourses and artistic practices suffered a linguistic catastrophe—and in a way that was highly entertaining to the informed viewer. It may be said that Moscow conceptualism took the discursive mass culture of its time as its subject: a discursive culture that may exist all over the world but was particularly omnipresent in the Soviet Union of the time. Moscow conceptualism was indeed a kind of conceptual art, but much more than that it was a kind of discursive pop art.

Moscow conceptualism strongly resembled conceptual movements in the West in another important respect: the systematic organization of a counterpublic or, as it were, a micropublic. The Moscow conceptualists made their art for a small public composed of the artists themselves and their friends. It could be claimed that this situation resulted of necessity, since the artists were subject to Soviet ideological censorship. That is certainly correct, and the artists certainly suffered under the isolation from the broader public. Yet they did not protest this censorship publicly, nor did they try to loosen it, as many other Soviet artists tried to do. This was not entirely due to their desire to avoid a direct confrontation with Soviet authorities. They did not try to fight existing art institutions but rather tried to create their own, independent art institution. In a sense, nearly all the avant-garde movements of the twentieth century were structured in that way. They all created a micropublic that programmatically separated from the larger public.

One can also observe numerous attempts in the art of the 1960s to create micro-publics. The Situationist International and the Art & Language group could serve as examples. In both cases, the goal of forming an artistic group was to create an independent space for social analysis, for an aesthetic metaposition, and for a communal praxis.

The entire unofficial Soviet art scene represented one such counterpublic. It was, however, above all the Moscow conceptualists who systematically built and maintained this counterpublic. They met regularly to discuss new works and texts. They had their own publications and circulated international ones; they established archives. Andrei Monastyrski and his group Collective Actions in particular contributed in the mid-1970s to setting in motion a kind of self-institutionalization of Moscow conceptualism. Monastyrski organized performances to which he invited other Moscow conceptualists, and they were meticulously, almost bureaucratically, documented, commented on, and archived. Monastyrski also involved many young artists in the group's activities and deeply impressed them with his ascetic attitude toward art and his systematic approach. These young artists, such as Pavel Pepperstein, Vadim Sakharov, and Yuri Albert, only began to work actively in the 1980s, but nevertheless they saw themselves as members of the Moscow conceptualist group. That is why Moscow conceptualism has two generations of artists—an unusual phenomenon in the history of art.

With the end of the Soviet Union in 1991, all of the Soviet State institutions were de facto dissolved or became irrelevant. In the post-Soviet era, the tradition of Moscow conceptualism obtained a special significance, since this group, which also included curators and art critics, formed the core of the new public for art that was emerging in Russia. It can, of course, be said that the panorama of Russian art has changed and diversified enormously in recent decades. Even if the influence of Moscow conceptualism on Russian art today is still strong, the conditions under which it emerged and evolved belong to the past. With the exception of Prigov, who died recently, all of the Moscow conceptualists whose works are presented in this show are alive and working successfully. Nevertheless, Moscow conceptualism may be regarded today as a historically concluded phenomenon—and that is why the present exhibition contains no current works but only those from the time when the Moscow conceptualists had a certain unity. In that respect, Moscow conceptualism still offers an example of how it is possible, even under conditions of a mass culture that dominates everything, for an artistic group to create its own institutions and establish them in the society.

5 Ilya Kabakov: The Artist as Storyteller

Ilya Kabakov belongs to that generation of Russian artists who discovered the panorama of Western art's achievements, from impressionism to more recent artistic movements, in the late 1950s and early 1960s. It must be pointed out that this was not the first generation of artists in Russian history for whom Western intellectual and artistic history was revealed simultaneously as a panorama—that is, as a new country full of miraculous and unusual possibilities. Discovery of the West occurred periodically in Russia, and each time, for one reason or another, the discovery came to naught. Thus a question arose which confronts and probably always will confront Russian innovators: Should they set out on the aesthetic conquest of this rediscovered country, or turn away from it and conduct their own affairs?

The peculiarity of the situation lies in the fact that this panorama exists only in the imagination of the beholder. Since the past and the future of the West are present in a historical "now" only for a Russian spectator as specific structures and tendencies of unrealized historical possibilities (which are opaque both for the observer and for the possessor), Russians always experienced a profound disillusionment upon contact with the real West, reinforcing their consciousness of Russia's special path. Indeed, Russians understood themselves as the only preservers of the country "The West," the only observers of an unrepeatable spectacle.

In the transition from contemplation to action, however, difficulties were quick to develop. The problem was that mutually exclusive Western ideas and artistic trends seemed equally convincing. And this is not surprising if we confine ourselves to art alone, and then contemplate simultaneously what happened on different stages of its development, which historically had followed one after the other. In their own time, each of them celebrated its own victories. Each constituted a virtually exhaustive whole, seizing almost all of reality in its grasp and following its own laws of vision. The question arises: Why does one stage then yield to another, equally self-sufficient and internally noncontradictory stage? This question itself, however, presupposes an outside point of view. The transition from style to style or from one era to another seems a matter of aesthetic choice only from the outside. From the "inside," no era, or style,

presents itself as a hermetically closed totality. They represent only an attempt to react to the historical necessity. But this necessity is not detectable from without. It is contained in the depths of that "now" which seems tedious and insipid to the observer blinded by the totality of the historic panorama.

The observer wonders: What should I prefer, if every style and every era contain within themselves the sources and rules of preference? Choose the most recent style? But even the most recent in time is no longer "now." Although it is the last, it is in the past nonetheless, and thus belongs to the panorama as whole. In this situation the observer can do nothing but become involved in whatever suits his fancy. He chooses from among his discoveries whatever is closest to him in spirit. Thus the basis of the choice becomes purely psychological. The logic of a historical movement is replaced by the inherent irrationality of psychological preference. Eras and styles become manifestations of a certain perception of the world, characteristic of individuals with various psychological makeups. In turn, these psychological inclinations and the differences between them become something more than simply personal attitudes. For this reason, among Russians a difference in "points of view" acquires the traits of an absolute abyss. It becomes a sort of metaphysical choice on the background of a metaphysical void, replacing the sequence and logic of historical development. These suprapsychological differences can be explained only positivistically or mystically—which amounts to the same thing. Possession by devils is just as convincing an explanation as relationship to the means of production.

Psychological assimilation of Western styles is the road that has most often been followed by Russians upon coming into contact with the West. The Slavophiles' reaction to Western culture falls into this category, for they employed de facto Western ideological and artistic methods in their construction of Russian culture—supposedly opposed to the Western one. The only approach to this matter that has proven definitely successful for Russian culture, however, is the one that turned its attention to the actual psychological position of contemplating the panorama. This approach gave birth to the inimitable Russian novel, from which little knowledge of human psychology can be obtained, but which adds much to the understanding of one's own position in the world. Ilya Kabakov has chosen this approach in his albums.

The very genre of the album suggests that the viewer is dealing with a story. What is the subject matter? We must answer in the following way: the event of the perception of art itself, against the background of non-art. This event occurs in various ways in different albums. Of all of them, two major cycles stand out: *Ten Characters* (ten albums) and *On the Grey Paper* (fifteen albums).

The first of these two series tells of ten people who are all dying at the end of each story. Each album presents the viewer with the history of one character's life and death. Each such history is the visual evolution of a certain artistic system. At the beginning

of the album a specific principle for the construction of images is set forth, and then, through development and modification, this principle destroys both itself and the image as such. The whiteness of the blank page sets in, symbolizing death.

The evolution of the visual image is accompanied by verbal commentary, which psychologizes the purely formal process of decomposition. Within one album the visual images may pass through many stages from realism to surrealism, to abstract forms and minimalism, culminating in monochrome whiteness. But it is also possible to follow the workings of internal tendencies in each artistic method, and their arrival at a point of self-negation. These processes take place, not in a purely logical way, nor in historic time, but within one human soul, in the real time of its existence. Historical and logical time are transformed into the lifetime of a mortal being who has identified the logic of his own development with the logic of impersonal powers, and is dying from this. What are these powers?

Each of the characters lives through his love for art and aspires to grasp and create art. But does any of them realize this goal? One is tempted to answer that art manifests itself most clearly in the character's death—in our last contemplation of the pure whiteness of the blank sheet. But this contemplation is filled with meaning for us only because we have traveled with the hero "all along the way." The character's ability to live in art as in something already historically given has made a work of art of his death as well. Our interpretation of the last white sheet of paper as embodying the ultimate value is conditioned only by sympathy for the character himself. A blank sheet of paper is the mute, absurd witness of the failure of yet another absurdly lived life. The line between art and non-art is drawn, but the meaning of the poles remains arbitrary, and, in this sense, ironic.

The commentary transforms the formal structure of the album into a story about a lonely and humble individual. In each of the ten characters we observe the "poor folk" and "lesser brothers" of Russian literature with their helpless, infantile fanaticism. However, the commentary in no way dominates the visual image. Rather, it is caught in the image's absurd logic.

Russian literature makes its way into Kabakov's works after having already undergone the absurdist experiments of the Oberiuty and the expressionism of the Revolution's early years. In this simultaneous movement of the image and the text it turns out that it is possible to solve problems that could not be solved by either of them individually. Many visual decisions are psychologically motivated which would otherwise have seemed to be surrealistic or conceptualist (i.e., in the use of words instead of an object's image). Being psychologically motivated, these artistic methods become de-aestheticized. A movement contrary to the historical movement of abstraction occurs, and that which should not have had a "content" acquires one. On the other hand, the text itself manifests its visual nature. The Oberiuty's absurdist word games were not always

Figures 5.1–5.4
Ilya Kabakov presents his album *Coincidences of Lev Lvovich* (1972) in his studio. Photo by Igor Makarevich, Moscow, 1979. Igor Makarevich Archive.

successful, since the text's reading time progresses in one direction and thus creates a certain order. But in Kabakov's albums they work. Included in the visual image, the word comes into simultaneous and spatial, not only temporal, relation with all the other elements of the visual whole.

Everything in Kabakov's albums serves as commentary on everything else. Even the characters' deaths are ambiguous. Through death, the character either arrives at a state of true contemplation, or he is deprived of all contemplation. The neutral style of mass Soviet artistic production is the common denominator in all these albums. Something must be said about the problem that arises here.

It is known that the Anglo-American experiment in pop art turned to the mass culture of its time. This was because of the certainty that advertising, comics, and other non-elite forms of art exercise a direct power of attraction on the viewer. However Western artists may have related to this directness—ironically or apologetically—they were, in any case, certain that it distinguished the fruits of mass culture from those of elite culture, which were devoid of any direct attractiveness. In the Soviet Union, however, mass culture was not formed by catering to the viewer's tastes, and therefore it did not express those tastes. It was, above all, understood as an educational culture. The whole of the culture was submitted to the identical ideological-educational demands. Art that was not directly understood by the wide masses was turned away. A style arose whose

foundation was not a certain artistic method, but an ideological purpose. Though it was directly accessible, it was not always directly attractive to the masses. This style tends not to allow any hierarchical or other demarcations within itself. It can express the most varied experience and is able to assimilate a huge variety of themes and forms of the visual arts. At the same time, this style, neutral in respect to artistic technique, expresses itself ultimately in the absence of any visuality—in the pure word alone, and even in a sort of silent common understanding that precedes any word.

Ilya Kabakov has made use both of the enormous efforts to unify previous artistic experiences made before him, as well as of the versatile, transparent style to which those efforts gave birth. However, this choice of a unified style lends yet another

meaning to his albums. The death of each character signifies their exit beyond the limits of this unified style into the nothingness that is its actual foundation. The narrative strategy of the ten albums serves as their common foundation, a result of the impossibility of finding a purely visual image that would quench the thirst for a vision, common to all the characters.

In the fifteen albums of the *On the Grey Paper* cycle, the narrative dimension is lost. Each of these albums describes a particular psychological state, and one of them is almost a metadescription of the principle by which the others are constructed, though it is also unified in its psychological mood.

One can well ask: Why, then, the album form? Wouldn't separate works intended for meditation have been sufficient? Once again the problem of time is central here. Time produces in the viewer's soul the very death which is that of all the characters of the first ten albums.

The size of the albums is calculated so that boredom accumulates in the viewer's soul during the time it takes to look at them. This boredom is called on to kill and disperse the spiritual state the viewer was in prior to looking at them. Boredom should not be understood only in a negative sense. Boredom is a person's meeting with himself, with the reality of his own existence in the world. No other emotional states can give us the experience of our own existence, for they all turn us outward; only boredom returns us to ourselves. Having undergone the ordeal of boredom, the viewer comes out of the sentimental mood he was in at the beginning of the album, and his attention is turned to himself, and to his spiritual state. Thus, the existential dimension as such, which the artist believes to be the substrata of any human relationship to the world and to art, manifests itself in these albums.

In addition to the two cycles mentioned above, there is also a series of isolated albums that are occasionally linked in small cycles. Among them are nostalgic albums devoted to simple everyday objects, presented in their pure geometrical forms which appear as the visible souls of these objects. There are albums in which the practice of contemplation is curiously mythologized.

In his albums, Kabakov forces the artist to share the lot of others—that is, ignorance. He outlines the limitations of the common language of Soviet culture through the very fact that his characters arrive at another vision as simple people, living everyday lives. The discovery of a new language does not point to the higher spheres of existence. But it does point to the limits of the existing language, and thereby checks its pretensions. It throws into question the issue of its origins and the laws of language itself. Kabakov's albums bring out the problem of choosing one's own language for those who historically have no such language, or for those who have only just discovered for themselves that they have none. In Kabakov's albums a cosmos of languages which cannot be unified co-exists in the time of individual human life. Thus the language begins again to develop itself in time, though not in a historical time.

The expanse of Kabakov's works confronted him with the question of their status as objects in relation to the mass of other objects. This new interest led the artist to the problems of "thingness" in the work of art—a central issue for many of the basic movements of the neo-avant-garde art.

A profane, detached position in relation to the sacred history of European art is by no means the lot of Russian artists alone. Within Western societies themselves, a larger audience finds itself often enough in a profane position relative to the artistic milieus of its own country. However, if earlier this audience recognized its ignorance, granting the cultural establishment the right to dictate its taste, now this situation in all areas of culture has come to an end. Different social groups are gravitating toward the creation of their own cultures. The diversity of styles and methods, equalized by market conditions, negates the internal logic of their historical development and juxtaposes them as objects of choice for a disoriented consumer.

The turn to popular culture is based on the illusion of its spontaneous attractiveness. But popular culture, which became an object of interest for "high art," itself arose as an outgrowth of European cultural traditions. The logic of art's historical development does not "cancel out" its previous phases to the advantage of the most recent. Artistic styles, which have already been realized and mastered, in a profane context reveal characteristics that were not and could not have been grasped by any artistic mastery. Therefore, styles that historically emerged not only testify to the historical past, but also preserve their place in the present as alternatives to the "elite" artistic trends that are their historical heirs.

The position of the Russian artist constitutes a natural corrective to the historical continuity of Western art, which transforms its earlier stages into an unrepeatable past all too quickly. The profane vision of the "continuous panorama of styles" also acquires historical actuality. And here, the work of the Russian artist is to the point, as always when one speaks of a loss of understanding and irreconcilable conflict.

In his art, Ilya Kabakov has combined the tradition of Russian psychological prose with the problematics of the postwar neo-avant-garde. And these are not the only threads running through Russian and world culture which he has chosen and tied together. Kabakov's ability to make each manifestation of art a commentary on another ties together phenomena that seem to be torn apart and to have no correlation. In order for this correlation to become manifest, all the artistic phenomena in his albums are deprived of their direct sensual attractiveness and simply retain their recognizable forms. In this way they are transformed into signs for themselves, and thus into signs symbolizing the life of those individuals who find them beautiful. The artist leads us into a kind of a dormitory situation in which people at the same time are deprived of a communality of interests and a communality of mutual recognition. Unable to share each others' cultural and artistic ideals, nevertheless they are able to share the feeling that all these ideals equally collapse upon confrontation with reality.

Art that shows how people may arrive at the same point by various paths captures what is, perhaps, the only possibility of understanding and empathy in our time. Indeed, as each individual retreats to his own world, understanding and empathy are transformed into rivalry and enmity. Our lives do not have a common ground, but they do demonstrate a certain parallelism. The images and texts do not constitute a unity, but can function as commentary on each other. The wisdom of this knowledge can be gleaned from the albums of Ilya Kabakov.

6 Ilya Kabakov: We Shall Be Like Flies

An author who was close to the circles of the Russian avant-garde recalls Mayakovsky's ironic reaction to the work of the then well-known artist Chekrygin: "So, he's drawn another angel. He should have drawn a fly. It's been a long time since someone drew a fly."[1]

In his work Ilya Kabakov constantly reverts to drawing flies. At first glance, therefore, it seems natural to ask what significance the depiction of flies has for the artist, or, to rephrase the question, what place the fly occupies in his artistic system. No doubt the simplest answer to this question would be that the fly by its very nature cannot occupy a definite position in any system. The fly constantly buzzes about, alights, and is instantly away again. Its movements through the air are always chaotic, the place it occupies on the surface of different objects is always random. Moreover, the fly lacks identity: We find it difficult to fix our gaze on it and can never be certain that the fly that circles, alights, and flies off again is the same one we saw a moment before. The foreignness of the fly to any fixed order of things is emphasized by Kabakov, particularly in his earlier graphic work: He sometimes places the thoroughly realistic representation of a fly on his minutely planned, bureaucratically ruled-up drawings—as if the fly had settled on them by chance for a moment before flying off again.

However, whereas the fly itself is so restless, it seems that the concept, at least, of the fly and its place in the language is firmly fixed. In his fly drawings Kabakov eliminates this illusion: The concept of the fly proves to be as volatile as the fly itself.

In our culture the fly usually figures as something that is a nuisance, unclean, and ugly—something one wants to squash, to get rid of. The struggle against flies and, for that matter, any insects in the name of hygiene is one of the most important factors in the entire history of human culture. For Kabakov, flies are also linked to the garbage dump, to dirt and refuse. In this respect flies remind Kabakov of his homeland, Russia, which, as we all know, is far removed from the ideal of a well-ordered lifestyle. In one of his texts Kabakov describes Russia as an eternal "building site and garbage dump."[2] Indeed, seen in the historical perspective Russia always appears to be under construction, always rebuilding itself, mercilessly smashing the old and erecting the crystal

Figure 6.1
Ilya Kabakov, "The Fly and the Ball," 1982. Colored pencil, watercolor, tusche on paper. Archive Ilya and Emilia Kabakov.

palace of a new society (whether a Christian empire, Communism, or democracy). But at any given moment this eternal building site seems no more than a filthy garbage dump, covered in rubble.

However, rubbish, which is another constant theme in Kabakov's work, certainly does not always have negative connotations for the artist. In a certain sense he sees the entire world as rubbish and every object as fragile, liable to be thrown away and swallowed up aimlessly by time. Kabakov therefore collects rubbish in his installations, catalogs it and attaches to it sentimental recollections of the past. Rubbish, which is mercilessly thrown away in complete disregard of its value as a recollection of life lived, is a metaphor for human existence: The individual, too, is cast out of collective memory after his death as something no longer necessary for life.

For Kabakov the fly also functions as a metaphor for human existence: Not for nothing do we sometimes say of someone that he was "killed like a fly." Elegiac comparisons of the span of human life and that of an insect are among the most constant speech figures in our poetic and rhetorical vocabularies. We may recall Kafka at this point, in one

Figure 6.2
Ilya Kabakov, *The Man Who Never Threw Anything Away/The Garbage Man*, 1988. Collection Museet for Samtidskunt, Oslo, Norway. Photo Morten Thorkildsen. Archive Ilya and Emilia Kabakov.

of whose stories a man metamorphosizes into a beetle. In light of this interpretation the fly, instead of natural revulsion, begins to evoke sympathy and a willingness to identify emotionally with its fate. Simultaneously, Russia, land of rubbish and flies, comes to appear a place of truly human existence, unlike those countries where the urge toward cleanliness sweeps away all unsuccessful projects and redundant memories. In Kabakov's work this anthropomorphic perception of the fly is further emphasized by the fact that he sometimes endows it with sex. For example, in one of his early works the symbol "fly" is given the interpretation "wife."[3] In other works by Kabakov the fly is juxtaposed with a ball, which also has the property of chaotic movement in space but most probably embodies the male principle.

However, for Kabakov the fly's ascent up the hierarchical ladder does not stop at the level of human existence. Of course, the fly does not figure only in Kabakov's work as a medium of higher forces. It is enough to recall Sartre's fly-furies or William Golding's demonic *Lord of the Flies*. But in the installation *My Homeland* the hierarchies of flies hovering over the land are far more reminiscent of the ranks of angels than of demonic forces (figs. 6.3–6.4). For Kabakov, flying or hovering above the Earth is always the highest conceivable form of bliss. He often returns to this theme, in particular in his most "affirmative" album *The Flying Ones*. The fly thus becomes a symbol of the soul, hovering freely and liberated from the bonds of earthly existence.

None of these interpretations cancels out the others. Flies move constantly from place to place and alight on the most varied objects without distinguishing between their values: From a filthy garbage dump the fly moves to the dinner table and then, perhaps, on to some eminently sacred object. In Kabakov's work the concept of the fly likewise shifts constantly from one level of the hierarchy of values to another, never lingering for long on any of them. Kabakov explicitly demonstrates this movement, in particular in his early installation *A Fly with Wings*. In this the depiction of the fly is correlated with a potentially infinite number of possible interpretations, from the most commonplace and profane to the most elevated and serious. The installation is organized visually in such a way as to "reproduce" schematically the body of a fly, in which a mass of interpretative texts forms the wings.

At the same time this flight from level to level certainly does not mean that Kabakov wants to destroy hierarchies of value. In recent decades all art has, in one way or another, placed these hierarchies in question, with the result that the impression could be formed—and really has been formed, in many minds—that all values have now been finally devaluated and an age of universal equality of all values has dawned, accepted euphorically by some as liberation and by others dejectedly as the loss of historical perspective. But this new "postmodern" equality is, of course, as illusory and utopian as all other previously advanced egalitarian projects. Values are contagious as well and are carried from object to object, just as their devaluation is. And so the fly, moving from one level of hierarchies of value to another, not only carries with it the

Figure 6.3
Ilya Kabakov, *My Homeland (Life of Flies)*, 1991. View of the installation. Kunstverein Koeln, Germany. Photo Boris Becker. Archive of Ilya and Emilia Kabakov.

Figure 6.4
Ilya Kabakov, *My Homeland (Life of Flies)*, 1991. View of the installation. Kunstverein Koeln, Germany. Photo Boris Becker. Archive of Ilya and Emilia Kabakov.

contagion of nihilism from the lower levels to the higher, but also transports the higher values to the lower levels.

The fly functions here as a metaphor for a metaphor—as the bearer of a metaphoric infection. But any metaphor operates in two directions. If an angel is no more than a fly, then, conversely, a fly is an angel. Therefore, when the artist, following Mayakovsky's advice, ceases to draw an angel and begins to draw a fly, the result is an angel anyway. Consequently, the collapse in the hierarchy of values for which Mayakovsky hoped does not, in fact, take place.

Our culture contains a certain stock of words that lack a clear, firmly defined meaning. These words are, in a way, linguistic jokers that, without meaning anything in particular, are thereby able to mean practically anything. They include, for example, "being," "life," and "thought." These words mean simultaneously everything and nothing—and are equally applicable to anything at all. For this reason they have traditionally enjoyed great prestige in culture. Kabakov transforms the word "fly" into another of these joker-words that is potentially applicable to anything whatsoever—just as the fly may alight on anything whatsoever. Kabakov achieves this by consciously

erasing the concept of a "fly," emasculating it, stripping it of a definite content and thus transforming it into an empty word, a parasite word.

The word "fly" does not, of course, have behind it the lofty tradition that such words as "being," "life," or "thought" do. Yet it is capable of functioning in the same way. In stating this we can see an ironic light cast on high philosophical concepts that, in essence, are indistinguishable from a fly. At the same time, however, in the ability of an ephemeral word bereft of a noble philosophical tradition to achieve the lofty status of the words that possess this tradition, we may see a historic opportunity that is also open to the fly—the opportunity to construct a "fly-paradise" of its own, its own world of platonic, fly-essences.

These two readings—devaluating and endowing with value—are intended equally by Kabakov. An unambiguous choice between them is impossible if only because they presuppose one another and constantly turn into one another. The tension between them is what, essentially, constitutes the drama of Kabakov's fly series as, indeed, it does of the majority of Kabakov's other works. For this reason Kabakov is unfailingly vigilant in ensuring that neither of these readings gains a perceptible advantage over the other. In each individual work, and in the fly series as a whole, the fly functions as an instrument for the ironic cutting-down and translation of all elevated values into rubbish and, at the same time, as an angel that descends from heaven into our sinful world. It is impossible to make a firm choice between these two readings—all that we can do is pass constantly from one reading to the other, like a fly.

7 Ilya Kabakov: The Theater of Authorship

In speaking about Ilya Kabakov's art, one should first of all ask whether there is actually an artist called Ilya Kabakov. For Ilya Kabakov's installations almost always relate to the history of other artists—showing their works, telling their biographies, commenting on their artistic methods, their aspirations and their disappointments. Admittedly, one might argue that all of these artists are fictitious: It was Kabakov who invented their identities, who painted or drew their works and who penned their texts. This observation is undoubtedly correct. On the other hand, it would also be true to say that the aesthetic positions represented by these imaginary artists are themselves unquestionably real—such attitudes and artistic strategies can be found both in art history and in the world of contemporary art. The heroes of Kabakov's installations thus possess their own reality because they embody recognized and existent artistic positions. Nonetheless, this is not just a further example of the now familiar practice of appropriation, a strategy that consists of quoting works by other well-known artists. Instead, Kabakov has adopted a practice that could be described as a mode of self-expropriation, whereby he attributes his own works to other, fictitious artists. So, rather than openly and directly confess to his own artistic production, Kabakov prefers to keep the viewer in the dark about the authorial status of his art.

Furthermore, Kabakov also denies, or rather suspends, his authorship even when he does not explicitly attribute his works to such fictitious artists. Thus on the whole, even his "authorial" works are presented as the documentation of someone else's life and someone else's aesthetics, and not as his own creations with the purpose of providing insight into the personal, individual, "inner" world of the artist. Accordingly, many of Kabakov's installations present visual evidence of Soviet life and artifacts of everyday Soviet aesthetics in such a manner that the viewer is led to believe he is looking at a piece of documentation and not a work of art. This impression is underlined when Kabakov persistently describes and elucidates his "Soviet" installations as pseudo-ethnographic displays. But even when Kabakov opts to work, for instance, not with Soviet or Russian, but instead with Italian or Japanese visual material, he does so in a way that makes his works seem anonymous: It is a form of mimicry, allowing

the author to disappear behind a myriad of doppelgängers of his own invention and their assumed artistic attitudes. Kabakov constantly withdraws from the privilege, but also the stigma, of personal authorship. Instead he creates his works in the name of an other—another artist (however fictitious), another aesthetic concept, another culture (his culture of origin or alien culture)—yet without entirely obscuring his own identity as the "true" author of these works. It is precisely this constant, albeit ambivalent, act of distancing himself from his own oeuvre, coupled with the multiple undermining of his own claim to authorship, that has made the problem of authorship the central focus of Kabakov's art. Inevitably, the question is why he needs to resort to such a complicated game of anonymity and pseudonymity that is familiar perhaps in the world of literature, but extremely unusual in the realm of art.

Our entire art system is based on the notion of individual authorship. The rules determining the modern art system require an artist to explicitly admit to being the author of his own work—the success of anonymity and pseudonymity as overall strategies would lead to the certain demise of the art market and the art system in general. Of course, over the last few decades we have been informed often enough about the death of the author. Roland Barthes, Michel Foucault, and numerous other great authors announced his death some time ago. Yet they were evidently referring to the "author-as-creator" or the "author-as-producer," intent on forging his own new forms, signs, and meanings. But the artist's signature no longer means today that the artist himself actually produced a certain artwork; it means rather that he is using a certain object within an artistic context and thereby assumes individual responsibility for it. And this strategy is not restricted to adopting particular things from the repertoire of contemporary mass culture—as Marcel Duchamp already practiced it. In addition to drawing on objects from the surrounding world, artists are increasingly assuming different social roles. In the past artists have frequently appeared in the guise of the preacher, prophet, teacher, revolutionary, seducer, decorator, or entertainer, but now they can also be witnessed in the role of social or institutional critic, ethnologist, sociologist, curator, art critic, and terrorist. Yet insofar as these roles are all assumed within the context of art, the artist remains an artist.

Of course, in the framework of today's Western pop culture a great deal is produced in the name of the other. Hence we can refer to Disney films, Mercedes cars, Prada or Versace design, or pop groups like the Beatles or the Rolling Stones. Individual authorship vanishes here behind a mask of imaginary authorship, whether it is of a theological, ideological, or commercial nature. Even works by well-known individual artists begin to seem like anonymous commercial brands once they have moved into the realm of mass culture. Picasso, Dalí, or Warhol, for instance, are brands that can hardly be distinguished from Prada or Comme des Garçons. But there is a well-known and clearly defined set of rules telling us how to deal with this anonymous mass culture within the art system. To gain admission into the art system, the products of mass culture

require secondary authorization: An artist or curator operating within the art system must first "countersign" these anonymous, or more precisely, pseudonymous works of pop culture—as, for example, Andy Warhol did in the 1960s. In our present-day culture authorship is a performative rather than a descriptive concept. Within the context of institutionalized art an artist can declare himself to be the author, namely by means of a performative act. Of course, there is no saying that an artist will succeed in doing so—should he fail, however, it is not because his work has been proven to be "actually" neither original nor authentic. Instead, an artist can fail within the art system in the same way as someone can fail when they proclaim a state or found a company. In short, our current, modern notion of authorship is established primarily in the institutional context of art.

For several decades, however, Kabakov worked as an artist in the Soviet Union—from the late 1950s until the late 1980s—so about thirty years—where no modern institutional framework for art existed. In the Soviet Union official art was created not in the name of an individual author, but in the name of the other, the Party, which was considered to be the actual author of all Soviet reality, including Soviet art—similar to how formerly Christian icons had also been made in the name of the other, that is to say in the name of God. At the same time, unofficial Russian art of the time professed a very emphatic, exalted notion of individual authorship. The artist had to establish himself or herself as an independent autonomous genius or prophet—beyond every institutional framework—to be recognized as a true artist. Both worlds, the official and the unofficial, were caught in a state of mutual nonrecognition. Those from the unofficial camp claimed that official art was not art at all, but merely cheap ideological propaganda. For its part, the official camp declared unofficial art to be non-art, merely an amateurish, hobbylike pastime. Meanwhile, both sides also had to face the fact that the institutionalized art system in the West might reject either form of art as non-art.

It now becomes clear why Kabakov is constantly playing with different and contrasting notions of authorship in his artistic practice. For Kabakov found himself in the position to directly experience just how divided, controversial, and ideologically charged the concept of authorship can be. During his time in the Soviet Union he simultaneously worked as a highly successful illustrator of children's books within the official system of Soviet culture and as an independent, unofficial artist outside the system. This caused a deep rift in his sense of identity as an artist, as an author, because it was defined by two quite distinct and even contrary notions of authorship. Where there is no institutionally sanctioned definition of authorship, it automatically becomes the battleground for a complicated game of insinuation, allegation, suspicion, denunciation, and accusation. Kabakov's installations represent a stage on which this *jeu d'auteur* is performed. This is a theater in which the fictive artist-heroes, whose works are shown in the installations, are both winners and losers at the same time. In most cases they are artists who have no idea whether they are even artists at all; or they believe they are

artists, but for entirely different reasons from those for which we as viewers would be prepared to accept them as such; or they are not attempting to make art, but in our eyes are nonetheless actually doing so—and so on, and so forth.

Yet in all of this Kabakov himself only partially adopts the role of a theatrical director astutely choreographing this drama of authorship. This is because he also exposes himself to the possible reproof—actually voiced by certain critics—that he is simply staging exotic aspects of the Soviet way of life without being the "real" author of his own work, in the emphatic sense of the term. For other observers, however, Kabakov's installations are no more than the authorial product of his own, solitary imagination and merely create the illusion of documenting collective experience. Thus the authorial status of Kabakov's works remains fundamentally undefined. But it is precisely this that allows him to reformulate the issue of authorship from a new angle—beyond the well-trodden terrain of legitimation and deconstruction. Through his work the viewer is confronted with a confused, beleaguered, and uncertain state of affairs in which he is compelled to make up his own mind about the attribution of authorship—and precisely on the basis of his own ideological perspective.

In this sense Kabakov's total installations have an obvious political dimension. Kabakov made them mostly having been a de facto émigré in the West—immediately after the end of the cold war. At that time there was no common history that would unite the capitalist West and the post-Communist East. Even now I would say that there is still no such common history—East and West remain historiographically, culturally divided. That means: Kabakov built his so-called total installations on culturally and politically foreign territory. That was and still is, of course, not an exceptional case in our time of globalization. The discourse of the other, the problem of how to represent the different non-Western cultural identities inside Western art institutions defined in many ways the international cultural discussions of recent decades. The problem of Kabakov's art, however, was not how to represent his cultural identity, but how to represent his cultural nonidentity. The Soviet unofficial art circles—and Kabakov was a part of them—also felt in the Soviet Union not quite at home. They lived in a kind of inner emigration: They operated in a territory that was controlled by a historical and ideological narrative that was familiar to them but which they didn't share. So the emigration to the West was for the unofficial Soviet artists and intellectuals a double emigration. What they took with them as they moved to the West was not their cultural identity but their cultural nonidentity—a radical inner division within their own artistic and intellectual practice that was Soviet and non-Soviet at the same time. And it should not be forgotten: Kabakov worked in a time in which to be non-Soviet could be easily interpreted as being anti-Soviet. The problem of the representation of one's own cultural identity is, as we know, already a difficult one. But the problem of how to represent one's own nonidentity is, of course, one of double difficulty. However, Kabakov has already in the Soviet Union found a way to translate this division of the self, this

nonidentity into a different set of terms—namely, to formulate it as a division between artist and curator, or between author and editor. That is the true source of pseudonymity that characterizes Kabakov's work as a whole. Kabakov acts as an artist and a curator at the same time—but by doing so he does not erase the difference between artist and curator; quite on the contrary, he makes this difference, this split, this division within contemporary art practice the central topic of his own art and of his theoretical reflection on art in general.

It was in the early 1970s that Kabakov first realized that the central artistic issue for him was one of authorship, with his series of albums under the common title *Ten Characters* that he developed between 1971 and 1976. Each of these albums is a book of loose sheets depicting in images and words the fictitious biography of an artist living on the margins of society, whose work was neither understood, recognized, nor entirely preserved. The images in the albums are to be interpreted as the visions or works of their particular artist-heroes. All the images bear inscriptions commenting on them from the perspective of the various friends and relatives of each artist. The final image in every album is a sheet of white paper announcing the death of the hero. And each album concludes with several general résumés of the artist's oeuvre, voiced by further fictitious commentators who, one presumes, reproduce the views of the art critics entrusted with the final evaluation of the artist's legacy. The visions and obsessions driving the heroes of these albums are of an altogether private nature. Their pictures capture these private visions without laying claim to being "art" in the modern sense. Besides, the artistic execution of these pictures refers back to the conventional aesthetics that mark the typical illustrations found in Soviet children's books; following almost seamlessly in the tradition of nineteenth-century illustrated books, this was a style that Kabakov, as noted above, mastered quite well. These somewhat nostalgic, outdated aesthetics further emphasize that this is the work of lay artists who are simply striving to find expression for their modest, personal dreams in tranquil privacy beyond the influence of modern art movements. Moreover, the comments made by outsiders and added to these pictures offer evidence of the various misunderstandings to which any form of art is necessarily exposed—particularly in the eyes of contemporaries.

Yet at the same time, in the eyes of any well-informed viewer the works by these lay artists betray numerous parallels to the glorious history of the twentieth-century avant-garde. The references range from early surrealism to abstract art, pop art, and conceptual art. It is almost as though Kabakov's heroes have accidentally stumbled upon modernist art—beyond the reach of its normative history. Their pictures are modern against their will; they are modern for their very ignorance of modernism. Thus authorship as defined by modern art can in fact be attributed to these lay artists— even if they themselves never consciously aspired to this status. With this, the history of modern art also loses its binding, normative character. Its glorious heroes are suddenly transformed before our eyes into remote, awkward dreamers who, beyond any

universally valid logic of artistic evolution, were in fact only pursuing their strange, private obsessions.

These lonely provincial artist-heroes can, of course, to some degree be seen as pseudonyms or alter egos of Kabakov himself. Nonetheless, the distanced and ironic treatment of these fictitious authors in Kabakov's albums should by no means be taken as just simulated. Kabakov only partially identifies with the protagonists of his narratives, and his adoption of certain artistic poses often has only an ironic motive. In effect, he is constantly orchestrating a game that oscillates between identification and nonidentification with his heroes—the game of attributing authorship. For Kabakov believes neither in the notion of an objective description of the art context, nor in the binding character of art as an institution. Nowadays there is a widely held view that it is up to the social sciences to provide an objective definition of the art context.[1] And where art itself attempts to mirror the social, commercial, semiotic, media-based, and, ultimately, political contexts of its own modus operandi, this is achieved by appropriating various theories borrowed from the social sciences and cultural studies that claim to offer an adequate, or at least an "up-to-date," interpretation of these contexts. Any art seeking to reflect its own context tries on the whole to take a realistic and positivist approach—and expects to find the answer to what constitutes reality in the critical, positivist discourse of the human sciences. The fundamental error of such a positivist-sociological description of the art context is its oversight that art is predominantly made in anticipation of another different viewer, a different audience reaction, and a different social context than those that are currently available for such a description. Art thrives on the promise of a longevity that will enable it to transcend the limits of the context in which it has been produced. A work of art is made with the expectation that it will outlast the context of its making and be appreciated in other times and other places, which cannot yet be predicted, let alone described. Even commercial art relies on the hope that it will make a worldwide and lasting impact—thereby reaping a suitable profit. This is the very reason that the context by which art in reality defines itself is in fact utopian and phantasmagorical, hence beyond description in positivist terms. This other, future context, not evident in the here and now but merely betokened, is impervious to strategic insight and can only be apprehended with hope or anxiety. Correspondingly, an artist today is incapable of knowing whether he will later be acknowledged as the author of his works. All he can do is hope that he will be attributed (or not) with a work's authorship—or harbor fears about it.

Starting with *Ten Characters*, Kabakov has repeatedly focused on this mixture of hope and fear that fills any artist as he waits for the as yet unknown viewer, the impending context, and the unfamiliar future impact of his work. Such an expectant attitude nurtures hopes that a different, future viewer might possibly understand his oeuvre better than his intransigent contemporaries do, and maybe even accord him as an artist the due respect, love, and esteem that is so withheld at all times from all authors in their

immediate surroundings. At the same time the artist is filled with anxiety at the prospect of some new and unknown future viewer who might, on the contrary, completely ignore his work and regard it as utter rubbish, with at best a certain sentimental value for the author and his immediate entourage—but not for anyone else. Caught in such a tense state of apprehension, waiting for judgment to be pronounced by the unknown other within a totally unpredictable context, each sign can be interpreted in either direction. Every sign could mark approaching triumph—but equally impending ruin. The hope that propels modern art stems from its "van Gogh complex": current success might presage future failure, while present failure could promise future triumph. Nor can we be sure whether those who follow us will actually view our failures or successes in the same way as we do. Conceivably, our current failures may not be radical enough to be later reinterpreted as triumphs. Similarly, our victories may not be sufficiently glorious for us to be pardoned for them at some later date. Everything an artist feels happy about in his work, including all his brilliant mistakes, could be reason enough in someone else's eyes to dismiss his artistic efforts. Conversely too, there might be something an artist is unaware of or judges as a sign of failure that later ends up being the very feature that causes another person to hold his work in especially high regard.

The sheer impossibility of predicting the next person's opinion was of course particularly evident in the Soviet Union at that time. By the Brezhnev era the failure of the Communist promise could no longer be denied; so many people had pinned their hopes to this promise, for which so much had been sacrificed and whose future victory so many had thought so certain. In the light of this failure people ceased to believe in any further promises of historic success. Nonetheless, the last remaining hope for an unofficial artist in Russia, having been deprived of an audience and recognition in his own cultural context, was the prospect of a benevolent reception in the future—or beyond the borders of the Soviet Union, in the West. Yet from a Soviet perspective the West at that time appeared no less apocalyptic than the most distant future. Kabakov offers a highly charged description of this situation in one of his later texts:

For almost thirty years the life of an unofficial artist was spent inside a locked and sealed world. All this time unofficial artists and authors were barred by strict political, ideological and aesthetic censorship from exhibiting or publishing their work. . . . Caught in this virtually "cosmic" isolation, artists in these circles had to be entirely self-reliant and depend on one another to perform the roles that others should have played: viewers, critics, experts, historians and even collectors. It was inevitable that such a situation would lead to a deformation of the criteria defining the quality of a work. What did these pictures or concepts signify to the disinterested world outside, what did they signify not just to us, their inventors, but also to other people? This agonizing question hung like the sword of Damocles over all those who for years had worked in the absence of objective criticism, or—perhaps worse—encountered nothing but the well-meaning approval of friends and family.[2]

Kabakov's first major installation in the West was called *Ten Characters* (shown in 1988 in the Ronald Feldman gallery, New York) (fig. 7.1). When it came to deciding how he should best exhibit his work in the West, Kabakov was of course being entirely consistent in instantly falling back on the old idea of fictitious authorship that he had developed at the beginning of the 1970s in his albums of the same title. The works in his New York installation, which had been mainly created in Russia, were distributed among ten different fictitious authors—whereby each figure was given an imaginary biography, presenting each in turn as a lonely, withdrawn individual who practiced his art in the seclusion of a small room. This demonstrates that Kabakov's installations are rooted neither in performance art nor postminimalist site-specific art, unlike most of his Western colleagues, but rather in narrative literature—or more precisely, the novel. Every installation by Kabakov tells a story—almost always the same story about an isolated soul living in an uncomfortable, menacing environment. But no less interesting than the similarities shared by his earlier works and his installations are the things that set them apart. One purely formal and immediately conspicuous distinction is the spatial arrangement that was entirely lacking in the earlier version of this work. But equally characteristic is that, far from being brightly illuminated, as were the white pages of the original albums, the space containing the installation *Ten Characters* is quite dark and shadowy. This somberness, coupled with the arrangement of the various pictures and objects around the space, is a deliberate disruption of the viewer's gaze, making it hard for him to see clearly. These almost baroque installations offer a programmatic contrast to the "white cubes" of minimalist and most conceptualist installations; they play a game of light and shadow with the viewer's gaze, drawing attention to the difficult issues raised by prying into other people's private lives and perusing the intimate dirt of their existence—but it also emphasizes the pleasure of such voyeuristic incursions into the darkness of hidden intimacy. Art here is seen as the disclosure of private rubbish, which in fact ought to be protected from the dazzling light of the public gaze. Yet it is precisely this disclosure of intimacy that renders the whole thing interesting. It is no accident that the entire installation space of *Ten Characters* was made to look like a typical Soviet communal apartment where the former residents had left behind some nondescript rubbish that should really have been cleared away.

The communal apartment was also the theme of several earlier albums by Kabakov. As can be seen in the installation *Ten Characters*, the communal apartment is inhabited by artists only. While the person living in each of the rooms is cocooned within his own private dreams, they all live together in one apartment. This is a case of communication without communication, of a close-knit daily life led in total inner isolation. The communal apartment is of course representative of the general quality of life under the conditions of Soviet Communism, a life marked by the fear of self-exposure and consequently of self-betrayal. At the same time people were also living at extremely close quarters, both physically and spatially. This mixture of inner isolation and outward

Figure 7.1

Ilya Kabakov, *Ten Characters*, 1988. Installation, Hirshhorn Museum and Sculpture Garden, Washington, D.C. Photograph by D. James Dee/Ilya and Emilia Kabakov Archive.

intimacy must undoubtedly have imposed an immense emotional strain. However, as so often in such cases, Kabakov endeavors to discern in this unbearable existential concoction a *condition humaine universelle*—and even a utopia. The installations he has created in the West are almost always evocations of the collapsed world of Soviet Communism that bring to life all of its ugly, intolerable, boring, and depressing features. Yet far from acting as a critique or a downright accusation, they attempt to formulate the experience of Russian Communism as the discovery of a dimension of human existence that would otherwise remain obscured—one that not only holds negative promise, but also suggests a certain hope.

In his well-known publication *La communauté désoeuvrée*,[3] Jean-Luc Nancy offers a definition of communality as opposed to society or community, an undertaking that comes astonishingly close to Kabakov's interpretation of the communal apartment. For reasons of space, Nancy's theoretical construct can only be paraphrased here in an abridged and fairly simplified form. Nancy shares the commonly held view of society as the communication between autonomous individuals who all possess certain human rights—in particular, the right to anonymity and, to a certain degree, to

Figure 7.2
Ilya Kabakov, *The Man Who Flew into Space from His Apartment*, 1985. Installation, Collection
Musée National d'Art Moderne-Centre Georges Pompidou, Paris. Photograph by D. James Dee/
Ilya and Emilia Kabakov Archive.

Figure 7.3
Ilya Kabakov, *The Man Who Flew into His Picture*, 1988. Installation, Collection MOMA/Museum of Modern Art, New York. Photograph by D. James Dee/Ilya and Emilia Kabakov Archive.

protection from the public eye. This society of individuals is frequently contrasted with the ancient ideal of community—as embodied by a family, an ecstatic religious circle, or perhaps a national community or class brotherhood, but in any case as represented by a union of love, by the fusion of a unifying, inner symbiosis. Both the individual within a community and the autonomous subject within a society control the images they present of themselves. It is the subject's control over his own image, over the outward aesthetic representation of himself that is common to both society and community. By contrast, as far as the communal dimension is concerned, we generate images of ourselves that we are no longer able to control. In a communal context the others always retain a certain surfeit of gaze over us. For Nancy, communality above all means this other, uncontrollable side of communication. Accordingly, he defines the communal as *être exposé*, as the individual being inescapably "exhibited." In other words, I am already exposed or exhibited on a communal level long before I can even begin to generate images. Perhaps all human efforts to produce images can therefore be seen as an attempt to retrospectively correct those images of the subject that the

others have already possessed—and if these images cannot be corrected, then at least to play with them.

For Ilya Kabakov the Soviet communal apartment is a paradigm of the place where the individual is exhibited, exposed, and disclosed to the gaze of others. This goes beyond the notion of privacy as a counterpoint to the social sphere, or at least separate from it—as a realm of personal feeling distinct from the coldness of social life. Instead, the communal apartment is a place where the social dimension manifests itself in its most horrifying, most invasive, and most radical form, where the individual is laid bare to the gaze of others. Furthermore, this gaze belongs to largely hostile strangers who consistently exploit their advantages of observation in order to gain advantage in the power struggle within the communal apartment. In the extreme intimacy of the shared apartment the entire visual realm becomes a battlefield in the struggle to dominate the gaze. Being able to observe the others is just as important as concealing and shielding oneself from the scrutiny of the others. And the fact that Soviet Communism has now been displaced has no effect on the communal dimension. The others always have a surplus of gaze and power over us, a supremacy we wish to protect ourselves from—but one that we can also enjoy. Since the death of God as a confidential and omniscient observer, the communal sphere is the only remaining observer interested in the intimate aspects of our lives. After the collapse of Communism it became clear that many people missed the pleasure and excitement derived from being watched, from being the object of someone else's constant attention—even when this interest is hostile.

Thus the communal dimension turns everyone into an artist—as well as a work of art. In a communal apartment each of the inhabitants is imputed to be the author of the image of himself he presents to the others; and, as the author, each person can be relentlessly called to account for any flaws in his "self-image." Hence, in a dystopic manner, the Soviet communal apartment manages to achieve the utopian vision of Joseph Beuys: Everyone must become an artist! So it is no accident that all the residents in Kabakov's communal apartment are artists—and by the same token, his communal apartment also acts as a metaphor for the "art community," the communal life shared by artists in our society. Indeed, what else is a museum or a major exhibition if not a communal apartment in which various artists, who may never have heard of one another before and who each aspire to very different goals and interests in their art, are herded together at the will of a curator appointed by society? In this manner, artists are forever encountering each other within the imposed intimacy of a shared context—together with often unknown, even hostile, neighbors.

The question here, however, is not if or how this context can be socially, politically, or institutionally described, controlled, and reflected, but rather concerns a residue of uncontrollable communal exposure that none of these descriptive modes is capable of resolving. It is this residue that prevents a museum from being a place of tranquil contemplation and instead transforms it into a theater of war about the gaze, a struggle in

which all manner of self-exposure and self-concealment strategies are deployed. Many of Kabakov's installations thematize and stage this struggle, whereby the pseudonymity of the artist is but one method of self-display—and simultaneously of self-camouflage. The others are the perceptive impediments that Kabakov constantly introduces and thematizes—especially the fatigue that unavoidably overcomes the viewer of many of Kabakov's installations when faced with the profusion of drawings and, notably, texts. Written mainly in Russian, the volume of text renders attentive reading quite impossible in view of the time constraints imposed by a normal museum visit. With all this, Kabakov attempts at least to call into question, if not destroy, the illusion of a homogeneous, evenly lit, and pleasant museum atmosphere, in which everything is presented to the gaze of the viewer in peaceful and "optimum" conditions.

Actually, I would like to argue that the already mentioned concept of the "total installation" was proposed by Kabakov primarily not with a goal to characterize the specificity of his own installation practice. Rather, Kabakov used his concept of the total installation as a theoretical tool to change our perception of every possible artistic installation—in fact, even of every possible art exhibition. Namely, we can look at every art exhibition as a total installation if we change our perception of the exhibition space. As a rule we tend to see an art exhibition as an accumulation of the individual objects in space. Then, we are moving from one exhibited artwork to another, experiencing an exhibition space as being our own symbolic property. Or, rather, the exhibition space between the exhibited objects is experienced by us simply as "no space"—as an empty space without any specific form and meaning. And that means: We overlook this space as such—like we tend to overlook the white surface of a page when we read a text. The exhibition space is for us only something that allows us to see art—but remains unseen as such.

The concept of total installation as it was proposed by Kabakov requires from the spectator to overcome this structurally determined blindness, to develop a holistic, totalistic vision of space, and most importantly, to realize that the spectator's own body is a part of the exhibition space, that by entering an installation the visitor finds himself or herself not outside but inside the artwork—and his or her own body becomes a part of this installation. Thus, the concept of the total installation is the next step in a long tradition of modern phenomenological and artistic programs that required us to change our attitude and to see what was overlooked before, or, according to the famous formulation by Marshall McLuhan, to understand that the medium is the message. In this sense, one can see the artistic installations that were realized by Kabakov as educational in the first place—as a school for the visitor's gaze. In this respect Kabakov remains in a long and venerable modernist tradition. Here it is sufficient to remember two Russian artists who also remain in this tradition. Kandinsky has interpreted his own paintings as eye-openers, as a way to realize that every possible painting is abstract because it consists exclusively of colors and shapes. The only goal of Kandinsky as a

painter was to prevent the spectator from overlooking this fact. Kandinsky made his paintings explicitly abstract—to demonstrate that every painting is implicitly abstract. In the same way Malevich has demonstrated that every image cam be seen as a suprematist one, that is, as radically autonomous one. That is why Malevich eventually moved from the explicitly suprematist images to the pseudo-realist images of his late years. He obviously believed that the informed spectator could differentiate between presuprematist and postsuprematist images—even if they seemed similar at first glance.

It can be seen, therefore, that for Kabakov authorship is not something that is attributed through the established institution of art. Instead it emerges on the border between the public and private spheres—wherever such borderlines occur. The language of authorship is none other than the language with which the relationship between private and public domains is negotiated. We ascribe authorship to someone whenever we discover that some aspect of his private life holds potential relevance for the public domain. It is of no consequence whether the person held to be the author of this "aspect" is deliberately displaying it or not. The author himself is not in a position to manage his authorship. But in order for someone to be credited as an author, his private sphere is required to be exhibited and exposed in the public theater of authorship. This tension between public and private spheres is particularly visible in Kabakov's installation *Toilet*, which he constructed for Documenta 9 in Kassel in 1992 (figs. 7.4–7.5). In outward appearance, this toilet, erected by Kabakov as a separate building in the courtyard outside the Fridericianum palace, is reminiscent of the standard, extremely primitive and uncomfortable public toilets which can still be found in the south of Russia. Yet the interior of this toilet building was furnished to look like private lodgings, similar to a typical family apartment. The family concerned was leading a peaceful, carefree existence inside a public toilet—a fact that Kabakov did not overly dramatize. In his own commentary on this installation Kabakov recalls an episode from his childhood: For a short while his own mother had to live in the (disused) toilet of a boarding school. But at the same time, this installation is also an ingenious commentary on Documenta itself. As in every major exhibition, self-contained berths have been constructed, within the enormous space inside the Fridericianum, each of which is designed as a private space for the artist to install whatever and however he wishes. Visitors to Documenta are entitled at any time to enter any of these berths for a while—and then to leave again once they have answered their aesthetic call of nature.

The interplay between private accommodation and public amenities staged by Kabakov's installation corresponds suggestively to the overall picture of today's major public exhibitions. A certain irritation implicit in this metaphor no doubt betrays Kabakov's nostalgia for the time when he could still receive visitors eager to see his work in the privacy of his own studio or apartment, and as master of the house was able to dictate the terms under which these visitors viewed his art. In the installations he creates in the West Kabakov attempts to regain individual control by purely aesthetic means:

Figure 7.4

Ilya Kabakov, *The Toilet*, 1992. Installation, general view. Documenta 9, Kassel, Germany. Collection Stedelijk Museum Voor Actuele Kunst, Ghent, Belgium. Photograph by Dirk Pauwels/Ilya and Emilia Kabakov Archive.

Direct or indirect instructions steer the viewer's gaze in one or another direction and prescribe the order for viewing the installation. Here, the installation becomes a theater of authorship through the amalgamation of two types of space, the private apartment and the public toilet. The installation is essentially a private space that has been thrown open to public access and public use. And it is precisely this "publication"—whenever, however, or for whatever reasons it occurs—that makes the person living in this private space an author.

The same theater of authorship was staged by Kabakov in his enormous installation *We Are Living Here* (Centre Pompidou, Paris, 1995) (fig. 7.6). The work presents the deserted construction site of some gigantic future palace, of which all that now remains are the building's ruins and the makeshift, shabby huts that once housed the workmen. This palace was evidently intended by its builders to be a work of "high art"; their lives were dedicated to the creation of this sublime artistic edifice. But not much is left of the palace, and what remains holds little fascination for us viewers. However, what Kabakov instead presents as the actual works of art are the temporary, private, and humble

Figure 7.5
Ilya Kabakov, *The Toilet*, 1992. Installation. Documenta 9, Kassel, Germany. Collection Stedelijk Museum Voor Actuele Kunst, Ghent, Belgium. Photograph by Dirk Pauwels/Ilya and Emilia Kabakov Archive.

lodgings once occupied by the construction workers, dwellings strongly reminiscent of *arte povera* installations. Besides this, we are also given the chance to behold the provisional clubs where the workmen spent their leisure hours and to appreciate them as modernist works of art. So the builders of the palace are in fact artists—albeit against their will. The palace they constructed as a work of art is not recognized by the viewer as such. Accordingly, its builders are denied the status of authors. On the other hand, once put on display, the private, everyday life of these workers *is* viewed as art. Thus the workers do after all acquire authorial status, but one that they would probably not have been overjoyed about. It is not for building the palace that the workmen are being rewarded with this authorial status, but for its dilapidation.

All of the installations in which Kabakov most explicitly focuses on the collapse of socialist dreams are indeed a ceaseless exploration of the ephemeral transition between construction and decay, the moment between something evolving out of waste and dissolving back into waste. Soviet civilization is revealed as a ruin, a transition between one state of debris and another—or as a temporary installation lacking any guaranteed permanence and in constant danger of disappearing without a trace. Soviet civilization is in fact the very first thoroughly modern civilization to have perished before

our eyes. All the other dead civilizations we know of were premodern. The reason the Soviet Union could disappear without a trace and land so irretrievably on the garbage dump of history was because it was unable to leave behind any immediately identifiable and original "monuments," comparable to the Egyptian pyramids or the temples of ancient Greece. Instead, this civilization simply decomposed back into the modern trash from which it, like any other modern, ready-made civilization had been made. The Communist utopia began by announcing the most ambitious historical claims ever made and proceeded to undertake the greatest imaginable efforts to deliver humanity from its historical hardships; but this utopia finally collapsed into poverty, filth, and chaos, thereby providing us with the most extreme example of historic failure ever witnessed—yet conceivably also the most sublime historical tableau ever displayed. It is precisely because of their strongly accentuated Orwellian shabbiness and quasi-bureaucratic ugliness that those Kabakovian installations that are thematically concerned with the demise of Soviet power come across as true monuments of some former, vanished splendor—and, by the same token, exert a strange kind of fascination.

For Kabakov, though, it is not only the utopian and messianic, in other words socialist, dreams that are short-lived, but indeed all forms of civilizing endeavor. In his view,

Figure 7.6
Ilya Kabakov, *We Are Living Here*, 1995. Installation, Centre National d'Art et de Culture Georges Pompidou, Paris. Photograph by Dirk Pauwels/Ilya and Emilia Kabakov Archive.

Figure 7.7
Ilya Kabakov, *Incident at the Museum, or Water Music*, 1993. Installation, Museum of Contemporary Art in Chicago. Photograph from Archive Ilya and Emilia Kabakov.

even the museum is transitory. By assembling his temporary installations inside the ostensibly stable institution of the museum, Kabakov also wishes to remind us that the museum itself is no more than an installation, a passing phenomenon ultimately subject to decay and destined for the rubbish heap. For his installation *Incident at the Museum, or Water Music*, shown at the Museum of Contemporary Art in Chicago in 1993 (fig. 7.7), Kabakov constructed a dilapidated room in a provincial Russian museum where works by an unknown and relatively conventional painter are stored. The museum has a leaky roof that lets in the rain, so a variety of kitchen receptacles have been positioned across the floor to catch the dripping water. In this work the museum has evolved into a sort of chaotic communal kitchen similar to those depicted in some of Kabakov's other installations. Here, as ever, Kabakov is staging the decline of civilization and art into prosaic, everyday trash. And, as ever, it is precisely this decline that kindles hope; with the aid of a special device the sequence of dripping water has been so finely orchestrated that the drips splashing in the various containers suggests a certain melody.

Decay, destruction, and dissolution are thereby given their own special signature—and assume authorial status. The museum also turns into a theater of authorship where

failure and misadventure can be authorized and consequently transformed into art. This allows art the opportunity to survive any catastrophe, decay, or downfall, since it is ultimately up to the viewer to find a certain perspective from which he is able to see anything he encounters as art. It should, though, be pointed out that this ability does not mean total "aestheticization," which would anaesthetize us against reality, but simply a further chance—or menace, perhaps?—of publicly authorizing the private domain. Imputing outside authorship like this tends on the whole to irritate artists, given that they aspire to the greatest possible control over their work and believe that it is this control that gives them sovereign status as authors. There can be little doubt that Kabakov is just as eager to exert such control over his work—maybe even more persistently and thoroughly than many others. At the same time, however, he never entirely trusts in his own efforts, and constantly reckons with the possibility of a mishap. Yet, instead of seeing this eventuality simply as a threat to his status as an author, he also treats it as an opportunity. For Kabakov is hoping that, if it one day comes down to it, he will still be recognized as the author of his possible failure.

One of the most widespread opinions about art is that there is no progress in art. That is partially correct but not entirely true. At least in one respect, a continuous development can be found in modern art. Gradually people are realizing that all aspects of art are equally fictional. No one believes anymore in art's ability to offer an adequate, genuinely realistic image of external reality or to manifest authentically the inner states of the human soul. However, the article of faith that the actual existence of an artist who "makes" art is necessary for art to be created remains largely undiminished. Despite well-known discourses on the death of the author, the practice of art today still suggests that hidden behind every work of art is an artist who has produced this work or has at least selected it as a readymade. The conviction that art is made by artists is particularly stubborn in the genre of painting. Whereas photography and video were suspect as art practices from the beginning, having made the classical concept of authorship uncertain, painting is considered the natural realm of artistic individuality. Not coincidently, when people talk about an artistic genius, as a rule they mean a painter. In German, the concept of a *Malerfürst* (prince of painting) is common. The concept of a *Videofürst* sounds rather odd.

Thus it must certainly be considered progress in art that Ilya Kabakov has for decades been working on the theme of the fictionality of authorship in the medium of painting. And in fact painting seems, on closer inspection, ideally suited to be a medium in which the fictionality of authorship can be thematized. After all, painting is nothing other than the combination of colors and forms on a surface. In that sense, every painting ever painted or ever to be painted can be seen as an excerpt from a single painting—a painting that contains all the possible combinations of colors and forms. Thus painting would be understood in analogy to text, since every text can also be seen as a combination of letters on a sheet of paper that represents an excerpt from the sum of all possible combinations of letters, as described in Jorge Luis Borges's famous story "The Library of Babel." Kabakov understands painting as precisely such a purely combinatorial practice—in analogy to text, to literature. For precisely that reason, in all his

paintings he causes the white background to stand out, functioning like a sheet of paper and equating every painting with a text.

At the beginning of the 1990s Kabakov made his early "total installations"—each of which was mostly presented as an exhibition of a work of a fictitious artist—in such a way that their visitor could not overlook the holistic, totalizing organization of the installation space even if he tried to do so. These installations were very baroque; the lighting was the most important tool to make the visitor to perceive the installation space, to experience it as a medium of light. But over time Kabakov's installations became less and less baroque, their lighting became more and more the standard lighting of a conventional art exhibition. With the installation *Life and Creativity of Charles Rosenthal, 1898–1933*, which was first shown at the Contemporary Art Center/Art Tower Mito (1999) (fig. 8.3), Kabakov began to experiment with presenting the artistic oeuvres of his artist-heroes in the conventional form of a neutral museum retrospective in which the painting itself was the focus of attention. Viewers were confronted with Rosenthal's oeuvre just as they would be with the work of Rembrandt or Cézanne. In addition, visitors to the exhibition were told about the circumstances of the artist's life in a fictive biography of Charles Rosenthal written by Kabakov. Now, it is striking that—according to this biography—Rosenthal died in the same year that Kabakov was born. It is said also of Rosenthal that he emigrated from the USSR to Paris in 1922. Nevertheless, the exhibition has a number of paintings in which the aesthetic of socialist realism is cited, whose origins and evolution Rosenthal could not have experienced firsthand, since he was living as an émigré. We are to assume that he followed these developments from

Figure 8.1
Ilya Kabakov, *The Answers of the Experimental Group*, 1970–1971. Enamel on fiberboard, 147 × 376 cm. State Tretyakov Gallery, Moscow.

Figure 8.2
Ilya Kabakov, *Subscription for Gioconda*, 1980. Oil and enamel on Masonite, 190 × 260 cm. Collection of Ilya and Emilia Kabakov.

abroad—by reading Soviet books, catalogs, and art magazines that made it to Paris—in the same way in which Kabakov has followed the development of Western art during his Moscow years. This external position enabled Rosenthal to combined socialist realism with suprematism, which he, as we also learn in the biography, had learned earlier under the direction of Malevich. Such a combination would have been impossible in the Soviet Union, of course. Hence Rosenthal's work represents a combinatorial possibility that is legitimate as such—like any other such possibility—but was prevented by certain historical circumstances. This exhibition of Charles Rosenthal's was followed by exhibitions of Ilya Kabakov (fig. 8.4) and Igor Spivak (fig. 8.5). Ilya Kabakov was described as a student of Rosenthal who produced works in Moscow in the 1970s that the "real" Ilya Kabakov did not produce. And Igor Spivak appears as a Ukrainian artist from the 1990s who was little known and little of whose work survived.

In all these exhibitions, Kabakov himself is identified as a curator, who did not create the works of the artists presented but rather discovered them, brought them together,

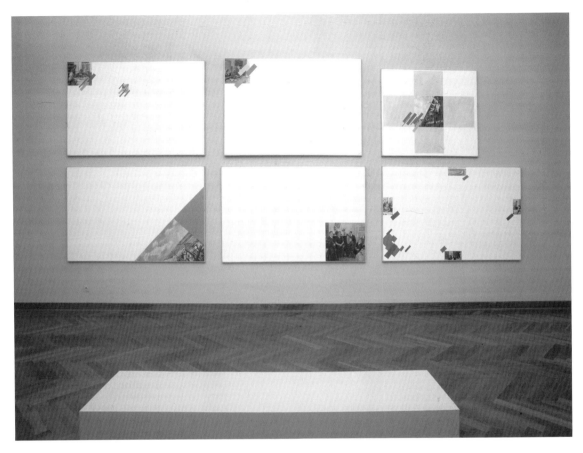

Figure 8.3
Ilya and Emilia Kabakov, *An Alternative History of Art/The Life and Creativity of Charles Rosenthal*, 1999. From the series *Alternative History of Art*. Installation view, Art Tower, Mito, Japan. Photograph by Shigeo Muto/Ilya and Emilia Kabakov Archive.

and commented on them. This radically undermines the "realistic" assumption that the art world functions as follows: First an artist creates a work, and then this work is exhibited by a curator. Kabakov shows by contrast that the work of an artist is actually produced not by an artist but only by his exhibition. As soon as a number of paintings are exhibited together, the illusion of a unity of artist's oeuvre that links these paintings to one another emerges in the imagination of the viewers—the illusion of a common style, a common history, a common message. The artist is only a projection of this illusion. It is not the artist who is exhibiting the work which he produced, but the exhibition producing the artist. Thus it ultimately does not matter whether this artist

Figure 8.4

Ilya and Emilia Kabakov, *Ilya Kabakov, A Ski Outing, 1973*, 2003. From the series *Alternative History of Art*. Oil on canvas, 130 × 201.5 cm. Collection of Ilya and Emilia Kabakov.

is "real" or fictional. Later, Kabakov placed Rosenthal, Kabakov, and Spivak in a series that he called *An Alternative History of Art*. This art history is alternative in the sense that all three artists are nowhere to be found in normative art history. To explain their absence from collective memory, Kabakov emphasizes in their biographies that the lives of these artists were marked by failure—and that they could and should be discovered or invented for precisely that reason. This connection between failure and fiction points to a question that can rightly be described as the great mystery of contemporary art: How is artistic failure even possible today? For today we are living after the victory of the artistic revolutions of the twentieth century—after the triumph of the avant-garde that proclaimed the fundamental equality of all forms of art and persuaded society to accept it. No one today would be prepared to reintroduce normative criteria for assessing art. All such criteria and all the hierarchies based on these criteria have been exposed as untenable—and hence they have lost their credibility for us. Nevertheless, the promised age of the complete equality of all forms of art and the associated unlimited freedom of artists to do what they like has yet to arrive. The avant-garde has been victorious, but the possibility of not being recognized by society still threatens the artist

as much as ever before. In fact, this threat has become even more acute with the victory of the avant-garde movements because the reason for a possible failure has become more obscure. Today's art operates in the chasm between the formal equality of all forms of art and their de facto inequality, which is caused by historical circumstances, market processes, and the personal biographies of the artists. The "alternative art history" that Kabakov has created through his painting practice of recent decades is situated in this chasm—and at the same time tries to make it its theme. Kabakov focuses on both things: the utopian horizon of the equality of all combinations of colors and forms and the "realistic" assessment of historical facts that lead to the dominance of specific artistic styles and attitudes.

Since the early 1970s, Kabakov has made the figure of the contemporary artist the main subject of his reflections. Reflection on the conditions of art production is a typical feature of the art of the 1960s and 1970s. In the West, this reflection usually took the form of institutional critique. All aspects of the system of art—the art market, the museum, art galleries—were analyzed and criticized. In contrast to this well-known type of institutional critique, Kabakov concentrates his attention not on the institutions of art but on the position of an individual artist—and specifically an average, "normal" artist, millions of which exist in our world today. When we use the word "art," we usually mean "good," successful, socially arrived art. Thus we often speak of the opposition of art and non-art, and mean by that that simple things from reality can be accepted in the museum as art or that art should break out of the museum and penetrate into reality. Located between art and non-art understood in this way, there is, however, the territory of "simple," plain, average art. This art does not manage to get accepted in the museum, but neither is it part of what we normally describe as reality. Rather, this is a zone that is simply overlooked by the dominant art theoretical discourse. But it is precisely this dark zone of the undiscovered, the leftover, and the forgotten in which Kabakov situates the lives and art of his artist-heroes. These are the artists who believed in the equality of all forms of art, who accepted the liberation of artists by the avant-garde as a historical fact, and who created their art in the faith that modern artists had in fact been granted the right to do whatever they personally want. These artists are just as much victims of the period that followed the avant-garde's revolutionary liberation of the arts as the Soviet people were prisoners of a regime that resulted from the liberation by the socialist revolution. Hence it is no coincidence that Kabakov, even if his art addresses a theme that is universal in our time and applies equally to artists everywhere in the world, refers on the formal level of his

Figure 8.5
Ilya and Emilia Kabakov, *Igor Spivak, On the Sanatorium Steps*, 1997. From the series *Alternative History of Art*. Oil on canvas on wood, 282 × 188 cm. Collection of Ilya and Emilia Kabakov.

oeuvre primarily to two seemingly irreconcilable traditions in Soviet painting: suprematism and socialist realism. The reasons for this choice of artistic methods surely lie primarily in Kabakov's own biography, since they are methods with which he has been very familiar since his youth. There are, however, also deeper reasons for this choice. I have already mentioned one reason: a certain analogy between the position of the citizens of the postrevolutionary Soviet State and that of artists in the context of today's system of art, which emerged from the artistic revolutions of the twentieth century. There are also other, more interesting, more profound reasons for the way Kabakov uses the tradition of Soviet painting in his work.

Suprematism, as Malevich understood it, wanted to eliminate every individual artistic style and taste and create a new collective style for the Communist humanity of the future. Socialist realism, though clearly distinct from suprematism, also wanted to create an anonymous, collective style. This nonindividualistic character of Soviet art clearly distinguishes it from the art of the West, which is marked by the artist's search for an individual style. Soviet art certainly did not practice a free combinatorial use of all possible forms of art—on the contrary, many such combinations were explicitly prohibited. At the same time, Soviet art, including Soviet painting, had a nonindividualistic character that made any claim to individual authorship implausible. Because viewers could not really distinguish between the works of two artists—let's call them Petrov and Ivanov—these names seemed purely fictional to them. In a certain sense, Kabakov made explicit the deep destabilization of individual authorship that official Soviet art had always implicitly practiced.

And in fact the effort to establish a specific, individual style is stimulated above all by conformity to the rules of the art market—with the goal of self-branding. In the Soviet Union, there was no art market in the first place. Correspondingly, the aesthetics of socialist realism belonged to everyone and no one. The paintings of socialist realism were produced en masse and exhibited collectively. In the West, painting is usually considered the realm of individualized high culture, which consists of original achievements by individual artists and thus is radically distinct from mass culture, which makes use of reproductive means like photography and video. For that reason, the battle between high culture and mass culture is often interpreted as a conflict between painting and photography. And so when quotations from mass culture turned up in painting by pop artists like Andy Warhol, it was perceived as an aesthetic shock. Soviet painting, by contrast, functioned in the context of mass culture from the outset—and hence it can be unproblematically appropriated today. Kabakov's appropriation of Soviet art is deeply ambivalent. On the one hand, his paintings are shown under the conditions of the Western art system, which functions on the principle of individual authorship. On the other hand, Kabakov attributes his own appropriations to other, fictional artists—and hence he underscores once again the collective character of Soviet art, even if it is an imaginary collective in this case.

This collectivity is alluded to by the white background of Kabakov's paintings. The white in Kabakov's paintings has different and rather heterogeneous meanings: It refers to suprematism, to pure light, to colors in the state of potentiality, to Russian snow, and so on. But in his recent paintings, the white also and perhaps above all marks the abstract, empty space of memory. And the emptiness of this space is becoming all the more evident the further we get from the Soviet period and the more the impressions of that time are fading. Here painting functions not only as a medium of memory but also as a machine of forgetting.

The power of forgetting has always played a central role in Kabakov's art. The fact that his artist-heroes repeatedly fail in their attempts to inscribe themselves in the collective memory does not at all mean that Kabakov looks down on their efforts from above. The lack of solid criteria for assessing art means that every success in contemporary art is just as illegitimate and uncertain as any failure. Ultimately, it is only the utopia of equal rights for all art forms that offers us the final hope of escaping radical forgetting because it opens up the possibility of constantly reinventing an "alternative art history."

As was already said at the beginning of this text, *Alternative Art History* looks like a regular exhibition—but it is also a total installation because its space is a totally fictional, "unreal" space. A "real" standard art exhibition is supposed to present to us a certain fragment of "real" art history—of the common history that the visitor shares with the curator of the exhibition and the exhibited artists. The empty space of a conventional exhibition is precisely the neutral space in which this common, shared history manifests itself. However, Kabakov creates in this case an exhibition of fictional artists and of a fictional art history. Here the relationship between total installation and strategy of pseudonymity becomes obvious. The difference between the space of a standard art exhibition and the space of a total installation becomes not visual but mental. We know that the whole space of *Alternative Art History* is a fictional space—as the space of a novel, or the space of a film. And then, suddenly, we realize that the allegedly empty space of the conventional exhibition is, in fact, also a total or maybe even a totalitarian space. In any case it is the space in which the ideological fiction of common history and common values is installed and celebrated. By installing his own personal, fictional art historical narrative Kabakov reveals the ideological character of the contemporary exhibition practice as such. And he does so by using extremely reduced, minimalistic—but precisely because of that, extremely effective—means.

9 Boris Mikhailov: The Eroticism of Imperfection

Photography's greatest asset is generally believed to be its capacity to take a picture of the world at the very moment when the world least expects it. An unanticipated snapshot catches people in poses, gestures, and activities they are not aware of, do not themselves perceive nor consciously perform. Photography is capable of arresting someone completely lost in thought. This also explains why photography is so often compared with psychoanalysis, since the photographer can lend pictorial form to a person's subconscious by surprising him or her in such moments of self-absorption. More often still, photography is likened to death, since death also comes upon us without warning. Thus the intrinsic truth of photography is taken to be the truth of the unconscious, the unexpected, and the surprising—and consequently also of that which exposes and reveals. Indeed, we are all particularly fascinated by photographs that seem to present us with a portrait mode beyond the subject's control or willful influence. Such pictures give us the feeling of seeing past all conventions, controls, and regulations and at long last of being able to view life in all its uncovered truth—and not as it would deliberately and strategically wish itself to be seen. And since photography puts this hidden truth at our disposal, we actually believe we can finally get a hold on life.

Boris Mikhailov, however, is interested in precisely the self-stylization of life, the moments when life endeavors to appear great, happy, momentous, or attractive. In most cases, the people shown in Mikhailov's pictures have adopted conscious poses or done their utmost to present themselves in the best possible light. And even when his subjects are not performing specifically for the photographer, they are nonetheless portrayed in situations where they are performing for someone else. Mikhailov likes to show people (particularly in his early pictures from the Soviet period) participating in street parades, family celebrations, sporting events, trips to the countryside, or in what are commonly known as friendly get-togethers. As we all know, on such occasions people like to turn out in their best clothes and put on makeup—in other words, they consciously try to style their own image according to their personal tastes. It is

precisely these people's endeavors to improve their own image that form the focus of Mikhailov's photography.

The end result is one of pictures that evince a subtle form of cruelty, since they clearly illustrate that these attempts to create the "right" image, to improve one's appearances and make oneself attractive, all inevitably end in failure. The impression made by Mikhailov's pictures is unequivocal: It is precisely when people think they are looking their best that they look most awkward, and it is precisely when they imagine that they can consciously control the picture they are giving of themselves that their image most emphatically slips out of their grasp. A snapshot that captures someone lost in thought often makes a touching impression. But a photograph that documents someone's efforts to look attractive is more often than not just embarrassing. The sense of having a grip on life vanishes. Mikhailov's photographs tend instead to deeply unsettle the viewer, giving him the sensation of having been similarly caught out in the way he presents himself. This sense of embarrassment is inextricably linked with a feeling

Figure 9.1
Boris Mikhailov, "Untitled," from the series *Lyriki*, 1970–1980. Black-and-white hand-colored photograph, 80 × 60 cm. Courtesy of the artist.

of deep-seated complicity and solidarity that connects the spectator with the people he sees in Mikhailov's photographs. This is hardly surprising, since the preoccupation with our own image is one of the most human of all our concerns.

Mikhailov does not actually want to peer behind this surface image of the self to discover the "real truth," since he is all too aware that the photographer can ultimately only photograph what is presented to him and in the manner in which it is presented. This is why Mikhailov's work is also deeply self-reflective and self-critical. Besides, he is also highly skeptical of a photographer's earnest quest for personal truth and the desire to develop his own, entirely individual photographic style. There is no essential difference between the resolute will of a photographer to exert complete control over his own pictures and the will of his models to control their own appearance. Similarly, Mikhailov does not really believe in the additional powers of sight offered by the camera. In effect, of course, the photographer does have such additional powers at his disposal because he is in the position to capture not only the subject's appearance, but also the subject's attempts to influence it. But not even the photographer can extract

Figure 9.2
Boris Mikhailov, "Untitled," from the series *Four*, 1982. Black-and-white photographs, collage, 18 × 24 cm. Courtesy of the artist.

Figure 9.3
Boris Mikhailov, "Untitled," from the series *Four*, 1982. Black-and-white photographs, collage,
18 × 24 cm. Courtesy of the artist.

himself from the circle of general complicity—after all, he shows the pictures he has
taken with the further aim of later presenting himself as a photographer in the most
flattering light.

Certainly, staged reality has been a constant theme in photography over the last few
decades. In her earlier photographs Cindy Sherman, for instance, gave an impressive
demonstration of how an artist invents herself when posing for her own camera. There
are hosts of other photographers who work with models who consciously style them-
selves, echoing the latest codes disseminated in mass media, advertising, and film. In
such photographic works the thematic interest is focused primarily on the technical
perfection with which someone today can don an artificial mask capable of completely
obscuring his real face. In contrast, Mikhailov thematizes the imperfect, unsuccessful,
and miserably failed *mise-en-scène*—a badly made, defective mask that only heightens
the embarrassment of showing the unprotected face. Unquestionably, this alternative
strategy above all betrays Mikhailov's paramount skepticism concerning the possibil-
ity of a comprehensively controlled self-presentation—a possibility that is asserted to

an equal extent by today's commercial image-makers as by critics of the purportedly ubiquitous "total simulation." In Mikhailov's view, however, a simulation can never be entirely "complete," which is why he relentlessly exposes its cracks and faults. Such disbelief in total simulation can in his case be traced back to certain cultural and political circumstances. Mikhailov grew up in the midst of a total collective simulation called the Soviet Union and was constantly in a position to observe how badly, shoddily, and implausibly this *mise-en-scène* was actually mounted, even if countless people at the time were quite willing to find it convincing.

In the 1960s and '70s, the period when Mikhailov shot most of his "Soviet" series of photos, many artists were turning their backs on all things Soviet in order to develop their own, highly individual mythologies. Others were keen to show what was actually going on behind the facade of official ideology. Yet such an unreflective, oppositional approach was fairly easy to subsume into the worldview of official Soviet ideology, which always foresaw a certain degree of space for its enemies. Totalitarianism is, after all, less a question of social homogeneity than a question of the radical division of society into "for" and "against." What totalitarian ideology genuinely intends to exclude, on the other hand, is the neutral, analytical gaze inspecting it from the outside. In this context one had the chance either of being sympathetic to this ideology and surviving, or of being antagonistic and going under—but the idea of maintaining a neutral attitude was viewed as simply unacceptable, inconceivable, and structurally impossible. This is why, in their desire to escape from the clutches of Soviet ideology, a number of intellectuals and artists sensed a growing reluctance to reassert the radical gulf that this ideology was cleaving in society. Instead they preferred to call this very chasm into question and observe the Soviet cultural context in its entirety with a neutral, descriptive, and analytic gaze quite alien to it. This meant above all artistically thematizing those very Soviet cultural codes and visual language engendered by Soviet ideology that most of the unofficial Russian artists in search of the reality concealed behind this ideology had chosen to completely block out. Paradoxically, for most people it was precisely official Soviet culture that remained the big unknown prior to its "discovery" in the early 1970s, simply because it lacked the means to analyze its own mechanisms— whereas the opposition refused to undertake such an investigation because it regarded Soviet culture as fundamentally wrong, inferior, and unworthy of analysis.

At first glance the pictorial world of Soviet Communism appears to be anything but terrifying. The everyday aesthetics of Soviet totalitarianism were leagues away from what is widely assumed when one speaks of the "fascination of power" or the "aesthetic seduction of totalitarianism." Such seductive power might perhaps be tangible in the films of Sergei Eisenstein or Leni Riefenstahl, but these are works of talented individuals who cannot be considered representative of the average style of modern dictatorships; in general, totalitarian aesthetics have no need to seduce, since they dictate their norms from above. It was not for the viewer to judge whether this or that set of images seduced

him. On the contrary, Soviet ideological advertising judged the viewer by forcing him to compare himself with the ideal image of the Soviet citizen that was portrayed in it. Of course, the same kind of judgment can also be felt in commercial advertising; it too propagates the ideal image of a wealthy consumer filled with *joie de vivre*, an image any real person will realize with alarm that he can hardly live up to. Nonetheless, it is more or less up to the viewer to decide whether he can identify with such an ideal image or not. But under the conditions of the Soviet regime, such freedom of choice was not available. Anyone who refused to cast himself as a typical Soviet citizen was likely to run into quite tangible trouble.

In his early works *Red Series* (1968–1975), *Private Series* (in the late 1960s), and, in particular, in the series *Luriki* (1971–1985) (figs. 9.1, 9.4), Mikhailov proceeds with great irony, but also empathy, to show how Soviet people ventured to style their self-display according to the prevailing aesthetics of the time. The fact that this almost always ended in failure was primarily due to the discrepancy between their own physical reality and the idealized image of the new socialist human being that was emblazoned everywhere on officially sanctioned pictures, posters, and in films. The bodies of real Soviet people were too fat, too unfit, and too out of shape, their faces too round and too soft—in other words, bodies and faces not capable of expressing confident and forward-looking decisiveness, but rather just a certain air of bewilderment. This purely physical inadequacy (which, however, was not to be remedied) made a mockery of people's endeavors to successfully stage themselves in the mold of prevailing aesthetics. It is this failure that Mikhailov comprehensively documents in his pictures, yet without the slightest trace of taunting *schadenfreude*.

It was not until the photo series *By the Ground* (1991), made immediately after the demise of the Soviet Union, that Mikhailov showed people who had lost all interest in staged self-display. At the same time, the formal artificiality of his photographs makes reference to the documentary photography of the Russian avant-garde, much of which was shot from a sharply tilted angle. Here, however, far from celebrating some elated quest for new perspectives, Mikhailov's photos instead reflect an atmosphere of menace, despair, and confinement. But even hopelessness has its own vocabulary of staged ostentation; thus, in his most recent large und impressive series *Case History* (Scalo, Zurich, 1999) (figs. 9.5–9.6), Mikhailov once more returns to the thematic complex of the staged body. This series, a portrayal of homeless people in the post-Soviet era, initially prompted controversy among critics, who saw it as a tribute to unfettered voyeurism and reproached Mikhailov for his lack of respect for the privacy of its impoverished and underprivileged subjects. But what these critics failed to notice was that these shocking pictures only superficially seem to be documenting the squalor of post-Soviet society. On closer inspection this series is in fact concerned with the *mise-en-scène* of the body—in this case not as an ideologically staged "Soviet" body, but as an erotic body expressing desire. For it cannot be overlooked that the frail, ruined, und repulsive

Figure 9.4
Boris Mikhailov, "Untitled," from the series *Lyriki*, 1970–1980. Black-and-white hand-colored photograph, 30 × 20 cm. Courtesy of the artist.

bodies of the homeless people in these photographs are at the same time presented as erotic bodies.

Indeed, the erotic body also figures as a key theme throughout Mikhailov's earlier series from the Soviet period. The erotic effect, particularly of the female bodies, seems to be heightened all the more by failure of their owners' efforts to stage their appearances. It is when cracks start to show in the body's *mise-en-scène* that this body becomes truly appealing, erotic, and seductive in Mikhailov's eyes. In *Case History* we encounter living bodies that look as if they are decaying and hence, in an ominous and flagrant manner, contradict all notions of the body that thanks to art history and today's fashion industry we associate with the physical manifestation of erotic desire. The contrast between the outward appearance of these old, infirm, and disfigured bodies on the one hand, and their owners' endeavors to enact erotically suggestive love scenes with these *very* same bodies on the other, seems shamelessly indecent and insufferable. But as the Marquis de Sade once observed, eroticism is identical to the expulsion of shame. To what degree the notion of cracks in the conventional erotic presentation of the self will also exert an erotic effect in this context too is, of course, debatable.

Nonetheless, seen against the backdrop of today's ubiquitous cult of youth, Mikhailov's exploration of the erotic dimensions of an aged and infirm body has nothing whatsoever to do with the arrogant supremacy of the voyeuristic gaze. Eventually, illness and age overcome all our bodies—the photographer's included. Every kind of consciously manipulated self-image is doomed to fail. Every aesthetic norm shows cracks the moment we attempt to squeeze our bodies into it. Yet seldom are these cracks demonstrated with such fascination and clarity as in the photographs by Boris Mikhailov.

Figure 9.5
Boris Mikhailov, "Untitled," from the series *Case History*, 1999. Archive Boris Mikhailov.

Figure 9.6
Boris Mikhailov, "Untitled," from the series *Case History*, 1999. Archive Boris Mikhailov.

Art can be defined as the shaping of the relationship between image and public. Usually artists are concerned with creating images for the public. Andrei Monastyrski, by contrast, has set himself the goal of creating, shaping, and organizing a public for specific kinds of images and art events. However, for him, this does not mean spreading propaganda for a certain artistic practice, attracting wider attention to his art. In fact, that sort of propaganda would have been impossible under the conditions prevailing in the Soviet Union in the 1970s under which Monastyrski developed his artistic practice. Rather, Monastyrski was interested in creating a small but attentive public in order to explore the laws of attention, the reactions to artistic action, memory, and communication about art. And Monastyrski was astonishingly successful at this.

The Collective Actions group, which Monastyrski organized in the mid-1970s, still exists today.[1] The group's activities have had a great influence on the production and reception of art in Russia. At different times nearly all the important representatives of the art scene in Moscow of recent decades were involved in the artistic practices of this group in one form or another, including Ilya Kabakov, Erik Bulatov, and Dmitri Prigov. The most interesting members of the current set of younger Russian artists began their artistic development under Monastyrski's direction. The theoretical texts that Monastyrski wrote to justify and explain his practices have profoundly influenced the discourse on art in Russia today. The Collective Actions group was a genuine school, not just for many artists but also for many writers and art critics. But the influence of the group, and in particular of Monastyrski himself, is much broader than the circle of those who worked with him directly. The explosion of performance art in Russia in the 1990s would have been inconceivable without the performance practice of Collective Actions. Today Monastyrski is considered a guru of the new Russian art in Moscow, and its decisive influence on its origins and development is indisputable.

Admittedly, the shift of interest from the art object to its public reception was characteristic of all international, conceptually oriented art in the 1960s and 1970s. Monastyrski himself views his own artistic practice in the context of international conceptual art, which already had a parallel in Russia as well by the late 1960s and 1970s—above all in

Figure 10.1
Collective Actions, *Apparition*, 1976. Performance. Black-and-white photo. Archive Andrei Monastyrski.

the work of Ilya Kabakov. Of course, the way in which the artists dealt with their public differed in East and West, because the structure of the public was different. Interestingly, however, several aspects of the artistic practice of Collective Actions have become particularly relevant for our own time—for the post-cold-war period. The growing commercialization of art we are experiencing today on a global scale is leading to a loss of an audience for all those art practices that cannot be easily commercialized or that actively resist commercialization. Artists are increasingly compensating for this loss of a public by collaborating with one another and with representatives of the sciences or various political movements in order to produce another, alternative public. These kinds of collaborative, communal practices which create "another" public beyond the global art and media market are characteristic of art all over the world today.

The Collective Actions group, under the leadership of Andrei Monastyrski, is an early example of such a strategy to try to compensate for the lack of a public by producing an alternative counterpublic. Admittedly, at the time it was not art's commercialization but rather its ideological and aesthetic censorship that was the reason the artists of this group had no public audience. Over the course of the 1950s and 1960s the unofficial

Figure 10.2
Collective Actions, *Apparition*, 1976. Performance. Black-and-white photo. Archive Andrei Monastyrski.

art scene in Russia had reappropriated and practiced most of the forms and procedures of modern art. However, the artists themselves and their friends were the sole audience for this art. That had advantages and disadvantages. The chief disadvantage was isolation from a wider audience. But this disadvantage could also be seen as an advantage: The audience to which the artists presented their works was not indifferent but rather interested, involved, and inclined to collaborate from the outset. Everything shown to this public was discussed, analyzed, interpreted, and received in a friendly way. One could almost say that the art object itself was merely a pretext for a celebration of reception, for a social event, for the creation of a public that was constituted around this art object. In a certain sense Monastyrski merely drew the necessary consequences from these conditions as he made them explicit and codified them through the activities of the Collective Actions group.

During the 1970s and 1980s, the activities of the group consisted primarily of the organization of performances, which as a rule took place outside Moscow. The audience, which was usually composed of artists, writers, and theorists, was invited to travel to a place a couple of hours away from Moscow to watch the performance. Most of the

Figure 10.3
Collective Actions, *The Slogan*, 1977. Performance. Black-and-white photo. Archive Andrei Monastyrski.

performances took place in winter. The road was long; it was cold. There was a sense of making a collective sacrifice for art. The site of the performances was mostly on one side of a snow-covered field. On the other side of the field a forest could be seen—as a straight, dark gray line between the white field and the pallid sky. The whole landscape was rendered in an ascetic, reductionistic, black-and-white aesthetic evoking the aesthetics of minimalism and conceptual art. The reference to the white background of Malevich's suprematist paintings was impossible to ignore. The audience stood, frozen, and stared at the white field. Then something happened. Usually it lasted only a short time, and took place at a considerable distance from the viewers, so that they could not see clearly what it was. Somebody came out of the forest, moved through the field, left behind several traces and went back into the forest. On the long road back to Moscow the viewers had lots of time to discuss what it was and, if it was what they had thought they had seen, what it could possibly mean.

Later these reflections were taken further. The members of the group informed the viewers in conversation or in writing what the course of the action actually looked like and what the authors had intended. Neither of these things, however, was considered binding. Quite the contrary, members of the audience were asked to describe their own experiences and propose their own interpretations. Later all this written material was gathered and edited and supplemented with photographs of the action and sometimes

Figure 10.4
Collective Actions, *The Slogan*, 1977. Performance. Black-and-white photo. Archive Andrei Monastyrski.

with the schema for the course of the action and Monastyrski's subsequent commentaries on it. This publication, circulated among those involved, represented, in effect, the self-contained artistic work. Even later these publications were collected in volumes titled *Poezdki za gorod* (Journeys to the outskirts of the city).[2] Five such volumes were published between 1976 and 1989, and in 1998 these were published as a book under that title. Today this book is something like an encyclopedia of advanced art in Moscow during this period.

Beyond its purely artistic and historical significance, however, the artistic practice of Monastyrski and his group is an important and timely contribution to a subject that is still highly relevant to art today: the relationship between action and documentation. In recent decades there has been an increasing shift in interest within the art system from the artwork to art documentation—the documentation of actions, happenings, art events, political interventions, social projects, and so on. This shift raises anew the question of the extent to which art is manifested in what is presented to us as art. The artwork is traditionally understood as something that embodies art, making it immediately present and visible. When we go to an art exhibition, we normally assume

Figure 10.5
Collective Actions, *The Third Variant*, 1978. Performance. Color photo. Archive Andrei Monastyrski.

that what we see there—whether paintings, sculptures, drawings, photographs, videos, readymades, or installations—*is* art. The works of art can, of course, refer, in one way or another, to something they are not—say, real objects or specific political content—but they do not refer to art; they *are* art.

Now, however, this traditional precondition of a visit to an exhibition or museum turns out, more and more, to be misleading. The art documentation *is* by definition not art; it merely *refers* to art and thereby makes clear that art is no longer present and immediately visible here. Art does not appear in the form of an object, as the product or result of a "creative" activity. Rather, art itself is this activity, art practice as such. Correspondingly, art documentation neither makes a past art event present nor promises a future work, but is rather the only possible reference to an art activity that could not be presented in any way other than by means of this documentation.

For those who dedicate themselves to the production of art documentation rather than artworks, art is identical with life, because life is in essence a pure activity that leads to no end result. Here, it seems, the identity between art and life which modernist art sought for so long has finally been achieved.

Monastyrski's art practice, however, is one that deconstructs this claim to an identity of art and life by making an explicit theme of the central significance that documentation has for an action. Many artists who work with performances and actions view documentation as something secondary, something that merely refers to an original action but has no value of its own—or even as a regrettable concession to the art market and art system in general. So one could say that actionism is in a sense a return to the realism of the nineteenth century in that it insists on the reality, on the facticity, of that which is documented artistically—though of course in this case not by means of painting or sculpture but through photography, video, text, and so on. The actions that Monastyrski organized undermine this claim to reality in that from the outset they are explicitly staged with an eye to the documentation that would appear later. The effect of reality only results from the participation in the production and later reading of this documentation. Only then is the action clarified—at least temporarily—and thus only then does it become "real." Monastyrski speaks in this context of an "empty action."[3] The action as it presents itself to the viewer, and indeed even to the artist himself in the moment of its execution, is an "empty," unreal, fictive action. It obtains reality only when it is later reflected on—that is to say, through its documentation. It would be easy to imagine, if you will, a form of action art that consists entirely in the production of documentations of actions, even though the corresponding actions never took place in so-called reality.

However, it is not just Monastyrski's documentations but also his objects and installations that present themselves less as solid, material objects than as symbols that obtain something like reality, a presence in living space, by means of interpretation only, by being inscribed in certain networks of associations and connotations. In making "empty action" his subject, leaving the space open for interpretation and thus laying no claim to its own reality, Monastyrski points the reader to the Eastern traditions of Buddhism and Taoism. Both traditions play an important role for Monastyrski; in contrast to most Russian artists in recent decades, he has sought his inspiration more from the East than from the West. But one could just as well say that his artistic practice represents an intelligent and stimulating reaction to the phenomenon of Soviet Communism. Communism can indeed best be understood as a collective and yet "empty action" that achieved its reality only through subsequent interpretations. The "collective actions" Monastyrski organized are the manifestations of life, but a life that from the outset was a life in an art project.

11 Medical Hermeneutics, or Curing Health

The artistic activity of Medgermenevtika (Medical Hermeneutics) does not fall within ordinary genre classifications. While including the creation of artworks, performances, the writing of texts, and the simple act of carrying on a friendly conversation, it is in fact neither the first, nor the second, nor the sum of all of these activities. First and foremost, the group's activity calls into question a basic distinction integral to the modern artistic process: the distinction between the production of art and its interpretation. The very name of the group indicates that it is primarily engaged in defining and interpreting certain symptoms, perhaps in order to cure the illness these symptoms reveal.

The notion of understanding works of art as symptoms of a kind of "artistic illness" distinguishing the artist from the common person is, of course, not new. The uniqueness of Medical Hermeneutics lies in the fact that all of the objects and texts it produces belong to the realm of explanation but not the explicable; moreover, nothing is presented that is "just art," emerging spontaneously and authentically prior to any interpretation. The artists of Medical Hermeneutics define themselves as artists and then, without providing any of the usual proofs of this assertion, immediately proceed to interpret their existence as artistic. In so doing they are radicalizing the position of such Moscow artists of the older generation as Ilya Kabakov or Andrei Monastyrski. Though the artists of Medical Hermeneutics do make an initial artistic gesture, they simultaneously minimize or banalize it to the utmost, virtually eliminating it, and in the process shift the entire emphasis to the multiplicity of its interpretations. It is precisely this diversity of interpretations that is consequently aestheticized, that becomes the field in which art actually takes place, so that these interpretations and illustrations themselves become transformed into the art products. Therefore, what was originally intended as the diagnosis and healing of art by means of relating it to a certain theory or to empirical reality is itself transformed into a kind of artistic illness. The premise for such aestheticization of art theory and all possible interpretations of art practice is, naturally, a total loss of faith in their effective explanatory power. That lack of faith in the effectiveness of art theory and in the objective reality of the art context is characteristic of the

Figure 11.1
Medical Hermeneutics (Pavel Pepperstein, Yuri Leiderman, and Sergei Anufriev), *Covers and Endings*, installation featured in an exhibition at the Kunsthalle Düsseldorf, 1990. Photograph by Natalia Nikitin/Natalia Nikitin Archive.

contemporary situation of art in general, but in the Soviet Union it was expressed in possibly the most radical of forms.

The Western art world operates by means of a system of public institutions, among them the art market, museums, private collections, and magazine and newspaper criticism. These institutions create for art as a whole and for each individual artist and work of art the illusion of a stable, objective context. Within the framework of this institutionalized context any given artistic gesture takes on a specific practical meaning, and artistic theories, regardless of their possible merits, promote the elaboration of a particular strategy in furtherance of the relevant institutions.

A contemporary artistic infrastructure was very weakly developed in the Soviet Union. That "unofficial" art which was independent of state control, and to which Medical Hermeneutics belongs by reason of its cultural roots, continually lacked that infrastructure—which is, in fact, still lacking today. From a social perspective independent artists were left entirely to their own devices, and in such conditions the external context of their art looked even more phantasmagoric than anything that they as

Figure 11.2
Medical Hermeneutics (Yuri Leiderman and Pavel Pepperstein) at the Museo d'Arte Contemporanea Luigi Pecci, Prato, Italy, 1990. Photograph by Natalia Nikitin/Natalia Nikitin Archive.

artists could have realized in their own creative work. Many Soviet artists of the older generation created a quasi-religious myth for themselves, a personal but at the same time all-encompassing ideology designed to guarantee—at least for themselves—the objective significance of their artistic production. Yet at that point in time when faith in such myths was lost once and for all, all that remained was an infinite field of contradictory and absolutely unnecessary interpretations, theories, histories, and mythologies. Rather than plunging the artists of Medical Hermeneutics into depression, the loss of an external orientation—a situation familiar to anyone involved in art today— instead led them to open up a field of theorization that was witty, not rigidly imposed, and in its own way attractive as a new kind of artistic material.

The endless explanations and debates in which Medical Hermeneutics engaged, and for which it created "artistic objects," which served only as a kind of visible, demonstrative material, make use of the languages of structuralism, deconstruction, dialectical materialism, Buddhist mysticism, modern anthropology, and psychoanalysis, among others. These debates preserved the serious tone and the specific rhetoric of the modern humanities; they seemed to consist of accurate observations and well-founded conclusions. At the same time Medical Hermeneutics' explications and arguments internally dissolved the customary form of discourse of the modern humanities by constantly

changing methodology, skipping from subject to subject and referring to facts and works obviously unknown to the reader, while also seeming to emerge from nowhere and to vanish into a void. Through this slight exaggeration of the usual makeup of modern and contemporary cultural essayism, Medical Hermeneutics reveals the purely playful and aestheticizing character of group's artistic practice, its internal distrust in any claim of truth and objective significance of its own arguments.

Because of these strategies, the texts and artistic objects of Medical Hermeneutics produce a uniquely parodistic or Dadaist effect. Yet this is not parody in the usual sense of the word—genuine parody is possible only against a backdrop of faith in the possibility of unparodied, genuine discourse. Where this faith does not exist, the boundary between serious and parodied speech is lost, or, more precisely, becomes a new factor in the formation of style. The result is the emergence of a unique kind of stylized-barbaric speech that makes incorrect, unusual, and hyperbolic use of techniques and terminology of scientific and, more broadly speaking, "cultural" reasoning. Through parody the claim to truth is thereby eliminated, while at the same time such erroneous use reveals a potential for unforeseen and entirely serious observations.

This method has a rather long-standing tradition, especially in Russian literature. It was used by Dostoyevsky, who embedded in his novels the linguistic disaster of

Figure 11.3
Medical Hermeneutics, view of the installation *Warming of the Hollow Canon*, part of the exhibition Mosca, Mosca at the Museo d'Arte Contemporanea Luigi Pecci, Prato, Italy, 1990. Photograph by Natalia Nikitin/Natalia Nikitin Archive.

Figure 11.4
Yuri Leiderman, *Factories, Plants*, 1988. Oil on canvas, 150 × 190 cm. Moscow Archive of New Art (MANI). MANI Collection.

the half-baked and semiliterate enlightenment of nineteenth-century Russia, and contrasted it with the unexpectedly profound insights resulting from this disaster—insights that revealed themselves as being deeper than the usual sterility of standardized, scientifically organized language. In the postrevolutionary period Andrei Platonov made similar use of the monstrously illiterate and pseudo-religious popular language of Russian revolutionary Marxism. Toward these same ends, Medical Hermeneutics makes use primarily of the semi-scientific, semi-ideological language of the structuralist-oriented cultural studies that was extremely fashionable in the milieu of the Russian liberal intelligentsia of the 1960s and 1970s. Medical Hermeneutics' work with this type of language, however, is even more distanced and aestheticized than that of Dostoyevsky or Platonov.

Figure 11.5
Yuri Leiderman, *Silent Pity*, 1988. Oil on canvas, 150 × 200 cm. Antonio Piccoli Collection.

The aestheticizing impact is further intensified by the Medical Hermeneutics artists' broad use in their texts and artworks of quotations, arguments, and terms created in their own discussions as well as those borrowed from friends, like-minded Moscow artists and essayists with whom they frequently engaged in dialogue. The meaning of these terms escapes the ordinary reader, although he can partly guess at their connotations. This creates a sense of being present at a conversation among family members who are linked by a long history of shared experiences and impressions, a conversation couched in language specific to the family—hints, catchwords, and turns of phrase understandable in their entirety only among the family members. Although the family members engaged in conversation are usually glad to explain to an outsider the origins of such hints and associations, those outside the family still cannot fully grasp their correct use, for the backlog here is that of the entire history of the life of that family, a history that remains closed to outsiders. To some extent, reading the books of the surrealists and the existentialists or even the writers of the Frankfurt School produces

a similar effect. Although their language lays claim to universal significance, since it was developed through a long history of conversations within a rather narrow circle of people linked by common basic values and cultural associations, it remains in part impenetrable to the outsider. So, too, the language of French poststructuralism continues to remain stylistically oriented toward conversational use, even though on the level of its content it affirms the primacy of writing and textuality. Since in today's globalized and pluralistic world any cultural communication is intended for a reader totally unfamiliar or only minimally familiar with the life experience, immediate cultural environment, and language of the author of the communication, the language of such communications is inevitably reduced to an absolutely banal level, the only level on which the mass media is able to function.

The artists of Medical Hermeneutics are of course consciously stylizing the esoteric nature of their language, fully aware of its incomprehensibility as far as the ordinary reader is concerned. Yet that stylization is ambivalent, since it provides the authors with an opportunity to continue speaking that language once the reader has been properly convinced that they are not taking it all that seriously. Whereas in classical irony everything stated seriously is turned into a joke owing to the absurdity of the world and of language, the irony of our time is that everything said as a joke turns out to be absolutely serious because at least a part of our real—and finite—life goes into that joke. Internally, the texts of Medical Hermeneutics continually waver between sincerity and parody, comprehension and noncomprehension, a search for the truth and stylization of the truth, aestheticizing that very uncertainty. In reality this is the kind of familial-theoretical conversation that often occurred in the economically rarefied and ideologically charged atmosphere of Soviet life. Deprived of the unified context simulated in the West through the mass media, Soviet society was split into small circles, each of which formed a closed microworld. Such a microworld felt itself as being in opposition to the entire surrounding environment, and related to the external world only as a semi-phantasmagorical reference of endless conversations among the participants inside this microworld. The internal drama and dynamic of these conversations resulted from the tension between the closed familylike circle in which these conversations took place, and the obscurity of the world beyond the borders of that milieu, in particular the world of the West and that of mysterious Soviet reality, represented by fanciful theoretical constructs reminiscent of fantastic and dangerous beasts from ancient hoary tomes about travels around the globe.

On a social level, Medical Hermeneutics also represents such a semi-family circle, differing from other Soviet circles of that type only in that the artists of this group, under the influence of the Moscow conceptualist artists of the older generation, were to some extent aware that their own lifestyle was rather exotic and could serve as material for art. At the same time members of Medical Hermeneutics were—even more than the older generation—acutely aware of the vacuum surrounding them, and of the danger

of outside interpretations of their circle's activity. The interest of the reader—and of the viewer—is therefore focused specifically on whether these potentially endless interpretations will gobble up the authorial discourse until only its bones remain in the form of "works of art," or whether the authors—using their techniques of medical hermeneutics—will survive, integrate these interpretations into their own texts, and remain capable of further discussion of their past adventures. What is even more interesting, the practice of Medical Hermeneutics allows a reversal in the usual concepts of health and illness. The finite and mortal speech seems too incurably ill, but its involvement in the infinite process of discussions and interpretations creates the sole surrogate of immortality still accessible to our imagination—an infinite play of signs beyond the bounds of any reality, or of its rejection. Here art and reality, illness and health are continually changing places. For both the authors and the viewers, however, Medical Hermeneutics seems to establish one thing with certainty. What was formerly the history of the search for truth has (in the best of cases) become an adventure novel, and contemporary art has moved from a claim to the truth to a fictional narrative.

12 Medical Hermeneutics: After the Big *Tsimtsum*

"In Russia a poet is more than just a poet." This statement by the famous Soviet poet of the 1960s, Yevgeny Yevtushenko, has become almost proverbial in Russia. This "more" marks a difference between the situation of the poet, artist, and intellectual in Russia and in the West that may perhaps be imaginary, but is nonetheless culturally relevant. In the West the artist—almost by tradition—struggles against the limits of the system of art, against an excessively narrowly defined role for the artist in modern society. In Russia, by contrast, the role of the artist has never been clearly defined. There the artist is confronted from the outset with a surplus of social expectations that may be perceived as undetermined and free-floating, but are at the same time urgent and binding. Thus many Russian artists perceive this "more" as a burden rather than an opportunity. Not coincidentally, many of them anticipated with delight that with the decline of Soviet power and its ideological world the situation of artists would finally normalize and they would finally obtain the right simply to be artists. Liberation from the ideological overburdening of art was celebrated as a liberation from the surplus of meaning that had oppressed artists for so long. These anticipations have not been realized, however, because the old ideology has, over time, simply been replaced by another: Most Russian artists and intellectuals were not able to endure for long the disappearance of the ideological burden and the resulting feeling of a loss of gravity. Pavel Pepperstein's artistic strategy developed precisely during a time in which the old ideology had already declined but the new one had not yet formed—that is, precisely in a state of emptiness, loss of gravity, and free fall.

Now, Pavel Pepperstein is quite clearly more than just an artist. He is also a poet, writer, critic, curator, and theorist. Above all, however, he is a designer of social spaces. Although Pepperstein is an exceptionally gifted draftsman and poet, he employs his talent only very much against his will when the point is to establish himself as an isolated "creative personality" in the context of the current art world. Rather, he invests his energy and ambition above all in the creation of microsocial groups that are bound together by a common ideology. Pepperstein theatricalizes, one after another, the ideological worlds, life practices, and pictorial languages of such groups. The best

example of this is the group Medical Hermeneutics, which was active primarily during the 1980s and '90s, and it was in this context that Pepperstein developed his method of ideological production. What does method consist of? What disease can be healed hermeneutically?

Medical Hermeneutics' methods always remind me of the story of a European ethnologist who wanted to disabuse an African shaman of the alleged superstition that all events in the world are the result of the influence of good or evil spirits. As an example of such influence the shaman told the story of someone in his acquaintance who died suddenly when a tree fell on him. The ethnologist, of course, found nothing extraordinary in this event: The fact that the tree fell could be given, in his view, a sufficiently scientific explanation. The shaman was not satisfied by that, however, because the explanation did not answer the real question, which is why the tree fell precisely when his acquaintance was passing by. The ethnologist, however, could give only one answer to that question: It was chance. It turns out that this answer satisfied the shaman, because he believed he had now learned what the evil spirit is called in Europe: Chance.

Medical Hermeneutics may be thought of as a search for rites and remedies that can protect us against this characteristically modern evil spirit—that is, protect us against chance. Chance manifests itself in our culture as an empty signifier—as a site of non-meaning, of a lack of planning, of the absence of any authorial intention, a lack of purpose. "It happened by chance" means that any further questions about the reasons for the event would be senseless. Thus our entire culture has been seized by chance—has fallen ill with chance. And this pertains to chance not just in life but also—and perhaps even especially—in art. Many things in a novel, a philosophical treatise, or a painting can be interpreted and explained, but not everything. For a reader or viewer an artwork always retains a relic of the inexplicable, the unmotivated, the random. Professional, academic hermeneutics tries to steep itself in the meaning of an artwork that is hidden to the superficial view and to find deep meaning precisely where this superficial view says there is only chance. At some point, however, any hermeneutic exploration that can be taken seriously eventually forgoes any further explanations and interpretations lest it drift into the fantastic, the far-fetched, the unreliable, or the purely subjective. Psychoanalysis, structuralism, and later, deconstruction pushed the limits of the interpretable, the readable, and the hermeneutically relevant even further.

Nevertheless, every method in the humanities capitulates at some point, in order to avoid appearing like the expression of mere paranoia. At some point the fact that an artwork looks thus and not otherwise, or is read thus and not otherwise, is attributed to mere chance. The uninterpretable relic of the text or image is sacrificed to the evil spirit chance. This is precisely where Medical Hermeneutics comes in: They exorcise this evil spirit. The texts and images of Medical Hermeneutics always refer to other texts and images, from Thomas Mann and Arthur Conan Doyle to Soviet children's book illustrations from the 1960s and '70s. These texts and images repeatedly reveal empty

Figure 12.1
Medical Hermeneutics, *Partisans*, 1989. Wooden box, sand, forty books written in Cyrillic, 29 × 204 × 154 cm. Ludwig Museum, Collection of Peter and Irene Ludwig.

spaces, seemingly chance constellations of words and images that Medical Hermeneutics fills with meaning. Pavel Pepperstein and his coauthors have no fear of any risk of "overinterpretation." On the contrary, the method of Medical Hermeneutics is the method of rigorous overinterpretation. For Pepperstein is well aware that even the boldest overinterpretation cannot escape the fate of all interpretations—namely, that they ultimately remain underinterpretations—and hence the power of chance cannot be broken entirely. Above all, however, Pepperstein discovers in the world of Soviet ideology this radical surplus of significance, this unconditional will to overinterpretation that undisputedly represents a model for his art. For the Soviet ideology knew nothing of chance. It had exorcised all the evil spirits. And precisely for that reason it was essentially paradisiacal. It saw itself as the necessary product of historical development as understood by dialectical materialism. And it saw everything that prevented or slowed its historical victory as the influence of enemy forces, as deliberate sabotage. An ideological enemy is not beyond ideology, however; it is not external or incidental to the ideology; rather, it is conditioned and produced by the ideology itself. The concept of

a chance effect—that is, an effect without an ideological cause—was profoundly alien, even incomprehensible, to Soviet ideology. Thus Soviet ideology developed a creative paranoia that filled the whole evil world of pure chance with meanings and thus transformed it into a paradise.

In the early 1990s this ideology was suddenly gone—and the world became devoid of meaning and dominated by chance again. Soviet citizens suddenly found themselves in a sea of empty signifiers—in a sea of ideological surplus value that had lost its reference. Even the explanation of why Soviet power arose in the first place went under along with that power. For Marxism provides the only plausible explanation for the socialist revolution and the creation of Soviet power. Because Marxism had disappeared along with Soviet power, however, the historical existence of the latter was left without justification. It became a mere event, a ghost that appeared without justification and then disappeared without justification; it became a drug trip that for inexplicable reasons had lasted too long; it became a meeting with the absolute other, which happened unexpectedly and left behind only vague memories. In short, it became irreducible chance. The mass of cultural signs left behind by Soviet ideology, emptied of meaning and become chance, was, however, perceived by Pepperstein and his friends not as a loss but rather as a opportunity and challenge—a challenge to imbue these signs with their own, individual meanings and thus create a new, unique, private mythology and ideology.

In the installations and texts of Medical Hermeneutics the Soviet ideological paranoia is replaced by private obsessions. The emptied semiotic world of Soviet ideology was thus populated artistically and aestheticized—and made compatible with the modern Western conception of art. In his programmatic text "Rapport NOMA—NOMA" (Report NOMA—NOMA), Pepperstein turned against the destruction of the monuments of the Soviet past that had begun with the quashing of the Communist putsch in 1991. Pepperstein saw this act of iconoclasm as an attempt to sacralize and ideologize Soviet space again after this space had already been aestheticized, secularized, and thus made compatible with the international art scene. Pepperstein writes:

It was not Soviet power that suffered a defeat in the putsch. . . . It was the utopia of making ideology aesthetic and "artistic" that had been embodied in a unique way in the material signs it had itself created, in monumental architectonic complexes, in the whole geopolitical space of the USSR. Making ideology aesthetic and artistic: an utterly postmodern project, of all the global projects of postmodernism it was stylistically, as it were, the most affected, the hyperpostmodern. . . . The overturning of the monuments in Moscow was certainly a signal for cultural functionaries (art historians and critics): the signal of the symbolic elimination of the commentators on these monuments, of the elimination of commentary in general.[1]

Whereas the artists of the older generation of Moscow conceptualism, like Ilya Kabakov, Erik Bulatov, and Andrei Monastyrski, were concerned with deconstructing an ideology that was still relatively intact, Pepperstein was already operating, after the fall

Figure 12.2
Pavel Pepperstein, *Untitled*, 1994. Watercolor, 69 × 50 cm. Dorothea Zwirner Collection.

Figure 12.3
Pavel Pepperstein, *Untitled*, 1994. Watercolor, 69 × 50 cm. Dorothea Zwirner Collection.

of the monuments, in the emptied, dysfunctional space of former ideology. For that reason, his strategy is no longer that of deconstruction but of the obsessive instilling of fallen monuments with new, private meanings. For the empty signifiers are not simply empty: Their function consists in producing a glitter, an appeal, a seductive power, in order to seduce into sense by way of the glitter of nonsense.

This connection between the order of things and the seductive power of the empty signifier was described by Claude Lévi-Strauss in his analysis of the term *mana,* which had been introduced by Marcel Mauss.[2] Mauss had described *mana* as a "magical, religious, and spiritual force" that the residents of Polynesia believed was inherent in gifts and ensured that a gift had to be returned to the giver at some point. Once the gift had been given and received, for a time it had a supportive and helping effect on the receiver—the *mana* of the gift remains, as it were, magically positive. Later, however, the spirit (*hau*) of the gift begins to feel a certain nostalgia for its origin, for the giver. The gift wants to leave the receiver and return to the giver. From that point on, the gift begins to be dangerous for the receiver—the *mana* becomes magically negative. Then the time has come to either give a gift in return and/or to give the gift to someone else. At some point, the gift has, thanks to this passing on of gifts, followed a circular path and returned to its origin, because all gifts are constantly circulating in a gift economy. In any case, for Mauss it is the *mana*—that is, the power inherent in the gift itself—that drives the symbolic exchange and not, say, the free will of the individual giver, the "external" conventions of a particular civilization, or the laws of nature.

For Lévi-Strauss, by contrast, *mana* does not belong to the order of reality but only to that of signs. At the same time, like Mauss before him, he presumes a totality of the semiotic order—specifically, the totality of signification. For Lévi-Strauss the whole universe becomes significant all at once. Before this big bang of signification there were no meanings at all in the world—thereafter, there were only meanings.[3] All things suddenly became signs, signifiers, which ever since have been waiting for their respective signified. The world after the big bang of signification thus offers us an infinite number of signifiers, but we do not know what they mean—signifiers without signifieds. We only know *that* they mean. The progress of thinking, as Lévi-Strauss says, consists in the "the work of equalising of the signifier to fit the signified," that is, in the gradual saturation of empty signifiers with specific meanings, with signifieds.

The progress of thinking, however, is very slow, always just finite and partial. Although it takes place "inside a totality which is closed and complementary to itself," it can never completely populate the infinite number of empty signifiers with signifieds, because the work of thinking takes place over a finite lifetime. There is thus always an infinite surplus of empty signifiers that cannot be populated by any progress in thinking. The basic situation of the human being in the world, understood as a world of signification, is thus that he or she always has many more signs available than can be assigned meanings: "There is always a non-equivalence or inadequacy between

the two [signifier and signified], a non-fit and overspill which divine understanding alone can soak up; this generates a signifier-surfeit relative to the signifieds to which it can be fitted." Hence there is always, as Lévi-Strauss puts it, a "supplementary ration" of signifiers that lack signifieds. It marks the difference between infinite divine reason and finite human reason and is something that human beings need to come to terms with in some way. For Lévi-Strauss, then, *mana* is nothing other than the name for this surplus of signifiers empty of meaning. *Mana* is the "floating signifier" that represents the whole infinite surplus of signifiers, which is "the disability of all finite thought (but also the surety of all art, all poetry, every mythic and aesthetic invention), even though scientific knowledge is capable, if not of staunching it, at least of controlling it partially." Accordingly, *mana* is "a zero symbolic value, that is, a sign marking the necessity of supplementary symbolic content." Lévi-Strauss thus considers his interpretation of *mana* to be "translated from [Mauss's] original expression" into a more current theoretical language that is "rigorously faithful to Mauss' thinking."

The infinite world of the empty signifiers, which opens up a space of dizzying freedom for poetry, imagination, and aesthetics, results, in Lévi-Strauss's view, from a big bang that is analogous to the big bang of the physical world. It seems more plausible to me, however, to assume that this world results from an operation that in the kabbalistic tradition is called *tsimtsum*. It refers to God's partial withdrawal from the all-unity, which creates the free space necessary for the world to exist. Likewise, the withdrawal of Soviet power, or the *tsimtsum* of Communism, created the infinite space of signs emptied of sense, this infinite surplus of pure chance that could be poetically colonized by the obsessive imagination of Medical Hermeneutics. The *tsimtsum* of Communism was, of course, merely the most radical expression of the withdrawal of all the collective myths of the modern age. What we call modern poetry or art is nothing other than a willful, individual occupation, a wild privatization of vacant spaces that have remained unpopulated after the *tsimtsum* of the great religions and ideologies. These spaces of the *tsimtsum* are accepted as gifts by art—and as such they indisputably have a surplus of *mana*, a strongly attractive and seductive power. Over time, however, this *mana* begins to have negative effects and to demand to be given away again. Then the artists move on, in search of new signs emptied of meaning, for a new giving by means of a new *tsimtsum*. Thus Pepperstein's artistic practice is exemplary not only for Russia but for our age generally, because it exposes the process by which art is produced today: by the individual imagination conquering symbolic spaces that were once governed collectively, communally, and socially.

13 Grisha Bruskin: Allegorical Man

The art of Grisha Bruskin is formed at the intersection of two traditions: the tradition of Judaism and the tradition of Soviet Communism. In that sense, Bruskin's works represent one of the early examples of what is now called identity politics. The artist asked himself, "Who am 'I'?" And he replied: a Jew who grew up under the Soviet regime. Seemingly trivial at first glance, this answer is in fact nothing of the kind. In the years during the decline of the Soviet regime, many gave a much more complex answer to this simple question. For example: My true "I" is the realization of the Brahma, or, My true "I" is my artistic genius, and so on. The source of the answer that Bruskin gave about the status of his artistic subjectivity is soberness and realism, which were characteristic of a rare few in those days. Even rarer for the times was Bruskin's decision to make his art a means for manifesting his identity as a "Soviet Jew."

The question arises right away: What do Jewishness and Sovietness have in common? In the 1960s and 1970s the answer to this question was rarely sought, since state anti-Semitism tended to make most outside observers and Soviet citizens alike think that the two were in direct opposition to each other. However, here Bruskin also displayed soberness and realism, seeing a commonality where the majority saw only incompatibility and conflict.

In reality, the Jewish and Soviet traditions have much in common, of course. First of all, both traditions are messianic. Judaism, we know, does not believe that things reveal themselves to the world as they truly are. Only the coming of the Messiah will open the truth of the world to our eyes. As long as the Messiah delays his arrival, the appearance of things cannot be trusted. To be trusted are only the book, the text, the word, which promise the Messiah's advent to the world. For Judaism everything in the world is friable, unsubstantiated, and transient—everything except the text.

Soviet ideology in the sense differs little from Judaism. Dialectical materialism, the philosophical teaching at the root of Soviet Communism, views everything extant as dialectically contradictory, doomed to being overcome, being "an effect of the negation of negation" that does not lead to affirmation. The truth will be revealed—if it ever is— only with the advent of Communism. The advent of Communism is seen by dialectical

materialism as an extended historical process of continual rejection of everything that is. In that sense dialectical materialism, even though it is called materialism, is committed to the reality of a material, visible world no more than Judaism is.

The messianism of Judaism and Communism at the same time also signifies their iconoclastic nature. Here I do not refer so much to the active destruction of icons as the undermining of trust in the visible per se. Iconoclastic cultures believe in the text and do not believe in the image. That is why they question the very possibility of art itself: The role of the artist becomes problematic and unclear. Plato had already rebuked artists for depicting a semblance of things instead of dealing with the thing itself. What can be said for art in conditions when things in themselves are declared unreliable? The artist is placed in the dubious role of a person who leads others into error, offering a stone instead of bread.

That is the situation in which the artist will inevitably find himself if he defines his identity as a "Soviet Jew." This definition is, upon closer inspection, a doubled iconoclastic ban, a doubled ban on taking up art. From this definition follows the question of how one can nevertheless do art without simultaneously rejecting one's identity as a Soviet Jew, that is, while preserving the double ban on depiction.

The problem is further complicated by the fact that the experience of modernism, which tried to resolve an analogous problem within the bosom of Christian culture, is not directly applicable here. Christianity declared Christ the Messiah, thereby making his body the true and eternal icon of the invisible God. The iconoclastic ban, which Christianity continued to obey, was integrated into the Christian tradition through the depiction of Christ's suffering on the cross and His death. It could be said that Christianity made the destruction of the icon the subject of the icon. In Christianity iconoclasm became an artistic method. And it is this method that the historic avant-garde employs. It could be said that the avant-garde stages nothing less than the suffering of the painting that replaces the Christian painting of suffering. The avant-garde subjects the body of the traditional painting to all kinds of torture, very reminiscent of the torture suffered by the bodies of saints in medieval icons. The painting is in fact or symbolically torn, slashed, fragmented, stabbed, mixed with dirt, and subjected to mockery. It is no accident that the historic avant-garde constantly uses iconoclastic vocabulary in its manifestos: It speaks of the undermining of traditions, the break with conventions, the destruction of the old art, and the annihilation of old values. But of course, there is no sadistic pleasure in the cruel treatment of the innocent body of the painting. The iconoclastic gesture is used as an artistic method, intended not so much to destroy old icons as to produce new images, or, if you will, new icons.

But this method is not completely suitable for an artist who defines himself as a Soviet Jew. In destroying the illusion of the image, the avant-garde proclaims the materiality, the "thingness" of the artwork itself. This proclamation of the thingness of art unites all the radical artistic movements of the twentieth century, from Malevich and

Tatlin to American minimalism. It is in the explicit affirmation of a work of art being "simply a thing" that the avant-garde saw the point of its critical and iconoclastic strategy. But this strategy is not very appropriate for Soviet Communism, because the iconoclasm of the Soviet regime was directed not so much at "metaphysical things" like images of gods and God but at "simple things." The coming of the Soviet regime meant the disappearance of things per se—things were turned into words, into text. Things are first and foremost commodities. The autonomy of things is based on the autonomy of the market as much as the autonomy of art is based on the autonomy of the art market. Demonstrating that artworks are simply things is the same as demonstrating that they are simply commodities. In the conditions of the capitalist market, such a demonstration is justified, because under capitalism things are essentially commodities.

But under the Soviet regime, there were no commodities, only "objects of consumption" or "tools of production." Their appearance, quantity, and distribution were determined not by the market but the decisions of the Central Committee of the Communist Party, the Council of Ministers, and Gosplan of the USSR. When the market disappears, commodities are transformed into written resolutions on their manufacture, and those resolutions are mere words, texts, promises, spells, and prophesies. The iconoclasm of the Soviet regime thus complemented the messianic iconoclasm of Judaism, extending it from divine things to worldly things. Not only God, but the things of the material world were turned into word, logos.

It was in that state that the Soviet Jew, artist Grisha Bruskin, found them—and it was in that state that he represented them in his paintings and in his sculptures. All the things in the works of Bruskin are presented in the form of an allegory of their disappearance, as signs of their absence in reality itself. Thus, a lovely young woman appears as an allegory of freedom, since freedom itself is not represented visually in the world, and therefore cannot be depicted. But in Bruskin's work even normal things, like bread, cellos, or fur hats, appear under the aspect of allegory, on the same level as portraits of Lenin and Stalin. This is appropriate, since bread and fur hats were manufactured and distributed in the Soviet Union along the same ideological lines and according to the same decisions and resolutions as were portraits of Lenin and Stalin.

Moreover: Bruskin's works are not simply allegories, but allegories within allegories—double allegories, corresponding to the double iconoclastic ban that applies to the Soviet Jew. Bruskin's famous painting *Fundamental Lexicon* (1986) (figs. 13.1–13.4), which is in a sense central to the artist's work, depicts pale, spectral, black-and-white figures of people holding colored images. These images play the role of allegories, linking to such concepts as Communism, labor, art, Judaism, love, and so on. Yet the figures holding these images are no less allegorical. Their individual features are blurred, their figures standardized; they do not pretend to be depictions of living people but are rather dead, abstract schematic "typical representatives" of certain classes of groups of the population—young girls, soldiers, workers, intellectuals, artists. One allegorical figure

supports another. The painting ceases to be different from text, and image becomes word. Bruskin's figures are placed, like all allegorical figures, in an abstract, "nonliving" space of conventional signifiers—in the twilight zone between painting and hieroglyph. That is the essence of Bruskin's artistic method: His works are iconoclastic because they turn iconic signs into conventional signifiers. It is generally accepted that the visual arts are iconic because they are mimetic. We recognize the depiction of a dog in a painting, even if we do not know the language spoken by the artist who painted it. At the same time, we only know that the English *dog* means the same thing as the Russian *sobaka* when we have mastered the conditionality of those languages. That difference seems obvious, but it is deconstructed by the figure of allegory. Thus, a lovely young woman placed in the space of an allegorical painting does not mean a lovely young woman at all, but could mean spring, liberty, revolution, love, or many other things. In order to understand allegory, you must learn its conditional meaning—just as this knowledge is needed to understand a foreign language. For this, dictionaries are created, lexicons of allegories—a practice well known to art historians at least since the time of Warburg and Panofsky. At first glance, Bruskin's *Fundamental Lexicon* is yet one more such dictionary created for the correct reading of allegories. Even externally it somehow resembles Egyptian hieroglyphs awaiting deciphering. But the deciphering never happens. Instead of this, one system of allegories is translated into another system of allegories. When an allegory is explained by an allegory, the direct meaning eludes us, becoming unfindable, nonexistent, opaque. The method of double allegory used by Bruskin plunges his work irrevocably into the space of mutual references, in which the direct vision of the world, of things per se and their unambiguous reading vanish. This space of total allegory is the space of iconoclasm, but of an iconoclasm that is very different from the iconoclastic practice of the avant-garde. The avant-garde, as I have said, combated plot, literariness, and signs in artworks, trying to make the artwork an autonomous thing. But the thing itself is, in turn, an icon—an icon of its own materiality. Another, and more effective, method of iconoclasm is the transformation of the image into allegory, hieroglyph, letter. In that case, the image merges with the text and becomes text, thereby becoming part of the general context of the iconoclastic culture.

The greatest theoretician of allegory in the twentieth century was Walter Benjamin. His interest in allegory was dictated by the same reasons that led Bruskin to allegory. To wit: Benjamin tried to create a synthesis of Judaism and Marxism. Just as Bruskin perceives himself a Soviet Jew, so Benjamin perceived himself "a Jew in Marxism." The theory of allegory formulated by Benjamin in his famous book *The Origin of German Tragic Drama* (*Ursprung des deutschen Trauerspiels*, 1925) was juxtaposed to the concept of "symbol," popular among Romantics and under their influence entrenched in later art and art criticism. A symbol is something real, living, and actual but which simultaneously refers to the abstract and generalized. In that sense the symbol is juxtaposed

Figure 13.1
Grisha Bruskin, *Fundamental Lexicon II*, 1986. Oil on canvas, thirty-two parts, 55 × 38 cm each. Total dimensions 220 × 304 cm. Private collection.

to allegory as living sense is to "dead letter," that is, to something purely notional, abstract, and inert. Hence the preference traditionally given to symbol over allegory. This preference is rooted in the custom of modernity to choose living over dead, whole over destroyed or declining, real over conventional, and progressive over obsolete. That is why "living art" in modernity is usually juxtaposed with "soulless formalism" and "dead schemas."

Benjamin overturns this hierarchy of preferences and sides with allegory over symbol. This is not the place to recreate and comment on Benjamin's highly complex arguments. It is enough to say that Benjamin sees in allegory not only an indication that the messianic revelation of things themselves has not yet occurred and that it is still

Figure 13.2
Grisha Bruskin, *Fundamental Lexicon II* (detail), 1986. Oil on canvas, four parts, 55 × 38 cm each.
Private collection.

to come; equally, allegory for Benjamin is a means of showing the transitory, declining, and doomed character of everything that exists. Allegory does not flatter things. In allegory, things show themselves as being half-dead, mutilated, dilapidated, waning. And it is their feebleness and dead schematism that allows them to appear as a simple sign, a simple letter, to be part of the messianic text. Benjamin wrote: "Whereas in symbol destruction is idealized and the transfigured face of nature is fleetingly revealed in the light of redemption, in allegory the observer is confronted with the *facies hippocratica* of history as a petrified, primordial landscape. Everything about history that, from the very beginning, has been untimely, sorrowful, unsuccessful, is expressed in a face—or rather in a death's head." And further: "This is the heart of the allegorical way of seeing, of the baroque, secular explanation of history as the Passion of the world; its importance resides solely in the stations of its decline. . . . But if nature has always been subject to the power of death, it is also true that it has always been allegorical."[1] The condemnation to death and the nonvitality of everything in nature is understood in a positive light here: Allegory allows us to use the things of nature in order to speak about history.

The fact that all things must decline, collapse, and die is shown more and more frequently by Bruskin. He uses this method most consistently in his recent sculptures in the series *Archaeologist's Collection* (2003). They all look a bit damaged and dilapidated. In this way they simultaneously resemble antique sculptures, which have lost limbs to time depredations, and Soviet park sculptures, succumbed to the same fate even though they have not spent time underground. Antique sculptures, like Soviet park sculptures, did not reach their piteous present-day condition through intentional destruction, for the most part. It is more the unconscious work of nature, which, as Benjamin writes, dooms all things, no matter what they are, to destruction and death. But this destructive work of nature also gives at the same time the possibility of using the things it has damaged as allegories of the historic. Bruskin's sculptures speak of the instability and vulnerability of human existence, both historical and biographical.

Thus his series of sculptures *On the Edge* (2003) presents human figures as they fall, slip off pedestals, step into the void, lose their balance. People trip. That is the meaning of any story. The human body inexorably deteriorates and falls apart—that is the point of any biography. Empires crumble and collapse along with their monuments, institutions, symbols, rituals, and hierarchies—that is the point of history. Pagans are proud when they build new temples, palaces, and machines. Jews know that those temples, palaces, and machines will be obsolete soon enough, becoming unsuitable for life. Jews are people of the Old Testament, not the New. The Old Testament is about, besides the obvious, the aging and decrepitude of the world. This decrepitude of the world points beyond its limits, revealing a messianic perspective. The pagan and Christian consciousnesses hope for a renewal of the world and that it will take on wholeness, vitality, and fullness. The world is renewed in Greek tragedies and mysteries. The

Figure 13.3
Grisha Bruskin, *Fundamental Lexicon II* (detail), 1986. Oil on canvas, 55 × 38 cm. Private collection.

Figure 13.4
Grisha Bruskin, *Fundamental Lexicon II* (detail), 1986. Oil on canvas, 55 × 38 cm. Private collection.

world is renewed when the Old Testament is replaced by the New Testament. Communism inherited some of that hope for the renewal of the world: "We will build our own, new world."

Benjamin called this type of consciousness and this hope mythological. Only disbelief in the possibility of a radical renewal of the world opens up the way to another hope—the hope that it will be overcome messianically. This other hope, this messianic prospect, is revealed by Judaism, which renounces the new and vital and clings to the Old Testament. The world is inherently obsolete. It is inherently in decay. The decrepitude of the world is incurable. But it is that obsolescence and decrepitude that gives the world the possibility to become the allegory of salvation and liberation. The world's inherent old age makes it too weak to hold back those who follow the messianic vow and want to be liberated from the world. That is why Benjamin constantly insists on the world's weakness, mutilation, illness, and age—in them he sees the only chance for salvation.

In that sense, Bruskin's "Soviet" works are perhaps the most "Old Testament." They present the powers-that-be of this world—for the Soviet Jew that was the Soviet regime—as instable, damaged, aging. In Bruskin's works, the half-destroyed, pale figures—the "specters of Communism"—awkwardly stumbling on Earth seem already "unworldly." Of course, Bruskin captures the atmosphere of the period of stagnation, the decadent "late" Communism, characteristic of the 1970s in the Soviet Union. But he regards this decline of imperial greatness without gloating and even with compassion. First of all, he recognizes that he himself is part of that process of decline. Second, he observes the process of the decline of the Soviet Empire from the perspective of the Old Testament, which promises the decline and fall of all empires. But perhaps the deepest level of relatedness between the Judaic and Soviet traditions is their inner complicity, which I have already mentioned. In the end, the Soviet regime was not conquered from outside, but it abolished itself, obeying the dialectical law of negation of negation, which it gave itself in the first place.

It is quite characteristic that when Bruskin turns to themes and images inspired by the Judaic tradition, he begins to use artistic techniques that may seem at first glance to be obsolete, such as tapestries. The notionality of tapestry, which is very clear to the contemporary audience, allows the artist to clearly delineate the allegorical character of his compositions. It is also characteristic that in this particular case, Bruskin is quite explicit in giving his allegories a verbal translation. Thus, he speaks of "Man with a house illuminated from inside" or "Man with a burnt cluster of grapes." Here one can see Bruskin revealing the allegorical method that has long been at the heart of his work. Not many artists in our time are prepared to turn to allegory, since allegory seems passé. Bruskin, however, on the whole turns to everything that seems, as Benjamin writes, not timely. The artist's interest in things that are not timely or contemporary can be tied to the postmodernist tendencies of recent decades. But a closer look shows that this

analogy is not convincing. Postmodernism appeared as a reaction to the current reign of mass culture. Here, we are talking about an individual, free play with the icons of artistic culture that demonstrates their non-obligatoriness. Bruskin proceeds not from the image but from language. The conditionality of his figures and signs; does not at all mean that they are not necessary. The language we speak is conditional; however, its conditionality is what gives language and the world meaning. But the meaning of language and the world inevitably slips away from the understanding of the speaker. The speaker stumbles—and goes off into the messianic perspective.

14 Alexander Kosolapov: The Artist in the Age of Commodity Fetishism

The history of art hasn't seen many artists whose work is indisputably symptomatic of their time. But Alexander Kosolapov is one of those artists. In our postmodern times, many believe that it is no longer possible to be surprised or provoked. However, Kosolapov has succeeded in both surprising and provoking—his recent works provoked a rather violent rejection by a section of the Russian public, and he was even accused of offending religious beliefs. It is easy to disregard such protests, thinking that they stem only from the more backward members of the population who haven't yet quite figured out the nature of contemporary art. A more interesting undertaking, however, might be to try to understand what it is the offended believers actually believe in, and why it is that the practice of contemporary art seems to controvert their faith.

Protests resulted mainly from the fact that Kosolapov quoted Russian orthodox icons in a profane context, placing them on the same level as a McDonald's advertisement and caviar (figs. 14.1, 14.7). As a matter of fact, there is nothing special about this kind of quotation. Moreover, not only has contemporary art come into existence through precisely these kinds of quotations, but also art in general. We shouldn't forget that art as such is a relatively recent phenomenon. In effect, art emerged out of the secularization of a sacred tradition—that which had once been an icon became a painting. The artists of the Renaissance had already placed the protagonists of the Bible in a profane contemporary setting. After the French Revolution, cult images and objects taken from diverse sacred contexts were placed in the profane context of European museums. Just imagine the indignation of a priest from ancient Egypt, if he were to see what the British Museum or the Louvre had done with his venerated mummies. The nineteenth and twentieth centuries elaborated on the hypocritical habit of understanding art as something sublime and beautiful. In reality, though, from its very beginnings art has been a profanation of everything sublime and beautiful—that is, of the sacred. Art has always been "just art," "simply art"—an essentially frivolous, unsound, idle, and, in any case, suspiciously profane activity. The merit of Kosolapov's recent works lies first and foremost in reminding the spectator of the profane beginnings of art practices as such.

Figure 14.1
Alexander Kosolapov, *This Is My Blood*, 2001. Digital print. Dimensions variable.

Therefore, one can argue that the offended believers felt offended not because of the desanctification of Christ, but mainly because of the desanctification of art that they rightfully detected in Kosolapov's work. The Russian Orthodoxy reveres the icon, and this very reverence was transposed by Russian art onto the painting. From the Wanderers on, through the Russian avant-garde and up to socialist realism, Russian artists, as much as the Russian public in general, expected from art a revelation of the beautiful and the true. To a certain extent, these expectations still persist. In any case, the believers offended by Kosolapov have been inculcated with such expectations by the Soviet power, and are now returning to the actual religious sources of those expectations. Of course, this secondary sanctification of art took place not only in the East but in the West as well. For this reason, art has had to continually reaffirm its profane nature—the entire history of contemporary art is, essentially, a history of such reaffirmations. Art has always manifested itself through the profanation of the sacred—primarily when desanctifying its own image. The situation essentially remained the same when art began to move away from the profanation of sacred images and objects, and instead increasingly use everyday objects and even things belonging to that sphere which Bakhtin called the "bodily lower stratum." Some might contend that Duchamp did the pissoir an honor by presenting it in an exhibition space as a work of art, or that Piero Manzoni paid respect to his shit by packing it in cans and exhibiting it as "merda d'artista." But actually, nothing has changed. In Latin, *sacer* signifies both holy and

Figure 14.2
Alexander Kosolapov, *Lenin—Coca-Cola*, 1993. Oil on canvas, 75 × 120 cm. Antonio Piccoli Collection.

Figure 14.3
Alexander Kosolapov, *Malevich*, 1993. Oil on canvas, 60 × 120 cm. Antonio Piccoli Collection.

unholy. Since at least the times of Roger Caillois and Georges Bataille we have known that everything related to excrement is sacred—that is, forbidden and taboo. Therefore Duchamp and Manzoni belong to the good old tradition of the profanation of the sacred—the no-less traditional replacement of the holy with the unholy included.

The practice of Andy Warhol and other pop artists, for its appropriation of icons of commercial mass culture, is in a similar vein. The word "icon" speaks here for itself. The notion of the sacred is inseparably bound to the notion of the ritual: repetition, copying, and reproduction. Any religion, and especially its fundamentalist—the most radical and authentic—interpretation, always insists on the immutability, repetitiveness, and reproducibility of the ritual. In that sense, all industrial culture of the twentieth century, which is also based on mass reproduction, can be regarded as nothing less than the propagation of the sacred ritual across the entire—hitherto profane—sphere of production and mass communication. Not for nothing did the socialist and Communist movements of the nineteenth and twentieth centuries sanctify the "working class." An industrial worker can indeed be sanctified, since he, like a priest, carries on one and the same mechanical ritual, for example screwing the same bolts into the same holes over and over again. Symbols of mass culture are de facto just as sacred, for they are infinitely reproducible, and so are the masses—every person in a crowd looks alike. Therefore, we can say that in defiance of the prevailing opinion, no secularization of culture ever took place in modern times. Instead, the democratization and "massovization" of the sacred has occurred. Not for nothing has our time seen a proliferation of fundamentalist religious movements through the mass media: The repetitiveness of the ritual coincides here with the mechanical reproduction through which mass media operates. It is this very condition of contemporary culture that Kosolapov's work diagnoses, at the same time as it reveals the symptoms of the contemporary sacred.

Throughout the 1970s to the 1990s Kosolapov made a great many works in which he combined symbols of the Soviet space with symbols of Western commercial civilization—Lenin, for instance, was combined with Mickey Mouse (fig. 14.4). The sanctification of the masses and mass culture was very characteristic of Soviet ideology. The incessant reproduction of Soviet signs manifested unity with people, the ability to be part of the whole and to partake in a mystery of the eternal recurrence of the same order of thought and life. Anyone who preferred reading, say, Proust, to watching the popular Soviet film *The Diamond Arm*, would generally be regarded as a suspicious renegade. Looking at Russian culture today, one gets the impression that this perception hasn't really changed since the abolishment of Soviet power, except that renegades are now habitually referred to as marginals. The point here is that the sanctification of the masses is as much a phenomenon of Western capitalist civilization as it was of the Soviet regime—although the character of this sanctification is slightly different. During the years of Soviet power, the masses were sanctified for their capacity to work, and as a result of the monotony and reproducibility of their social and productive practices.

A key symbol of this monotonous reproduction is that of the portraits of Lenin that marked every corner of Soviet space and were carried aloft by the workers during demonstrations. In contrast, the source of the masses' sanctification in capitalist society is the monotony and reproducibility of their ability to consume. A symbol of this monotony of consumption is Mickey Mouse, images of whom frequently appear in all sorts of American processions. We can therefore argue that in his early work Kosolapov prefigured the gradual transition from Lenin to Mickey Mouse, that is, from the monotony of production to the monotony of consumption. We can also say that the famous perestroika precisely implemented this transition. Occurring in parallel was the transition from socialist realism to glamour, that is, from images of the laborers of production to the laborers of consumption, carried into effect by Russian culture in the same period.

The sacred potential of the contemporary masses consists in their collective power of purchase: Clearly, only a product being sold to the general masses can generate a serious, real profit. Accordingly, a central question for contemporary capitalism might be: What unifies the masses? What transforms a versatile human crowd into a standardized consumer mass? For the answer to this question, contemporary thought turns increasingly to religion, while the question itself increasingly reveals a theological bent. Kosolapov's recent work answers this very question and gives, I believe, a rather accurate theological answer. In fact, Kosolapov sees in Christianity the initial form and archetype of our current consumer society. The figure of Christ appears in Kosolapov's work as a symbol of the contemporary masses' purchasing power, while the figure of Lenin appeared above all as a symbol of their power of production. In turning from commercial brands toward religious brands—in fact, predecessors and models of commercial brands—contemporary consumer society is returning to its roots. Kosolapov demonstrates this process by making a Christian icon share space with images of caviar or the MacDonald's logo.

Indeed, both Orthodox and Catholic communion might be considered a primary form of mass consumption—at least in the context of Christian and post-Christian civilization. The mystery of the Eucharist aims at the unification and standardization of the versatile human mass, and aspires to transform it into a community of consumers of divine bliss. The Russian Slavophiles have already begun to describe Christian sacraments in terms of their consumption, as opposed to their traditional interpretation of them in terms of production. According to Slavophile theoreticians, these sacraments are sacred not so much by virtue of their divine origin, but rather by virtue of their having accumulated the desires of the masses: The icons are holy because of the prayers they have received, the Eucharist is holy since it unifies the community, and so on. Some parallels with the functioning of commercial brands are evident here. We are talking in particular about an equation of commodity and divine bliss—or rather, about a theology of commodity as bliss. The consumerist ideology of our time has its origin in the Eucharist: contemporary mass consumption is a secularized ritual of the Eucharist.

Figure 14.4
Alexander Kosolapov, *Mickey-Lenin*, 2003. Bronze, 130 × 60 cm. Private collection (Russia).

Figure 14.5
Alexander Kosolapov in front of his studio in Moscow, 1979. Photograph by Igor Makarevich.

It is no coincidence that some Western authors (Marie-José Mondzain, for one) have based their analysis of the icon on the etymological adjacency of the words "icon" and "economy": The icon has been addressed as a manifestation of the divine "iconomy," that is, the most economical way to display the invisible in the visible world. Consumption of the icon by contemplation corresponds to the role of the icon as image of consumption—namely, consumption of the divine grace. If we recall the analysis of Marxian commodity fetishism, this should suffice for proving the iconic genealogy of commodity. Any commodity can be interpreted as the manifestation of an invisible, symbolic monetary value. In essence, Kosolapov's works reveal and continue this Slavophile theological tradition of understanding the symbolism of the commodity, so that at first glance it isn't clear why they generated such irritation and annoyance among those who actually believe themselves to be part of this very tradition.

The reason can only be that a quotation of the icon of Christ and its interpretation as a symbol of the masses' purchasing power was carried out in an unsanctioned way, that is to say, privately. Evidently, Kosolapov's unsanctioned privatization of symbols that are supposed to operate in a centralized and organized manner generated the outrage of a certain section of the populace. However, such unsanctioned, private use of social and state symbols was characteristic of the art of the 1970s–1990s, the tradition

Figure 14.6
Alexander Kosolapov, *North*, 1973. Gouache on fiberboard, 40 × 60 cm. The Norton and Nancy Dodge Collection of Nonconformist Art from the Soviet Union. Jane Voorhees Zimmerli Art Museum, Rutgers, The State University of New Jersey.

within which Kosolapov belongs. During the epoch of Soviet Communism, its symbols were officially perceived as belonging to nobody, collective—so that apparently anyone could use them privately. The official reaction to the works by Sots-artists, however, repeatedly demonstrated that the collective property of Communist symbols—such as the red flag or a portrait of Lenin—was fictitious and illusory. Any attempt to take this claim of collectivity seriously and realize it was interdicted as affecting the state power's privileges.

The very same reaction confronts Kosolapov today. At first glance, Christ is communal and doesn't belong to anyone in particular; anyone can appeal to him in the form he or she wishes, or use his icon in the way he or she desires. In practice, however, this is not the case. The consumption of the icon of Christ—like consumption in general—is considered sacred, that is, correct and normative, only in its standardized, ritualized form. In contrast, any individual idiosyncratic methods of consumption are rejected and regarded as marginal and thus dangerous to the masses' consumerist psychology. But precisely this kind of individual and thus profane consumption of

Figure 14.7
Alexander Kosolapov, *Caviar Icon*, 1996. Digital print. Dimensions variable.

social symbols is practiced by Kosolapov in his works from both the Soviet and post-Soviet periods. The real act of profanation doesn't consist in utilizing images of Lenin or Christ in the context of art—such usage has, naturally, a long and established tradition; rather, it is a matter of the individual playing with societal symbols in a way that goes beyond their ritualized usage. Thus, Kosolapov has again revealed in his work the current mechanisms of sanctification, and first and foremost the fact that, in relation to these mechanisms, art is still capable of playing its traditional role: the secularization and profanation of the mechanisms of sanctification themselves as well as the results of their implementation. Since the purchasing power of the masses is the actual object of worship today, a private appropriation of the symbols of this purchasing power—what is more, conducted free of charge—occurs as a frivolous and even mocking act of irreverence toward the sacrament. However, such has always been the practice of art that effectively performs its task.

Notes

Introduction

1. J.-P. Sartre, *Being and Nothingness* (New York: Washington Square Press, 1984), pp. 340ff.

2. Yekaterina Degot and Vadim Zakharov (eds.), *Moskovskiy kontseptualism* (Moscow: VAM, 2006).

3. Boris Groys, Max Hollein, and Manuel Fontan del Junco (eds.), *The Total Enlightenment: Moscow Conceptual Art 1960–1990* (Ostfildern: Hatje Cantz, 2008).

4. Giorgio Agamben, "Beamten des Himmels. Ueber Engel," in *Verlag der Weltreligionen* (Frankfurt am Main, 1908).

5. Erik Bulatov, "Ob otnoshenii Malevicha k prostranstvu," *A-Ya*, no. 5; quoted in Boris Groys, *The Total Art of Stalinism* (Princeton: Princeton University Press, 1992).

Chapter 4 Communist Conceptual Art

1. Benjamin H. D. Buchloh, "Conceptual Art, 1962–1969: From the Aesthetic of Administration to the Critique of Institutions," in *Broodthaers: Writings, Interviews, Photographs*, special issue of *October*, no. 42 (1987): 119–155.

2. G. W. F. Hegel, *Phenomenology of Spirit*, translated by A. V. Miller (Oxford: Oxford University Press, 1977), pp. 334ff.

Chapter 6 Ilya Kabakov: We Shall Be Like Flies

1. L. F. Zhegin's reminiscences are quoted in E. F. Kovtun, *Russkaya futuristicheskaya kniga* (The Russian futurist book) (Moscow, 1989), p. 11.

2. Ilya Kabakov, "On the Subject of 'The Void,'" in *The Total Enlightenment: Conceptual Art in Moscow 1960–1990*, ed. Boris Groys, Max Hollein, and Manuel Fontan del Junco (Ostfildern: Hatje Cantz), pp. 368ff. Catalog of an exhibition.

3. See Kabakov's early drawing "Zeichenerklaerung" (Image legend) (1968) in Ilya Kabakov, *Am Rande: Katalog der Ausstellung an der Kunsthalle Bern* (Bern, 1985), p. 13.

Chapter 7 Ilya Kabakov: The Theater of Authorship

1. See, e.g., Pierre Bourdieu, *Les règles de l'art* (Paris, 1992).

2. From Ilya Kabakov's preface to Paul R. Jolles, *Memento aus Moskau* (Cologne, 1997).

3. Jean-Luc Nancy, *La communauté désoeuvrée* (Paris, 1990).

Chapter 10 Andrei Monastyrski: Living in Art

1. Other members included N. Alekseev, G. Kisevalter, N. Panitkov, and I. Makarevich.

2. Kollektivnye deistviia, *Poezdki za gorod* (Moscow: Ad Marginem, 1998).

3. Ibid., pp. 20ff.

Chapter 12 Medical Hermeneutics: After the Big *Tsimtsum*

1. Pavel Pepperstein, "Rapport NOMA—NOMA," in Ilya Kabakov, *NOMA oder Der Kreis der Moskauer Konzeptualisten*, exh. cat., Hamburger Kunsthalle (Ostfildern: Hatje Cantz Verlag, 1998), pp. 14–16.

2. Marcel Mauss, *The Gift: The Form and Reason for Exchange in Archaic Societies*, trans. W. D. Halls (New York: W. W. Norton, 1990), 10. Originally published as "Essai sur le don: Forme et raison de l'échange dans les sociétés archaïques," in Mauss, *Sociologie et anthropologie* (Paris: Presses Universitaires de France, 1950), p. 157.

3. This and following quotations are from Claude Lévi-Strauss, *Introduction to the Work of Marcel Mauss*, trans. Felicity Baker (London: Routledge & Kegan Paul, 1987), pp. 61–64. Originally published as "Introduction à l'œuvre de Marcel Mauss," in Mauss, *Sociologie et anthropologie*, pp. xlviii–lii, esp. xlix–lii.

Chapter 13 Grisha Bruskin: Allegorical Man

1. Walter Benjamin, *The Origin of German Tragic Drama* (London: Verso, 2003), p. 166.

Sources

1 Moscow Romantic Conceptualism

Originally published in *A-Ya*, no. 1 (Paris, 1979): 3–11. Translated from Russian by Keith Hammond.

2 Privatizations/Psychologizations

Originally published as "Privatisierungen/Psychologisierungen," in *Kräftemessen* (Stuttgart: Cantz, 1996), pp. 81–90. Translated from German by Catherine Schelbert.

3 Sots-Art: Eastern Prophecies

Originally published in *Artforum* (March 2008): 331–333.

4 Communist Conceptual Art

Originally published in *The Total Enlightenment: Conceptual Art in Moscow 1960–1990*, ed. Boris Groys, Max Hollein, and Manuel Fontan del Junco (exh. cat.; Ostfildern: Hatje Cantz, 2008), pp. 316–321. Translated from German by Steven Lindberg.

5 Ilya Kabakov: The Artist as Storyteller

Originally published in *A-Ya*, no. 2 (Paris, 1980): 17–22. Translated from Russian by Jamey Gambrell.

6 Ilya Kabakov: We Shall Be Like Flies

Originally published in *Life of Flies* (Cologne: Koelnischer Kunstverein/Edition Cantz, 1991), pp. 211–213. Translated from Russian by Keith Hammond.

7 Ilya Kabakov: The Theater of Authorship

Originally published in *Ilya Kabakov: Installations 1983–2000* (Kunstmuseum Bern, Bern: Richter Verlag, 2003), pp. 33–44. Translated from German by Matthew Partridge.

8 Ilya Kabakov: The Utopia of Painting

Originally published in *Ilya Kabakov: Paintings/Gemaelde 1957–2008* (Museum Wiesbaden, Wiesbaden: Kerbel Verlag, 2008), pp. 29–33. Translated from German by Steven Lindberg.

9 Boris Mikhailov: The Eroticism of Imperfection

Recipient of the Hasselblad Award 2000, Scala, Zurich 2001. Translated from German by Matthew Partridge.

10 Andrei Monastyrski: Living in Art

Catalog of the Vincent Award Exhibition, 2006, Stedelijk Museum, Amsterdam, 2006. Translated from German by Steven Lindberg.

11 Medical Hermeneutics, or Curing Health

Translated from German by Lynn Visson.

12 Medical Hermeneutics: After the Big *Tsimtsum*

Originally published as "Nach dem grossen Zimzum/After the Big Tsimtsum," in *Pavel Pepperstein und Gäste/Pavel Pepperstein and Guests*, ed. Matthias Haldemann (Ostfildern-Ruit: Hatje Cantz, 2004), pp. 197–205.

13 Grisha Bruskin: Allegorical Man

Originally published in *Grisha Bruskin, "Alephbet. Tepistry Project"* (Moscow: Palace Editions, 2006), pp. 11–27. Translated from Russian by Antonina Bouis.

14 Alexander Kosolapov: The Artist in the Age of Commodity Fetishism

Translated from Russian by Elena Sorokina and Emily Speers Mears.

Index

Note: Page numbers in italic type indicate illustrations.